Gardens of the Gods:
Myth, Magic and Meaning

Picture credits

All photographs were taken by the author except those of the North Carolina Center for the Advancement of Teaching, which were taken by Connie Hanna. The view of The Hide, Ohio, was drawn by Jan Heynike. The plans in Chapter 12 are by Sandra-Jasmin Kuhn.

Gardens of the Gods:
Myth, Magic and Meaning

Christopher McIntosh

I.B. TAURIS
LONDON · NEW YORK

Published in 2005 by I.B. Tauris & Co Ltd
6 Salem Road, London W2 4BU

In the United States and Canada
distributed by Palgrave Macmillan,
a division of St. Martin's Press
175 Fifth Avenue, New York NY 10010
www.ibtauris.com

ISBN 1 86064 740 5
EAN 978 1 86064 740 6

A full CIP record for this book is available from the British Library
A full CIP record is available from the Library of Congress

Library of Congress Catalog Card Number: available

Typeset by ITS, Edinburgh
Printed and bound in Great Britain by TJ International Ltd, Padstow, Cornwall

To Ian Hamilton Finlay,
who started me on the quest

CONTENTS

Chapter 12
Creating a garden of meaning
Practical suggestions for applying some of the approaches
described in the book to create meaning in one's own garden.
Tuning in to the space, choosing the overall mood, selecting
decorative motifs and plants. Three case studies, illustrated by

LIST OF ILLUSTRATIONS

1. The garden of the Tenryu-ji Zen Buddhist temple, Kyoto, Japan.

2. Sand garden at the Ryoan-ji temple, Kyoto. It consists essentially of an area of pale sand carefully raked into a pattern of parallel lines, the surface broken only by 15 carefully placed stones.

3. Looking out from one of the pavilions of the Red Fort garden, Delhi.

4. Image from a French sixteenth-century manuscript showing an enclosed garden in the medieval style.

5. Statue of Hercules at the Villa Castello, Florence.

6. The Fountain of Oceanus in the Boboli garden, Florence.

7. Garden of the Villa Garzoni, Collodi, Tuscany.

8. One of the fountains of the seasons at Versailles: Autumn.

9. The Gothic Temple at Stowe, Buckinghamshire, England.

10. Wörlitz, Germany: the Venus Temple and the window of the Grotto of Aeolos.

11. The 'Stone of Good Fortune' at Goethe's Garden House, Weimar.

12. Allegorical figure of Spring in the garden of the Bossard Temple, Lüneburg Heath, Germany.

13. Little Sparta, the garden in Lanarkshire, Scotland, created by the poet and artist Ian Hamilton Finlay: view across the pond to the Apollo Temple.

14. Little Sparta: head of Apollo depicted as the French revolutionary Saint Just.

15. The garden in Tuscany with images from the Tarot trumps, created by the French artist Niki de Saint Phalle.

16. Dumbarton Oaks, Washington DC: the Star Garden.

17. A figure of Pan points the way in the Dumbarton Oaks garden.

18. Renaissance garden designed in the 1990s by Neill Clark at a teachers' study centre in Cullowhee, North Carolina, USA.

19. Paving at the entrance to the Cullowhee garden.

20. A fish-eye view of The Hide, Ohio, USA: a drawing by Jan Heynike.

Case study 1: Druidic mystery in a town garden

Case study 2: As above, so below

Case study 3: A *feng shui* patio

ACKNOWLEDGEMENTS

In addition to recording my special debt to Ian Hamilton Finlay, for his seminal role in arousing the interest that led to this book, I would like to express my thanks to the following people: to Katherine Kurs for sharing with me her own research and insights into the garden as sacred space; to Sandra-Jasmin Kuhn for her drawings and planting suggestions for Chapter 12; to Princess Emanuela Kretzulesco for the inspiration I have gained from her work on the symbolic dimensions of Renaissance and Baroque gardens; to Deborah Forman for visiting with me some remarkable gardens; to Joscelyn Godwin for giving me the benefit of his knowledge of Renaissance paganism and for a memorable and insightful tour of the Boboli garden in Florence; to Lionel Snell for his practical suggestions on the magical approach to gardening; to Jan Heynike and Neill Clarke for providing information on their own sacred and symbolic gardens; to the staff of Dumbarton Oaks Garden Library in Washington DC for enabling me to consult their rich collection; and to the creators of all the gardens that have given me inspiration and delight.

ACKNOWLEDGEMENTS

INTRODUCTION

This book is an invitation to look at gardens in a new way – or rather to rediscover a very old way of looking at them. My theme is the garden as a sacred space, an outdoor temple carrying an intentional transformative message, religious, mystical or philosophical in meaning.

For the author, this rich subject has been a compelling personal quest. It began in the year 1976 when I was invited to write an article on Stonypath (now called Little Sparta), the world-famous garden in Scotland created by the poet and artist Ian Hamilton Finlay and his then wife Sue Finlay. One afternoon in late summer I found myself driving up a bumpy dirt road towards what appeared from the distance to be a small green oasis, sheltered by windswept trees, amid the bleak Lanarkshire hills. But, once inside the garden, its dimensions seemed miraculously to expand like the Tardis of Dr Who. With Ian Hamilton Finlay as my guide I was shown an astonishing world filled with specially created objects – sculptures, reliefs, plaques, sundials, classical columns, bird-tables, poems written on paving-stones – each placed in a carefully chosen and beautifully tended setting and each carrying a verbal message that resonated with its surroundings and evoked a response on many levels. It was and is a garden of profoundly powerful impact.

Another person who opened my eyes to the possibilities of garden design was the French artist Niki de Saint Phalle, who died in 2002 and whom I met in the 1980s when she was in the early stages of creating her amazing Tarot Garden in Tuscany. A documentary film has been made about her life and the creation of the garden. In contrast to the disciplined neo-classicism of Stonypath, Niki de Saint Phalle's garden is a wildly surrealistic creation, a collection of giant figures based on the Tarot trumps, some of them big enough to live

in, brilliantly coloured and decked out in a shining mosaic of glass and ceramic. With echoes of the weird sixteenth-century garden of Bomarzo near Rome, it is a place of intense exuberance and vitality. In Chapter 10 I shall discuss this garden and that of Ian Hamilton Finlay in greater detail.

What Niki de Saint Phalle and the Finlays were doing made me realize how impoverished most modern gardens are by comparison. It showed me how a garden, instead of being just a collection of ornamental plants in a decorative setting, can be a place resonant with meaning. The experience led me to realize that they were not the first people to use gardens in this way. Indeed, they themselves were consciously rediscovering and reinventing the art of using gardens to convey a message. Inspired by their example, I began to study the gardening traditions of other cultures – China, Japan, Persia, the Islamic world, Renaissance Italy, eighteenth-century England. I read all the relevant material I could find, and I began to visit and photograph as many gardens as I could. After I joined the United Nations system in 1989 I found myself travelling to many different countries in all regions of the world – and of course gardens were on my agenda whenever possible. Most of the photographs reproduced here were taken by me on those journeys.

Like all good quests, this one contains an element of the impossible. Trying to identify the meaning of a garden is like trying to read some old book, half mouldered into illegibility, where certain pages are written in a long-forgotten code and others are re-writing themselves constantly, adjusting their message to the age or to the individual reader. A garden is not a text with a fixed meaning. Even if some gardens begin that way, over time they change hands, become overgrown, are re-shaped, re-planted and re-ornamented, always acquiring new meaning. Furthermore, the most poignant moments of meaning are those unpredictable occasions when the visitor's eye falls on some part of the garden and experiences a sudden profound resonance that could never have been planned by the original creator of the garden – just as the reader of a poem may find meanings that never occurred to the poet. During the course of this book I will allude to a number of such moments that I myself have experienced.

This book is therefore about an impossible quest – impossible, but not quite. Many gardens *were* created as places of deliberate meaning – meaning written in a language that can sometimes be understood, however dimly, by the visitor of today. All languages have a structure,

and I have attempted in Chapter 1 to categorize the basic elements that make up the symbolic language of horticulture – even though the grammar, vocabulary and idioms may vary from culture to culture. Taking this structure as a point of reference, I describe a range of gardens of different ages, regions and traditions that convey meaning in different ways. The choice reflects my own particular interests – religion, myth, magic and the esoteric – although I touch on other areas of meaning as well.

Since I began work on this book a number of others have ventured into similar territory. Among the resulting books are: *Spiritual Gardening* by Peg Streep (1999), *Gardens of the Spirit* by Roni Jay (1999), *Cultivating Sacred Space* by Elizabeth Murray (1997) and *Sacred Gardens* by Martin Palmer and David Manning (2000). These could be described essentially as practical manuals with a number of small 'windows' on to some of the sacred gardening traditions of the world. This book, while dealing with many of the same motifs, has a fundamentally different approach and focus. On one level it is a detailed account of my own personal journey through this territory and my encounters with a number of remarkable gardens and sometimes with their creators. In parallel, the book is an in-depth examination of the world views, ideas and traditions that underpin these gardens as well as the symbolic 'vocabulary' that they employ. It also contains a chapter with practical suggestions. There, however, my approach is not to start from a particular model of sacred garden but rather from the nature of the space available, and to ask what sort of symbolic language it calls for, in the light of the information given in earlier chapters.

Inevitably, given the vast scope of the subject, there was much that I had to leave out. For example, I devote only a small part of Chapter 9 to cemeteries and just one chapter (11) specifically to the theme of interacting with nature, its energies, intelligences and cycles. Obviously there is much more to be said on both of these subjects.

During my research I had recourse to many books on different aspects of the subject, to which I refer in my endnotes and in my bibliography, but I will mention here a few of them that I found particularly interesting or significant.

An author who has greatly inspired me is Princess Emanuela Kretzulesco, whose book *Les Jardins du Songe* (latest edition 1986) is a remarkable study of the Renaissance work *Hypnerotomachia Poliphili* and its influence on garden design throughout Europe. Her

book, although controversial, enabled me to perceive in a whole new way the symbolism of such gardens as those of Versailles, Fontainebleau and the Medici villas in Tuscany. The book *Landscape and Memory* by the cultural historian Simon Schama (1995), is a rich exploration of the way in which history and myth merge in our perception of landscape and gardens. Turning to the Orient, a classic study is *The Chinese Garden* by Maggie Keswick (1978), which contains much valuable information on the influence of Taoism and other religious and philosophical traditions on garden design. The best equivalent that I know for Japanese gardens is Günter Nitschke's *Der japanische Garten* (1991). Elizabeth Moynihan's *Paradise as a Garden* (1980) explores the paradise garden tradition in Persia and Mughal India, while John Brookes' *Gardens of Paradise* (1987) is an excellent study of Islamic gardens as a whole. There are also a number of more general works that I have found useful. For example, Christopher Thacker's *History of Gardens* (latest edition 1985) is a very valuable overview of the subject and throws much light on the symbolic dimensions of garden design in different cultures. A similar overview is provided by Ronald King's *The Quest for Paradise* (1979). Finally I must mention Marie Luise Gothein's classic two-volume work *Geschichte der Gartenkunst* (1926). Although written three-quarters of a century ago, it remains one of the best and most comprehensive surveys of gardening history.

However, the most important source for me has been the gardens themselves, which can speak more eloquently than any book. Many of the gardens that I mention have long since vanished, like the fabulous gardens of Heidelberg created by Salomon de Caus in the seventeenth century. Some have fallen into ruin or semi-ruin, like the once legendary gardens of the Red Fort in Delhi. Some, like those of the Zen Buddhist monasteries in Kyoto, have been lovingly maintained for centuries. Some have been created very recently. Some exist only in the minds of poets or on the canvases of painters. Some will remain for ever unrealized dreams. All, however, have in common a conception of the garden as a place in which nature and art come together to create a special kind of meaning. I hope this book will inspire its readers to look at – and perhaps to create – gardens in the light of an expanded vision of what a garden can be.

1

THE SYMBOLIC LANGUAGE
OF GARDENS

A verandah in Kyoto overlooking an expanse of white sand, its carefully raked parallel lines broken only by a few rocks; the mysterious recesses of a Chinese garden glimpsed through a circular opening in a high wall; the dried-up fountains and watercourses of a once sumptuous Mughal garden in India; a flight of terraces in Tuscany peopled by satyrs, dwarves, monkeys and gods; the surrealistic rock sculptures of Bomarzo; the throng of deities around the Fountain of Apollo at Versailles; a grotto in England with a nymph sleeping by murmuring waters; a Scottish hillside with the golden head of a Greek god half hidden in the shrubbery – these places, disparate geographically and culturally, are linked together. They are all gardens, yes, but gardens that 'speak' in a special way to the visitor who knows how to listen and who understands something of their language.

What is a garden? The stock dictionary definition might be 'a piece of land in which fruit, vegetables or flowers are planted'. But the people who dreamed up the gardens I have just mentioned would give a very different answer. To them, gardens were – or are – not merely places of beauty but places of meaning. To the modern mind the idea of gardens as conveyors of meaning is an unfamiliar one. Yet a garden can convey meaning in the same way that a building can. To visit one of the great medieval cathedrals such as Chartres is to experience not just a building but a kind of book, a text written in carved stonework and stained glass, which makes a statement about medieval theology,

cosmology and values – indeed about the whole order of things as the medieval mind saw it. Similarly, to visit, say, the garden of Versailles is to catch a glimpse of the world order as it was seen by Louis XIV and his court. In other words, a garden can be a metaphor, used to convey a world view, a mood, a thought or an ideal. A whole book – or many – could be devoted to the garden as a metaphor in literature and art. We shall of course touch on this aspect of the subject. Primarily, however, we shall focus on real gardens.

What makes gardens such potentially powerful metaphors is the way in which they bring together nature and art. This combination allows for enormous variations in emphasis, depending on how nature is viewed in particular cultures. For cultures that live inseparably from nature the concept of a garden can have no meaning, since a garden is by definition something that is set apart. For some cultures, such as those of ancient China and Japan, a garden is a refinement of nature. The modern city dweller is likely to see gardens as places where a lost natural beauty can be recreated. Then again, a garden means one thing to a dweller in an arid desert environment and another thing to someone from a damp and verdant region.

By the same token the individual motifs that appear in gardens vary greatly in the meanings attached to them – woods, for example, are traditionally sacred in northern Europe but grim and perilous places in the south (see 'Trees, groves and woods' below). On the other hand, there are certain motifs that appear to have a universal or widely shared meaning that crosses cultural boundaries – the fountain, with its life-giving water, is one example. Some would see these shared symbols as belonging to the store of images inherited by all of humankind and accessible through the 'collective unconscious', as the psychologist C.G. Jung believed. Ultimately of course anything in a garden can take on the character of a 'symbol' if the observer chooses to see it that way: a bee gathering nectar from a flower, the dance of sunlight filtered through foliage, the pattern of freshly fallen autumn leaves on the ground, a spider's web hung with dew – and an infinite number of other things. 'Reading' a garden is therefore no simple matter, and no garden can be seen as a text with a fixed meaning. A garden, like a good poem, contains many levels of meaning and draws a different response from every individual.

There are, however, enough shared images and symbols (either within or across cultures) to make possible the existence of a language of gardens – or rather many languages, in fact an almost infinite

number. It would be impossible to learn all of these languages – in any case, many are lost to memory. Nevertheless it is possible to identify a common structure to these languages, which has three basic ingredients.

First, there is the form of the garden as a whole. This includes the lines traced by the perimeter and the internal divisions, which can be straight or rounded, symmetrical or asymmetrical. They can incorporate significant numbers or special geometrical shapes. Compass alignments can also be important. The formal aspect would include the question of what proportion of the garden is left to nature and what proportion is shaped by human hand. The English gardening tradition, for example, prefers to leave more to nature than the French tradition with its preference for symmetry and formality. Japanese gardens employ a sleight of hand, which creates a natural appearance that is in fact carefully contrived. Questions of form, shape and compass alignment are particularly important in gardens based on the *feng shui* tradition, which will be discussed in detail later.

The second basic ingredient of the language consists of the objects that are created or placed in the garden or the existing landscape features to which specific meanings are attached. These might be natural or man-made hills, rivers, ponds, caves – not forgetting the animals that live in the territory or have been introduced there. Such features might also include fountains, statues, reliefs, topiary hedges, labyrinths, pavilions and gazebos.

The third ingredient of the language relates to the plants in the garden and the meanings they are given. A plant has of course a large number of different meanings and associations depending on the region and the culture. Its meaning can be determined by physical characteristics, such as colour, shape or chemical properties. In some cases the astrological attribution is an important factor. Among the herbs, for example, rosemary corresponds to the Sun, mint to Mercury, thyme to Venus and sage to Jupiter. Then there is the whole field of religious and mythological associations. We can think, for instance, of the laurel, sacred to Apollo and symbolizing glory and poetic inspiration, the willow sacred to Hecate, goddess of witchcraft, the oak, sacred to Jupiter, and ivy and the vine, sacred to Bacchus. A more extensive list of plant meanings can be found in the appendix to this book.

These are, so to speak, the three main 'parts of speech' in the language of gardens. The vocabulary of that language has no end, as

it has been reinvented many times in history and continues to be created. Nevertheless, just as the origins of many European words can be traced back thousands of years, so many of the meanings attached to garden features stem from the very earliest civilizations that are known to have created gardens. At this point it might be helpful to look at some of these recurring motifs before setting off to explore the sacred and symbolic gardens of specific regions and periods. The list of motifs that follows is not intended to be exhaustive, and the order is intuitive rather than logical, with certain motifs grouped thematically together.

Images of paradise

Perhaps the oldest metaphor connected with gardens is the idea of the garden as an image of paradise, and it is interesting to follow this metaphor – or complex of metaphors – down through the ages. The idea can be traced back at least 5,000 years to ancient Mesopotamia, that is roughly the area that we now know as Iran and Iraq. Then as now, this was a hot, dry region. It was therefore natural to imagine paradise as a green oasis where the gods and immortals lived or as a verdant place of primal bliss and innocence – as in the Old Testament account of the Garden of Eden.

In the early writings of this region, such as the *Epic of Gilgamesh*, one of the world's most ancient pieces of literature, named after the mythical King of Sumer in Babylon and dating from the third millennium BC, we find that paradise is described as having certain specific features. It had four rivers dividing the garden according to the points of the compass, and coming together to form a cross – a feature that we find repeatedly in the gardens of later times, notably in the paradise gardens of the Islamic tradition, which will be discussed in detail in Chapter 3. This theme of the four rivers was taken up and reinterpreted again and again over the centuries. In some accounts of paradise there was a fountain at the centre where the rivers intersected. The two themes come together in the Fountain of the Four Rivers in Rome, created by Gianlorenzo Bernini in the mid-seventeenth century, in which the rivers become the Danube, the Nile, the Ganges and the Río de la Plata. Behind Bernini's design lies the view that ancient symbologies and systems of belief prefigure the Christian revelation. As Simon Schama writes, in *Landscape and Memory*: 'In such an ecumenical cosmology, though the waters of

paradise had indeed divided the world, they retained, at their ultimate source, the *fons et origo*, an issue from a single indivisible divinity.'[1] Again, the fountain is a powerful motif found in gardens all over the world and suggesting the flow of the life force itself, as well as the source of spiritual nourishment (see also 'Water' below).

Marking the centre

The image of the centre has a profound symbolic meaning. The mythologies and religions of many different peoples and regions tell of a hidden 'centre of the world', a place of timelessness and immortality where superior beings dwell, immune from the temporal flux of the world we live in. It is sometimes also described as the 'axis' or 'navel' of the world. Arguably the concept of paradise originally referred to this centre rather than just to the heavenly abode of the dead. René Guénon, in his book *The Lord of the World*,[2] describes the age-old human urge to reproduce this place on a smaller scale by locating sacred sites or objects at the centre of a kingdom, a territory, a city or a garden. Each of these geographical centres is symbolic of a spiritual centre to which each individual can orient himself or herself, and in every garden there is the possibility to create such a centre.

There are many ways of marking the centre. The fountain at the intersection of the four rivers of paradise has already been mentioned. Another feature described in Mesopotamian sources is that of the mound or hill which stood in the centre of paradise, sometimes combined with the fountain. The sacred hill or mountain features also among the Hindus as Meru, in the Western Grail legend as Montsalvat, the home of the Grail King and his knights, and in ancient Greek mythology as Olympus, home of the gods, as well as Parnassus, abode of Apollo and of the Muses – these latter also inhabit Mount Helicon, where the winged horse Pegasus struck his hooves against the rock, causing the spring known as Hippocrene to gush forth. It is for this reason that fountains are often surmounted by the figure of Pegasus on top of a rock that sometimes represents Parnassus and Helicon combined.

Sir Francis Bacon echoed the age-old tradition of the paradise mound when he recommended, in his essay 'Of Gardens' (1625), that the ideal garden should have at its centre 'a fair mount, with three ascents, and alleys, enough for four to walk abreast'.[3] What lay behind

Bacon's use of this motif was a belief, shared by many of his contemporaries, that it was possible for humankind, through intelligence, industry and dominion over nature, to recover the paradisical state that had been lost through the Fall. For Bacon, horticulture was the perfect expression of this possibility.[4] In England, possibly due to Bacon's influence, paradise mounds or mounts became particularly popular for a time. The few that remain in England today include those at Little Moreton Hall in Cheshire, Packwood House in Warwickshire, and New College, Oxford. Examples on the continent of Europe include the spiral hill at the Eremitage near Bayreuth in Bavaria, the mound in the gardens at Enghien, Belgium, and the terraced pyramid in the spectacular island garden of Isola Bella in Lake Maggiore, Italy. As for mounts representing Parnassus, one of them, combined with a fountain and complete with Pegasus and statues of Apollo and the Muses, was created by the great seventeenth-century French garden architect Salomon de Caus, for the garden at Somerset House in London, but has long since vanished. A similar example is illustrated in his book *Les Raisons des Forces Mouvantes*, published in 1615. Other examples of fountains combined with mounts are found in his *Hortus Palatinus* (1620), the collection of designs for the Heidelberg palace gardens, created by de Caus for Prince Frederick of the Palatinate. These gardens, one of the marvels of their age, were tragically destroyed following the defeat of Frederick by the Habsburg forces in 1620 at the Battle of the White Mountain.

A variation of the mountain at the centre of the world is that of the Omphalos, or sacred stone (from the Greek word meaning 'umbilical'), and another variation is the sacred tree, which similarly symbolizes the axis of the world (see 'Stones' and 'Trees, groves and woods' below).

Compass points and fourfold patterns

In gardens where there is a strongly emphasized centre, there is often also an emphasis on the four directions of the compass or the four quarters of the earth. In Islamic gardens this follows naturally from the placing of the traditional four watercourses, already mentioned. We shall also find it in other horticultural styles, such as that of the botanical garden, where plants are allocated to the quarters according to their region of origin.

Four is also the number of the seasons of the year and of the classical four elements (see 'The elements' below). Both of these groups are represented allegorically in countless gardens, and both can be linked with the compass points. In Europe the most common system of correspondences is: east with spring and air; south with summer and fire; west with autumn and water; north with winter and earth. In the oriental *feng shui* tradition there are five elements and five directions, since the centre is considered one of the compass points.

Approaches and entrances

Whether we consider a garden as an image of paradise or as a kind of temple, a place set apart, one of its key features is the entrance or threshold. J.E. Cirlot, in his *Dictionary of Symbols*, defines the threshold as:

> A symbol of transition and transcendence. In architectural symbolism the threshold is always given a special significance by the elaboration and enrichment of its structure by means of porches, perrons, porticoes, triumphal arches, etc., or by symbolic ornamentation of the kind which, in the West, finds its finest expression in the Christian cathedral. . . Hence the function of the threshold is clearly to symbolize both the reconciliation and separation of the two worlds of the profane and the sacred. In the East, the function of protecting and warning is effected by the 'keepers of the threshold' – dragons and effigies of gods or spirits.[5]

We find such guardian images at the entrances to gardens all over the world. Sphinxes, for example, are ubiquitous in Western gardens, flanking gates, stairways and pathways. The sphinx, with its dual nature – half-animal, half-human – underlines the theme of transition and the fact that the garden is a meeting place of nature and human artifice. Other dual creatures such as gryphons (half-lion, half-eagle) and satyrs (half-man, half-goat) are also found as guardians of entrances. Their presence in so many gardens is surely not just a matter of cultural convention but rather points to a deeply felt impulse, which perhaps can be explained in terms of inherited images, the 'collective unconscious', to use C.G. Jung's term. A different way of marking the

same boundary is found in China in the form of the 'moon gate', a circular opening cut into a wall – this we shall encounter again when looking in greater detail at Chinese gardens.

The experience of transition created by a threshold can be either sudden, as when one unexpectedly stumbles on an urban garden in the depths of a city, or gradual, as in the case of the great country estates with their long approach avenues and imposing gateways. In the gardens explored in this book we shall find both types of threshold and many varieties in between.

Trees, groves and woods

More than anything else that grows from the ground, trees have been the object of reverence and worship from the very earliest times. Indeed the sacred grove, the wooded place set apart and possessing a special atmosphere of numinosity, was arguably the earliest form of garden. In many mythologies and religious traditions trees play a role as oracles or places of transformation or divine revelation. I have already mentioned the tradition of the tree in the centre of paradise, which often represents death but also birth and immortality. In the Middle East this was often a cypress, but many other peoples, including the Hindus, the Chinese, the Japanese, the Maoris of New Zealand and the pre-Columbian civilizations of Central and South America, incorporated a sacred tree into their images of the after-world or the abode of the gods.[6] Other examples of sacred trees include the bodhi tree under which the Buddha achieved enlighten-ment; the burning bush from which Moses heard the voice of God; the Ygdrassil of Norse mythology, which is both the 'axis of the world' connecting the upper and lower realms and the tree on which the god Odin hung for nine days and nights in order to receive the secret of the runes. A similar role is played by the Irminsul, the symbolic family tree of the Germanic peoples.

Although the mystique of trees is universal, they have acquired very different associations, depending on the cultural context. In the Italy of Dante woods were alarming places where one was liable to lose one's way. In the Germanic north, by contrast, they were sacred places. To see the two views visually represented one only needs to look at, say, one of the illustrations of Dante at the beginning of the *Inferno*, lost 'in a dark wood', or of the wanderer in a similar forest depicted in the Renaissance work the *Hypnerotomachia*, and then

to compare these images with the painting *Sacred Grove* by the nineteenth-century Swiss Romantic artist Arnold Böcklin. In Böcklin's beautiful and haunting picture a procession of worshippers, white-robed and hooded, emerges out of the dark depths of a wood and turns to bow down before a stone altar on which a sacred fire is burning. In the background, in stark contrast to the shadowy wood, one can just see part of a sunlit Doric colonnade, gleaming in white and ochre, overlooking a pale blue sea. In this way Böcklin brilliantly combines and contrasts in one painting the worlds of the druidic north and the Apollonian south. A similar symbolic contrast can also be made between the forest and the desert. As Paola Maresca eloquently writes in her book *Boschi sacri e giardini incantati*, 'If the desert, the retreat of the saints, is the place of truth because there are no shadows, by the same token the nocturnal wood is the place of the vital enigma.'[7]

Topiary

Although topiary is often used in a purely decorative way, I include it here as it is a perfect example of the interaction between art and nature and therefore potentially profoundly symbolic. At Versailles, for example, the extensive use of topiary becomes symbolic of mastery over nature. It is frequently used for labyrinths (see below). The word comes from the Latin *topiarius*, which originally meant one who created pleasure gardens, inspired by paintings of landscapes (*topias* in Greek). As such, the *topiarius* was distinct from the *hortulanus*, who created gardens for more practical purposes. In time the art of topiary came to refer to one specific way of beautifying a garden, namely by artistically shaping trees and bushes. The ancient Romans used it for representing animals, obelisks, pyramids, porticoes, statuary, giant letters and many other things. Since then it has gone in and out of fashion a number of times. In the Middle Ages it was reduced to the extreme simplicity of the hedge border, except in the Islamic world, where more elaborate forms were kept alive. In the Renaissance it returned, and a number of illustrations of its use are found in the seminal work, the *Hypnerotomachia* or *Dream of Poliphilus* (see Chapter 4). It went out of fashion again in eighteenth-century England with the open, sweeping landscapes of the Capability Brown school, but returned in the twentieth century and is now popular among gardeners all over the world who have the patience

to work with it. It can be used with a variety of plants including box, yew, privet, cypress and juniper.

The elements

In the West the four traditional elements are earth, water, air and fire. In the ancient world these were considered the basic constituents of everything in the universe. This belief was continued by the alchemists and survives to this day in astrology, where each zodiacal sign is allocated to one of the elements. These elements are of course literally present in every garden: earth in the form of the soil and the rocks; water in ponds, rivers and fountains or as rain and dew (see also 'Water' below); the air that we breathe and that blows through the garden; and fire in the form of sunlight and warmth. The elements can be linked with the four compass points and the four seasons (see below), and can be represented symbolically in many ways, some of which will be suggested in Chapter 11. In China and Japan there are five elements: earth, water, fire, wood and metal. In Chinese and Japanese gardens it is considered important to balance the elements, such as through the juxtaposition of plants belonging to different elements.

The seasonal and daily cycles

Unless you have an indoor garden, lit only by artificial light, it is clearly impossible to avoid being aware of the annual miracle of the seasonal cycle, which Ian Hamilton Finlay has called 'the world's oldest windmill'. Just to observe the process in a garden is in itself to witness magic at work. However, there are those who want to go further and portray the seasons symbolically in the garden, perhaps by linking them with the compass directions and the elements, or with the signs of the Zodiac that mark the course of the solar year, or perhaps by personifying them as gods and goddesses. Here, as we shall see, is a subject for rich iconography. Similarly we cannot ignore the miracle of the daily cycle, which we can, if we wish, emphasize both symbolically and practically through a sundial.

Light and darkness – and other contrasts

The element of contrast is a feature of many of the gardens described in this book – light, open spaces contrasted with dense shrubberies,

grottoes and dim, ferny corners; or tidy, well-tended areas contrasted with wild and overgrown or bleak and rocky places. The boundary line can by analogy be seen as the boundary between the civilized and the primitive, the rational and the irrational, clarity and mystery. In the juxtaposition of two contrasting modes lies a special kind of allure.

Stones

Stones have been revered throughout the world from the earliest times. The Chinese, the Japanese, the Celts, the ancient Hebrews, the indigenous people of America and Africa – all have treated stones with a special awe. They have been seen as dwelling places of gods, tokens of regal power, symbols of longevity, oracles of wisdom. Often a stone has been placed at the symbolic 'centre of the world' (see also 'Marking the centre' above). The best-known example of this from the ancient world is the Omphalos in the temple at Delphi, once the spiritual centre of ancient Greece. It is therefore not surprising to find that stones are often given a special place and significance in gardens.

The contemporary Slovenian-born artist Marko Pogačnik has developed a remarkable way of working with stones, which he calls 'lithopuncture', a kind of earth-acupuncture using carefully shaped standing stones inserted into the ground at points where lines of earth energy meet. Chiselled into these standing stones are special images – birds, spirals, complex geometrical patterns or shapes that look like Arabic calligraphy – each one intended to represent the particular quality and energies of the spot. The town of Villach in Austria, for example, commissioned Pogačnik to install 12 such stones at strategic points. Apart from being very beautiful objects, they have apparently had a beneficial effect on the atmosphere and mood of the town.

Grottoes and caves

The phrase 'vital enigma', which we encountered in connection with woods, could also be applied to the cave or grotto, another landscape feature found in gardens in innumerable different forms. Caves and grottoes are heavy with mythic and symbolic associations. They are profoundly feminine places, suggestive of the womb of Mother Earth, especially when combined with water. From the very earliest times they have been places of initiation, divine revelation and miraculous events. Their importance in ancient Greece is underlined by the

frequent references to them in Homer's *Odyssey*, of which the following is an example:

> At the head of the harbour there is an olive tree with spreading leaves, and nearby is a cave that is shaded and pleasant and sacred to the nymphs who are called the Nymphs of the Well-springs. . . and there is water forever flowing. It has two entrances, one of them facing the North Wind, where people can enter, but the one toward the South Wind has more divinity. That is the way of the immortals, and no men enter by that way.[8]

Many other examples can be given of the importance of caverns and grottoes in classical antiquity. The rites of Mithraism, one of the most widespread cults in the ancient world, were celebrated in caves and underground chambers. The philosopher Pythagoras is said to have received enlightenment in a cave. And the cave of Persephone at Eleusis played a key role in the initiation rites of the Eleusinian mysteries, as Naomi Miller writes in her study *Heavenly Caves*:

> Within the two deep chambers of the sanctuary was a stairway, perhaps used in the staging of Persephone's annual springtime return from the underworld to take part in the celebration of the mysteries, the rites symbolizing nature's cycle of life, death and rebirth. This idea of the grotto as a place of passage between worlds is reinforced by the imagery of Dionysiac craters, where caves represent sacred passages within which the initiation rites were performed.[9]

The tradition of sacred grottoes and springs continued into Roman times when it merged with the fountain in the form of the *nymphaeum*, the place dedicated to the nymphs, which could be a grotto, shrine, basin or enclosure with a spring or a hydraulic device of some kind.

Water: streams, lakes and fountains

All the great gardens of the world feature water in one way or another – even the dry sand and rock gardens of Japanese Zen Buddhism represent water symbolically in the form of raked lines in the sand. In many cultures water represents not only physical but also spiritual

nourishment. It can be made to delight our senses in a thousand different ways, from the dramatic fountains of Versailles or the Villa d'Este to the channels of the traditional Islamic garden. Many examples will be found in the pages that follow (see also 'Images of paradise' and 'The elements' above).

Labyrinths and mazes

The labyrinth is one of the most ancient and ubiquitous of motifs. It is found on megalithic tombs, on Babylonian clay tablets, scratched as graffiti on the walls of Pompeii – and of course in countless gardens. It is a multivalent symbol, akin to the mandalas of Hindu and Buddhist tradition. In some traditions it is a protective device for deterring intruders or evil spirits. In others it represents an initiatory journey to the centre of oneself or a pilgrimage to the true source of spiritual truth through the snares and distractions of the world. The psychologist C.G. Jung saw it as one of the symbols of the collective unconscious, the inherited store of images that humanity carries in its common memory. The terms 'labyrinth' and 'maze' are used almost interchangeably, although some would argue that, strictly speaking, a labyrinth has only one way in and out with no false turnings, whereas a maze has many false turnings designed to confuse and mislead.

Labyrinths are liable to spring up in unexpected places – like the one that I and a group of friends came upon one twilight winter afternoon in Prague. On the way down from the summit of the Vyšehrad, the old sacred power-centre of the city, suddenly there it was, painted in white on a flat paved area – a copy of the famous Chartres labyrinth. We walked through it conscientiously, tracking back and forth between the white lines until finally we stood at the centre where a kind of rose cross bloomed. I was glad of this experience, as when I visited Chartres the labyrinth was always covered by chairs. Another labyrinth, or maze, that stands out in my memory is the one in the gardens of Hampton Court Palace, where the heroes of *Three Men in a Boat* succeed in getting lost.

The most famous labyrinth of ancient times is that of Knossos on the island of Crete, where legend has it that Theseus killed the Minotaur and then found his way out of the labyrinth with the help of Ariadne's thread – although some experts doubt that a physical labyrinth ever existed at Knossos. Another legend is that of the Trojan

horse, filled with armed men, pulled by the unsuspecting inhabitants through the city, which was itself a kind of labyrinth. Hence mazes were sometimes called 'Troy towns' – indeed the very word 'troy' possibly means 'maze'. The ancient Egyptians built tombs of labyrinthine design, and the prehistoric Britons constructed maze-like earthworks, such as the one at Maiden Castle in Dorset. Apart from these physical mazes there exists the tradition of the maze dance, different varieties of which are found in cultures from Bavaria to the Pacific, where the dancers thread their way through a labyrinth marked out on the ground or in some cases an imaginary one.

The Chartres labyrinth is an example of how the tradition has been linked with Christianity, but the practice of cutting mazes into rock or shaping them in turf existed in Europe long before the coming of Christianity. A number of beautiful turf mazes are preserved in Britain, including those at Wing in Buckinghamshire, Hilton in Huntingdon-shire and Saffron Walden in Essex. Britain also has many hedge mazes of various dates. Apart from the famous one at Hampton Court, dating from 1690, there are hedge mazes in the gardens of Hatfield House in Hertfordshire, Glendurgan in Cornwall and Hever Castle in Kent. In her book on mazes, Janet Bord gives a remarkable example of a British maze built with a religious intention: 'The rector of Wyck Rissington, Gloucestershire, began planting the maze in 1950 following a vivid dream in which he was given instructions by a man who stood behind him. The work took six years.' The winding path represents life's journey, with the wrong turnings representing sins and mistakes. The path leads symbolically through death and then into the garden of paradise. Every year on the day of St Laurence, the church's patron, a special service is held and parishioners process through the maze.[10]

On the continent of Europe there are numerous examples of mazes, especially in the great gardens of the Renaissance and Baroque periods. Some of these have vanished, but many still survive. The princes and wealthy patrons for whom they were built were inspired by legendary accounts, such as that of the Cretan labyrinth given in Ovid's *Metamorphoses*. In choosing the design for a labyrinth they could look to examples in painting and also to those that abounded in the pages of practical manuals on horticulture. No doubt these mazes were often seen as playful follies, but some obviously had a serious symbolic purpose. The maze built for Louis XIV at Versailles, for example, had 39 fountains incorporating statues depicting themes

from Aesop's fables, and was clearly intended to convey a moral message to those who wound their way through it. It has unfortunately disappeared, as has the remarkable maze built in China in the early eighteenth century by the Jesuit missionary Father Benoit in the gardens of the Emperor's summer palace, no doubt with an underlying Christian symbolism.

Some fine examples of mazes also exist in North America. One of the most interesting was built at New Harmony, Indiana, a settlement founded in the early eighteenth century by a German Protestant sect, the Rappites, and later associated with the utopian socialist Robert Owen. The maze constructed by the Rappites out of vines and shrubs had an explicit message, as described by the contemporary writer John Mellish in 1822: 'This was a most elegant flower garden with various hedgerows disposed in such a manner as to puzzle people to get into the little temple, emblematic of Harmony, in the middle. The Labyrinth represents the difficulty of arriving at harmony. The temple is rough on the exterior, showing that, at a distance, it has no allurements, but it is smooth and beautiful within to show the beauty of harmony when once attained.'[11] This maze disappeared in the early twentieth century but was reconstructed in 1941 using a new design, as no record of the old one had survived.

In the present day, mazes are enjoying a come-back, and there are now firms that specialize in creating them in gardens. We shall find further interesting examples of mazes from various periods in the gardens that will be described later.

Knot gardens

One of the common features of formal gardens from the Renaissance onwards has been the knot garden, usually a square parterre incorporating a knot pattern laid out in clipped box or various low-growing plants. These knots range from the simple to the highly complex, and often they take the form of a continuous line with no beginning or end, looping and interweaving with itself like the shapes that one finds on ancient Celtic monuments. The knot is one of the oldest and most multivalent symbols known to humanity. It can represent, among other things, binding (and its opposite, loosing), commitment, fidelity (the marriage knot), protection, infinity (the figure of eight is a simple closed knot), cyclical processes and the complications and entanglements of life.

Wildlife in the garden

The creatures that live in or visit gardens must also be mentioned. In many cultures that have created gardens, animals have been seen as part of the pattern of meaning. In Japan the white crane is considered a symbol of good fortune and the upward flight of the spirit, but more common creatures also have their mythological and symbolical associations. Birds in general are found in both Eastern and Western traditions as intermediaries between earth and heaven. The bee is allegorical of many things, including virtuous toil, the descent of the soul to earth, the principle of royalty, as well as poetry and eloquence. The butterfly is also an ancient symbol of the soul, and the spider of perseverance and of fate. The tortoise, which used to be a familiar sight in many a suburban garden (in some countries its import is now banned), is among other things the bearer of the cosmos itself.

The element of play

In our quest for meaning in gardens we should not be too solemn. Playfulness is a highly important and recurrent element that is very often present in gardens as part of the fabric of meaning or as a kind of background music that brightens and enhances the mood of the observer. As we shall see, it can take various forms: play as a puzzle (the labyrinth); humorous playfulness (the cheeky apes with their ball game on the balustrades at Collodi); practical joking (jets of water spurting out suddenly from unexpected places); visual puns like Ian Hamilton Finlay's marble paper boat, aircraft-carrier bird-tables and trees with stone column bases; play as music (the fountains playing tunes at Heidelberg); play in the form of an esoteric card game (the Tarot Garden), and play as make-believe (as at The Hide, Ohio, where the grounds were divided into imaginary areas of darkness and light). Many gardens have a distinctly playful, *Alice in Wonderland* quality and at the same time are places of profound meaning.

The garden as initiatory journey

Many of the motifs described above feed into the idea of the garden as a place that offers an initiatory journey, so that when someone

walks through it they come away uplifted or transformed in some way. It is in this spirit that we can now proceed to look at specific gardens and gardening traditions in various regions of the world and at different times in history.

2

BALANCING THE FORCES OF NATURE: CHINESE AND JAPANESE GARDENS

The Chinese gardening tradition is a great river into which many tributaries flow. It ranges from the immensities of an imperial hunting estate to a handful of miniature plants on a window ledge, and from the luxury of a lakeside pavilion designed for sensual pleasure or poetic inspiration to the serenity of a garden in a Taoist or Buddhist monastery. By the same token, many different religious, spiritual and philosophical traditions have influenced the development of Chinese gardens. One of the oldest and most influential of these is the tradition of the Immortals, or *Hsien*, a group of half-human, half-divine beings who possessed the secret of eternal life. Sometimes they were described as living high up in the Himalayas to the west (as echoed in James Hilton's novel *Lost Horizon* and the film of the same name), sometimes in a vast underground world with grottoes, mountains, rivers and its own sun and moon. Another account placed them on three mysterious islands in the eastern sea, which always melted away in the mist when they were approached. 'Ultimately', writes Maggie Keswick in *The Chinese Garden*, 'it is the idea of these magical dwellings that lies behind the rock-piles and strange standing-stones of Chinese gardens.'[1] She goes on to describe how the Emperor Han Wu-ti (141–86 BC) attempted to recreate the paradise of the Immortals in the grounds of his own palace, the Chi'en Chang, hoping that the Immortals themselves would come and dwell there:

> Han Wu-ti created two spacious lakes with islands. Here were
> built simulacra of the fairy mountains, arranged 'in a pattern'.

Beyond them arose distant views of the hunting parks. The isles themselves were planted with remarkable flowers that bloomed even in winter, 'spirit trees' in groves and jagged rocks that looked like crags. . . A barbarian shaman advised on the necessary techniques for creating suitably potent buildings. The devices he recommended included a revolving weather-vane and a maze of corridors and pavilions with no fewer than a hundred doors and a thousand windows. On high columns, statues of the Immortals held up bowls to catch the dew (. . . identified with the vital breath, essential element of all things).[2]

The purpose of such creations was not only to invoke the legendary Immortals but also to promote longevity among the mortal users of the garden. Indeed, this is one of the purposes of all traditional Chinese gardens, as Pierre and Susanne Rambach argue in their book *Gardens of Longevity*. Hence the great care that is taken to ensure the right flow of vital energies in the landscape.

In his garden, his private realm of longevity, Chinese man saw to it that the flow of these vital energies should be visible or traceable (water, stone, vegetation) and in the man-made elements (pavilions, walls, bridges, bases and lattices). In this way he was able to revitalize himself through the outflow of energies from the elements around him. . . To attain longevity, it is of the utmost importance for a man to keep his garden in good working order by unrelaxing care and upkeep. When tree growth is no longer controlled, when the flow of water dries up, and the stones are loosened and scattered, then the garden dies and man can no longer benefit from it.[3]

The belief that a landscape contains powers and energies is the basis of the Chinese art of geomancy, known as *feng shui* (literally 'wind and water').[4] These energies can be either positive or negative and vary in character depending on the landscape features and configurations. If a landscape or garden is considered inauspicious for its owner it can be altered, often at great effort, to give it the right geomantic characteristics, which could include compass alignments and the positioning of mountains, rivers, lakes, buildings and other features. A spectacular example of applied geomancy was the park created by the Emperor Hui-tsung (1100–1126 AD) at Kaifeng. When Hui-tsung

came to the throne at the age of 26 he was worried by the fact that he had no sons, and he called in his geomancers for advice. They concluded that the land to the north-east of the imperial capital was too flat. It needed a mountain to provide the right kind of energy to ensure male succession. Accordingly, the Emperor set about creating what he called *Ken-yu* (Impregnable Mountain) – actually not so much a single mountain as a whole mountain landscape, 'an artificial pile. . . of "ten thousand layered peaks", with ranges, cliffs, deep gullies, escarpments and chasms'.[5] In due course these efforts bore fruit in the form of a male heir, but in the process Hui-tsung bankrupted himself and lost his empire.

An important influence on Chinese geomancy and garden design is the religion of Taoism, dating from about the fifth century BC. The word *Tao* itself is an almost untranslateable term meaning roughly the 'way' or the essential 'flow' of all things. One of the fundamental concepts in Taoism is that of the *Ch'i*, sometimes translated as 'breath force', an invisible but all-pervasive energy that animates everything in the universe. The *Ch'i* has two basic forms: *Yin* and *Yang*, which are respectively feminine and masculine. It also has various manifestations such as the Dragon, a ubiquitous Chinese symbol for the *Ch'i* in its character as the energy of nature. It is essentially this philosophy that lies behind the medical system known as acupuncture – indeed there are many similarities between acupuncture and geomancy.

Taoism is a holistic philosophy which sees no separation between spirit and matter, heaven and earth, the world of nature and the world of human beings. All are of the same basic substance and all are pervaded by the *Ch'i*. All of nature – animal, vegetable or mineral – is alive, and the contemplation of nature, with its continual cycles of change, is for the Taoist an important form of meditation. Consequently, in China wild landscapes were being admired, painted, described in poetry and recreated many centuries before the English aristocracy began to imitate the beauty of untamed nature. One of the purposes of the Taoist garden is to enable a person to glimpse, within a confined space, the oneness of all things and the mysterious workings of the *Tao*.

When choosing where to place a garden, a building or an entire city, the Chinese often favoured a terrain sheltered on three sides by high ground forming a pattern like a horseshoe or the back and arms of an easy chair. This was thought to be particularly pleasing to the

spirits of the ancestors, whose tombs formed an important feature of any city. Another way of choosing a site involved discerning the Dragon in the contours of the landscape and finding the best position within the undulations of the Dragon's body. In applying geomancy to architecture and garden design, the Chinese have tended to follow two different schools of thought: one emphasizing intuition and a felt rapport with the site; the other highly systematic and involving the application of intricate geomantic compasses and elaborate rules of placement and alignment. The two methods often merge and complement each other, and examples of both can be seen today in the gardens of China as well as Japan.

Another contrast typical of China is between the straight line and the curve or between the square and the circle. Looking at the ground plans of Chinese towns or palace complexes, one sees a mass of interconnected rectangles. Similarly, many gardens are divided up into numerous walled compartments, each one leading into another, so that when one emerges one has the illusion of having passed through a much larger area and that there is still more to see. However, off-setting the rectangular elements are cultivated areas where curves and natural lines dominate. One could also see this contrast as corresponding to the polarity between earth and heaven (earth square, heaven round) and between the masculine and feminine modes in Chinese culture. Confucianism, with its emphasis on hierarchy, social order and correct behaviour, can be characterized as masculine, whereas Taoism, with its fluid, feeling approach to life, can be seen as closer to the feminine pole. Thus, a Confucian house will often be juxtaposed with a Taoist garden. Here we shall find a parallel in the West, where in certain societies a freer rein was permitted in the garden than within the confines of the house.

'The Chinese garden', writes Charles Jencks, 'is a symbol of the owner's life and character, it must express and articulate his day-to-day activity as well as his abstract thoughts. There is thus a function given to the garden which it cannot completely fulfil: it should symbolize the entire universe with its "ten thousand things", and make this profusion quite intelligible. . . The way in which the garden resolves this dilemma is twofold: it tries to incorporate every bit of experience into a tight space; and it restlessly oscillates between polar opposites, the *yin* and the *yang*, the solid and the void.'[6]

Jencks also sees the Chinese garden as a 'magical space', mediating between the divine and earthly realms. 'All. . . religious or spiritual

places seek to break across everyday social time, disrupt the normal flow of events with an abnormal, sacred event. . . In a convincing Chinese garden as much as in an effective play, one's sense of discrete, ordered intervals is transcended by a new order.'[7]

Hong Kong: *feng shui* in a Chinese Manhattan

Hong Kong, although in many ways not typical of China, is one place where one can witness the continuing influence of Taoism and *feng shui* on the Chinese environment, including gardens. At first glance Hong Kong is the epitome of urban modernity, with its forest of skyscrapers along the harbour, its shops and markets overflowing with everything from state-of-the-art computers to jade ornaments, the endless commercial bustle, the bumper-to-bumper traffic filling the hot, humid air with petrol fumes – all the throbbing, pulsating life of a Chinese version of New York. But a closer look reveals another side to the city. Hidden away in a side street or suburb you may find a temple dedicated to one or more of the endless number of Chinese deities, where huge burning spirals of incense hang from the ceilings, filling the air with smoke, while around the sanctum fortune-tellers ply their trade and worshippers shake yarrow stalks to consult the I Ching oracle. Take a conducted bus tour and you will be shown an apartment block against the slope of Victoria Peak on Hong Kong Island where a huge square opening has been cut through the middle of the building – 'to let the Dragon out' as the guide will tell you, explaining that the dragon does not like to be hemmed in against hillsides. And look at the headquarters of the Hong Kong and Shanghai Bank, an aggressively functional building, all grey tubular steel, glass and girders, designed in the 1980s by the British architect Norman Foster. But note the traditional lion statues at the entrance and the curious angle of the escalator ascending through the vast atrium – these again betray the work of the geomancers. The nearby and even more futuristic building of the rival Bank of China, designed by the Chinese-American architect I.M. Pei and erected slightly later, has been accused of using geomancy in a negative way. Its razor-sharp angles and roof with two gigantic spikes are believed to have the effect of slicing and piercing the *Ch'i*, upsetting the geomantic harmony in its environs. In fact, virtually every building erected in Hong Kong has to have the approval of the geomancers before it can proceed. And the same of course applies to gardens and parks.

The location of Hong Kong itself meets several basic *feng shui* criteria for a favourable position. The site must be protected from strong winds and should ideally be near water, because the Dragon will move forward until it reaches the boundary of land and water, where it will halt and energy will accumulate. The site should also have natural shelter on four sides, represented by four auspicious animals: in front, the Phoenix or Red Bird; behind, the Black Tortoise; on the left the Green (or Blue) Dragon; and on the right the White Tiger. If one faces south, Hong Kong, together with Kowloon across the harbour, are protected from behind by the mountain ranges of the New Territories. On the left they are sheltered by Kowloon Peak, on the right by the peak of Lantau Island, and to the front by Victoria Peak.[8]

Hong Kong therefore illustrates on a vast scale the kind of harmony that *feng shui* experts attempt to achieve on a smaller scale in every building or garden where they are called in to advise. The five points of the compass are one of the key factors in the *feng shui* system, that is north, south, east, west and centre, and the intermediate directions down to a few degrees. Ideally a site should face south, since that is where the main flow of energy comes, as from the Sun at midday in midsummer. South, and not north, is the main direction of alignment in the Chinese compass. Linked with the points of the compass are a great variety of other factors such as the four auspicious animals already mentioned, the 12 animals of the Chinese Zodiac, the five elements (fire, earth, water, wood and metal), the eight trigrams of the I Ching divinatory system, the seasons of the year and various astrological factors. To take bearings on objects in a landscape, highly complicated compasses are used, with anything from nine to 36 concentric rings indicating the animals, elements and other factors associated with the compass points.

The forces flowing through a site and the way they influence the occupants will also vary with time and with the individual. The *Ch'i* will change during the annual cycle and also during the 60-year cycle of the Chinese calendar. As time moves through the cycle, different features in the landscape will become more or less fortunate or sig- nificant as different aspects of the *Ch'i* are activated. Factors such as the individual's year of birth also play an important role. Through a calculation involving the birth year, each person can be assigned a number from one to nine, corresponding to one of the directions or sub-directions of the compass, including the centre. Depending on the

personal number, certain directions will be more favourable than others, and this too will affect the alignment of a house and the landscaping of the site around it. Such considerations can become extremely important when, for example, determining the position for a grave. Thus the art of *feng shui* involves taking into consideration a large number of factors, directional, geographical, meteorological, numerological and personal.

Mountains and hills, provided they are not too sharp or precipitous, are favourable, as they are sources of *Yang* energy and can play a protective role. Trees, preferably evergreens, can play the same role in the absence of mountains. Sometimes a single, carefully placed evergreen will be known as a *feng shui* tree. The tradition of bonsai trees is also based on Taoism. Although bonsai are associated in many people's minds with Japan, they did not originate there but in China. They are based on the idea that miniature trees contain the *Ch'i* in highly concentrated form. The same applies to miniature rocks and mountains. It is therefore not surprising to find bonsai in places of worship. In the Wong Tai Sin Temple in Kowloon I saw a stand with shelves containing bonsai trees, rocks and mountains. Many illustrations of Chinese gardens also show pots containing bonsai plants – sometimes several set on a small, low table, like a miniature garden within the garden.

The presence of water is of key importance, and here the *Ch'i* is represented as the Water Dragon. An old Chinese text known as the *Water Dragon Classic* recommends that an ideal site should rest among watercourses, protected in the stomach of the Dragon. It also explains how the shapes created by watercourses and their branches and tributaries can have different influences, favourable and unfavourable, and where a house should be placed in relation to the water. Some shapes will encourage the accumulation of the *Ch'i*, while others will inhibit or dissipate it.

Every landscape feature can be 'read' according to an enormous variety of correspondences. Taking the elements, for example, some watercourses or hills will represent fire, others water, etc. And, since the elements influence each other both positively and negatively, it is very important how they are juxtaposed. Fire, for instance, destroys metal, and therefore a fire-shaped river next to a metal-shaped hill would be undesirable. On the other hand, since metal produces water, a metal-shaped stream flowing into a water-shaped one would be favourable. Another set of correspondences is connected with the

'Nine Stars' – not the planets but the seven stars of the Plough plus two nearby stars. These are sometimes at rest, as we see them in the sky, sometimes moving invisibly around the cosmos, affecting human affairs. Each of these stars has a corresponding shape of hill or mountain. A sharply pointed hill, for example, would represent Lien-chen, the star of Purity and Truth, and thus would encourage these qualities. The art of the geomancer therefore consists partly in reading the complex message of a site and partly in advising how to adapt and shape the site so as to gain the maximum advantage from it.

While I did not have time to see any of the older Chinese gardens, I took the opportunity to visit the new Kowloon Walled City Park, constructed in 1994–95 on the cleared site of the old Walled City, which had become a slum area. In the blistering summer heat it was a relief to escape from the concrete canyons of Kowloon into this peaceful oasis. An exhibition on the park informed me that it had been constructed by the city's Architectural Services Department, whose garden designers had visited many classical Chinese gardens and carried out extensive research on the subject. On this basis they had decided to adopt the Jiangnan garden style of the early Qing dynasty. They had included a garden of the Chinese Zodiac, with sculptures of the 12 zodiacal animals: tiger, hare, dragon, serpent, horse, sheep, monkey, hen, dog, pig, rat, ox. These sculptures had been positioned according to *feng shui* principles.

The Kowloon Walled City Park therefore provides an excellent opportunity to see many features of the classical Chinese garden brought together in one place. One feature that strikes the visitor immediately is the presence of large organic-looking rocks, pitted and weathered into the shapes of gnarled tree trunks or statues of monsters. Such rocks are a key element in Chinese gardens and reflect an ancient tradition of rock veneration that has parallels all over the world, especially in religious cultures that focus on nature, as Taoism does. We can think, for example, of the majestic standing stones found all over the Celtic parts of Europe. Stones impress us with their hard, enduring quality. Yet they are alive, and to many people they are receivers and transmitters of cosmic energy. They take us back to the very origins of the Earth itself. Hence their veneration is also part of the search for longevity. Rocks have inspired much Chinese poetry as well as an entire treatise, the *Yuan Yeh*, written by Chi Ch'eng in 1635. In China these rocks are sometimes as high as 15 feet, sometimes small enough to be displayed on a table indoors. Some of them give an

intense impression of being in motion, pirouetting on a tiny 'foot' like a ballet dancer, floating like a cloud or surging up like a wave. The *Yuan Yeh* specifically recommends that single rocks should be top-heavy. Another prized feature was what the sixteenth-century writer on gardening Li Li-Weng referred to as *lou*, meaning literally 'leak' or 'drip' and referring to the existence of upright holes in the stone. Collectors not only paid attention to the appearance of the stone but would sometimes strike it to see what note it produced. This would vary according to the number and configuration of the holes. Types of rock that were used ranged from the very hard jade to the softer and more quickly weathering limestone. Stalagmites of limestone known as 'stone bamboo shoots' were extremely sought after.[9] The most coveted rocks used to be found in the Tai-hu lake near Soochow. When these became scarce, people would bring rocks from other regions and leave them in this lake so that they could retrieve them, sometimes decades later, sculpted by the action of the waters – and the *Tao*. Many connoisseurs even tried to improve on nature by having the rocks sculpted and polished to as to enhance their beauty. In the twelfth century the painter Mi Fei had a garden pavilion built from which to contemplate his rocks, including one to which he would bow, addressing it as his 'elder brother'.[10]

Apart from its rocks, the Kowloon Walled City Park exemplifies other typical aspects of Chinese gardens. There are carefully placed pavilions, some built out over water, reflecting the Chinese habit of using gardens for poetic contemplation and the notion that a garden does not really 'exist' until its essence has been distilled in the mind and inner vision of the poet. There are also areas in the park that are divided up by walls into smaller sections – as already mentioned, this is a device used in many Chinese gardens, creating the illusion of size by skilful division of space rather than by opening up large vistas. In the same park one also finds a 'moon gate', a circular opening in a wall, leading into the garden or from one section to another. As one passes through the circle, the symbol of perfection, one has the sensation of leaving behind the mundane realm and entering a different reality.

As for the plants in Chinese gardens, these too have their associations and attributions, which give further dimensions of meaning to the poet or philosopher contemplating the garden vista from his pavilion.[11] The orchid, the bamboo, the chrysanthemum and the flowering plum are linked respectively with spring, summer, autumn

and winter and with the four qualities of the ideal gentleman: grace, resilience, nobility and endurance. One plant, familiar in other mythologies from Egypt to India, is the lotus, which is found in nearly every Chinese garden pond or lake. It is a symbol of perfection, corresponding to the rose in Western iconography. The rose of China (*Hibiscus rosa-sinensis*) is called *fu sang* in Chinese, which is also the name of the legendary tree of eternal life that was believed to grow in the land of the Immortals. As mentioned earlier, one theory placed this abode on a distant island in the eastern sea, and in 219 BC an expedition of 3,000 people was sent by the Emperor Shih Huang-ti to find the island and the tree with its miraculous fruit of eternal life. They failed to return, and legend has it that they are ancestors of the Japanese people. Meanwhile, having failed to find the tree, the Chinese set about trying to discover the elixir of immortality through alchemy, and it is said that these efforts led – ironically enough – to the invention of gunpowder. Other significant plants include the orchid, representing joy and lightness of spirit, and the peach and the pine, both associated with longevity. The crane is also a symbol of longevity, and in Chinese paintings a pine and a crane are often depicted together.

Many Chinese plants are of course familiar features of gardens in Europe and elsewhere, thanks to the great plant collectors of the eighteenth century. It is to China that we owe the wisteria, the Chinese privet, the Chinese hibiscus and numerous other species. Although in Europe and America it is the Japanese style that is more widely imitated, we should not forget how much both Japan and the West owe to the older Chinese gardening tradition.

The Japanese garden: serenity and sleight of hand

Even from inside one of Japan's breakneck 'bullet trains', once you have cleared the sprawling Tokyo suburbs it is easy to have the impression that the whole Japanese landscape is a garden – where the gods are never far away. Perhaps from the eye's eagerness to record as much as possible of the scenery rushing past, my mind has preserved a series of sharp images: gentle hills covered with delicate, feathery conifers, groves of slender bamboo, pine trees with round, prickly cones, tea plantations with the bushes ranged in neatly clipped rows, the gables of red-tiled roofs against the sky – everything apparently painted with a very fine-pointed brush and carefully

composed and balanced. The same qualities of fineness and balance are found, distilled to a greater degree, in the gardens of Japan, whether secular or religious.

To convey the spirit of Japanese gardens I can do no better than quote Lafcadio Hearn, an American writer of Graeco-Irish extraction who settled in Japan in the 1890s and wrote with incomparable sensitivity and perception about the country, its life and customs. In his essay 'In a Japanese Garden' he writes:

> No effort to create an impossible or purely ideal landscape is made in the Japanese garden. Its artistic purpose is to copy faithfully the attractions of a veritable landscape, and to convey the real impression that a real landscape communicates. It is therefore at once a picture and a poem; perhaps even more a poem than a picture. For, as nature's scenery, in its varying aspects, affects us with sensations of joy or of solemnity, of grimness or of sweetness, of force or of peace, so must the true reflection of it in the labour of the landscape gardener create not merely an impression of beauty but a mood in the soul. The grand old landscape gardeners, those Buddhist monks who first introduced the art into Japan, and subsequently developed it into an almost occult science, carried their theory yet farther than this. They held it possible to express moral lessons in the design of a garden, and abstract ideas such as Chastity, Faith, Piety, Content, Calm, and Connubial Bliss. Therefore were gardens contrived according to the character of the owner, whether poet, warrior, philosopher or priest.[12]

Gardening, like many other aspects of Japanese culture, owes much to Chinese influences, which began to penetrate Japan significantly from the sixth century AD. From China the religions of Taoism and Buddhism as well as the Chinese script, and the art of *feng shui* was enthusiastically taken up by the Japanese, as was the convention of the garden as a living picture to be viewed for poetic, artistic or spiritual inspiration. In the seventeenth-century Koraku-en gardens at Okayama there was a pavilion with a stream running through it, where poetic competitions were held. Each contestant floated a wine cup down the channel, and the poem had to be completed by the time the cup reached the end of the pavilion.[13] The moonlit solitudes and subtle fragrances of gardens at night were also celebrated by poets in both China and

Japan. However, Japanese gardening also developed its own distinctive character, in which indigenous influences, such as the religion of Shinto, played an important role. According to Shinto all things in nature – trees, rocks, mountains, springs – have gender, and the art of gardening includes the balancing and correct placing of male and female objects. Stones, for example, that stand up boldly are considered masculine, whereas low, rounded stones are considered feminine. Care is taken in juxtaposing male and female forms so as to create balance. Here is what Lafcadio Hearn writes on the subject of stones:

> Until you can feel, and keenly feel, that stones have character, that stones have tones and values, the whole artistic meaning of a Japanese garden cannot be revealed to you. . . At the approaches to temples, by the side of roads, before holy groves, and in all parks and pleasure-grounds, as well as in all cemeteries, you will notice large, irregular, flat slabs of natural rock – mostly from the river-beds and water-worn – sculptured with ideographs, but unhewn. . . And large stones form the skeleton, or framework, in the design of old Japanese gardens. Not only is every stone chosen with a view to its particular expressiveness of form, but every stone in the garden or about the premises has its separate and individual name, indicating its purpose or its decorative duty.[14]

One of the major written sources on Japanese gardening is the *Sakutei-ki*, composed in the eleventh century AD, and purporting to reveal the 'secrets' of the art – unfortunately without any visual illustrations. The *Sakutei-ki* lists the main purposes of a garden as follows:

- To recreate symbolically ideal surroundings in which man can have his being and live happily.
- To be a vision of the 'Pure Land' of Buddha Amida, the cosmic unity of the one who has reached Awakening [this is a reference to the cult of Amida Buddha or Buddha Amida, which will be explained shortly].
- To enable man, following up his meditation, to go ahead along the road of spiritual search leading to Awakening.
- To ease the descent of the tutelary spirits.
- To be a micro-image of Japan, identified as the Isles of the Immortals of Chinese tradition.

– To rouse fine feelings through the recreation of a 'Japan space' peopled by divinities, suitable for the celebration of a cult to the beauty of the world.[15]

The *Sakutei-ki* evinces the two types of approach to gardening that I described earlier – one precise and systematic, the other more intuitive. Into the first category come the author's very detailed rules for the placing of stones, water and other garden features, which he urges his readers to observe lest they attract ill fortune to themselves. Water should flow east, then south, then west, and ten different forms of flow are described. Waterfalls are also classified, and strict instructions are given regarding their size, shape and the planting around them. Most complex of all are the rules regarding stones:

> The material, size, proportion, placing, relationship and grouping, the setting upright, slantwise or horizontally according to the qualities of the stone, these matters have been codified in Japan in a way which is unknown elsewhere and astonishing in its complexity. . . Stones which look water-worn should be used in water-scenery, while rugged, mountainous rocks should be used in mountain-scenery. Some stones are simply not suitable because of their bent or distorted form, and are called 'diseased stones', since they will look as if they have been accidentally overturned – such stones are 'dead stones'.[16]

In the course of time the Japanese developed over 130 categories of stone, each of which had to be represented in a garden that aimed to be complete. In the gardens of Buddhist temples, the stones were often used to represent Buddha and other revered figures. 'These stones include a trinity at the centre, with Shakyamuni or Buddha in the middle, and the saints Monja and Fuken on either side. The hagiography is extended sometimes to include sixteen disciples. . . But this open symbolism was soon replaced by a broader approach. . . in which the direct "one-for-one" symbolism was superseded by the view that the Buddha was omnipresent, and that the contemplation of any and every object could lead to wisdom.'[17]

The system of complex rules governing the design of gardens (sometimes referred to as the 'Chinese' rules) was complemented by a less precise and more feeling approach. In the *Sakutei-ki* this approach can be reduced to four essential principles:

1. *Shotoku no sansui* (literally 'mountain-water of living nature'). This emphasizes that, whatever one is doing in a garden – whether planting, placing a stone or constructing a pond – one should always remain aware of living nature, of which the garden should be a reflection.

2. *Kohan ni shitagau* (literally 'conforming to a desire'), implying that all elements in the garden, including stones, are alive and have their own desires, which the composition of the garden should follow. Stillness and receptivity are necessary to perceive these desires.

3. *Suchigaete* (literally 'devoid of equilibrium'), underlining that everything in the garden should be arranged asymmetrically, contrasting with the regular and symmetrical nature of the buildings overlooking it.

4. *Fuzei* (literally 'breath of feeling'), that is to say the atmosphere of a place. Interestingly, this has a double meaning: either the inherent spirit of the site (the *genius loci*, as one would say in the West) or the subjective taste of the individual conceiving the garden.[18]

A later treatise on Japanese gardening, *Tzukiyama Teizoden* (Creating Landscape Gardens), written in 1735 by Kitamura Enkin, sets out different degrees of hilliness, ranging from *tszukiyama* (hilly) to *hiraniwa* (level), as well as three degrees of complexity or elaboration: *shin* (very elaborate), *gyo* (intermediate) and *so* (simple).[19]

Having gained some insight into the various traditional elements in Japanese gardening, we can gain some idea of how the principles were applied by reading the guidelines for creating a 'hill garden', as quoted in Maria Luise Gothein's classic work on the history of garden design:

The hill garden should have at least five hills. In the middle ground is a broad hill (1), sloping down on both sides, which has its ideal counterpart in Mount Fuji. Close by is hill 2, lower by contrast. On the other side is hill 3, lying further to the foreground from hill 1. In between is a thickly planted valley intended to contain or to hint at a hidden spring. Hill 4, right in the foreground, emphasizes further the hilly landscape; and for the same purpose, as well as to give depth to the view, a further hill (5) rises up in the background between the two principal

hills. A garden of this kind has ten main stones with particular functions and names. The largest (1) is the Guardian Stone. Its female counterpart (2) lies on the other side of the waterfall. The Worshipping Stone (3) is frequently placed on an island. The Stone of Perfect Vista (4) is in the foreground or to the side and indicates the position for the most beautiful view of the garden. Thus each stone has its name and place. Similarly the main trees are easily identifiable to the Japanese eye. Number 1 is a stately oak or other deciduous tree, standing in the middle ground, which should be in full growth and prime beauty in order to be the first object to draw the eye. Number 2 here is the much-loved pine, standing on the island. Other trees include the Tree of Solitude (3), the Waterfall Tree (4) and so on. For the Sunset Tree (5) a maple is usually chosen and planted facing west so that the rays of the setting sun shine through its red leaves. A complete garden should have seven such selected trees. Water, in whatever form, should also not be lacking. The lake should be in the shape of a turtle, a crane or some other definite thing. The main tableau must always be animated by a waterfall. Flowing water must always go from east to west, preferably flat but fast-flowing water. . . Where no water is present it is at least symbolically indicated through overhanging trees, river stones or a bed of fine sand. . .

The other indispensable adornment of such a garden view are the bridges. . . which are also subject to rules in their form and placing. Where a tree and a lantern stand together a bridge should not be lacking. As far as lanterns as concerned. . . they appear to be of purely Japanese origin. This kind of garden ornament is not found in China. It was transferred from the gardens of Buddhist temples, where lanterns often stand in long rows as votive offerings, to secular gardens. In fact they do not really serve for illumination, as they are very seldom lit. In their richly multifarious forms, they are both decoration and a sign of holiness or piety. Basins and water vessels are usually placed near the house, as they are used to wet the hands. The older Japanese gardens have no lawn. The foreground as far as the lake consists of firmly stamped earth, which is always kept moist, or of fine white sand, often laid in ornamental patterns. In both cases the ground may not be walked on, hence the stepping

stones, made of irregular stones, which lead in a meandering pattern from the verandah to the bridge or other destination.[20]

Kyoto, in its heyday as imperial capital in the ninth and tenth centuries, was filled with gardens that reflected the social hierarchy of the country. The mountains in a park were compared to the Emperor, the rocks to his officials and the surrounding water to his courtiers. In the late tenth century a new influence entered Japan in the form of the cult of Amida Buddha, who was said to reside in the Pure Land of the West, a paradise to which followers of the cult hoped to be admitted after death. Under the influence of this cult, to which many aristocrats belonged, gardens began to represent not the imperial court but the paradise of Amida. Here we are struck by an obvious parallel with the Islamic tradition of the garden as a foretaste of paradise. The gardens of the Pure Land tradition were conventionally arranged in the form of mandalas, the circular symbols of the cosmos that are widely used in Hinduism and Buddhism, especially in the Buddhism of Tibet and in the various forms of Tantrism.

To see the finest examples of Buddhist monastery gardens, especially those of Zen Buddhism, one must go to Kyoto, no longer the official capital but now the spiritual capital of Japan. Paradoxically, one of the most fertile periods for horticulture, as well as for other arts (such as the tea ceremony and the *no* theatre), was the violent and strife-ridden Muromachi period (1336–1573), named after the district of Kyoto where the Shogun (the military leader of Japan) had his palace. By some curious alchemy, this era produced some of the most tranquil gardens that have ever been created.

It was during this period, for example, that the art of the Zen Buddhist dry garden was developed to perfection. Designated in Japanese by the term *kare-sansui* (mountain and water), this is a form that reduces Japanese horticulture to its purest and most essential principles. One of the finest examples is at the Ryoan-ji temple in Kyoto. The garden, set in a walled enclosure, viewed from the verandah of the abbot's quarters, is intended for meditation. It consists of a rectangular area of pale gravel carefully raked into a pattern of parallel lines, the surface broken only by 15 carefully placed stones, arranged in four groups. The sole organic element visible is a little moss growing around the stones. One might expect such a garden to be cold and severe, but in fact it radiates an atmosphere of extraordinary beauty and serenity. As for the symbolism, it is sometimes

said that the raked sand represents the sea and the rocks symbolize islands – perhaps the Islands of the Immortals derived from Chinese tradition. However, the real meaning of the garden is surely deeper and more subtle. On one level it is a highly minimalist expression of the balance between *Yang* and *Yin*. The rectangular shape and the straight lines in the gravel are *Yang*, while the asymmetrically placed rocks and the raked lines curving around them are *Yin*. The balance is also there in the rocks themselves, some of which are upright (*Yang*) and others low and rounded (*Yin*). And one must remember that immense care would have been taken in the choosing and placing of the rocks. As we have seen, rocks were venerated as living things with a will of their own. The master gardener who placed the rocks would have first communicated with them, so that in a sense they chose their own positions.

While the dry gardens have their own kind of beauty, so do the many Buddhist gardens in Kyoto that make full use of nature. An outstanding example is that of the Tenryu-ji (Temple of the Celestial Dragon), dating from the fourteenth century, which I regard as one of the most beautiful gardens in the world. The temple, which has viewing porches for contemplating the garden, is built next to a lake, with little islands, jutting rocks, tree-covered banks – all flowing together in an apparently effortless harmony which is in fact carefully contrived and sustained by constant hard work. Every rock has been deliberately chosen and placed according to Shinto and *feng shui* principles, and the flawless carpet of velvety moss that covers the ground is continually weeded by the monks, who treat the work as a spiritual exercise in which the weeds are analogous to spiritual impurities that must be plucked out. One particularly vivid image remains from my visit to the Tenryu-ji: as I stood by the temple looking across the lake, a white crane, symbol of good fortune and longevity, landed on one of the islands and remained motionless long enough for me to photograph it – a perfect instant, frozen in time as in a *haiku*.

3

A FORETASTE OF PARADISE: THE ISLAMIC GARDEN AND ITS FOREBEARS

The garden of the Alhambra at Granada in Spain and that of the Red Fort at Delhi in India, although geographically far apart, belong to a shared tradition – that of Islam – and they bear witness to both the diversity and the consistency of the Islamic gardening style. In the seamless, intricate, divinely ordered pattern of things that constitutes a traditional Islamic society, gardens have a particular – and important – place. Gardens, along with the Quran, Arabic numerals, ceramics, spices and rich fabrics, were brought to every part of the territory that came under the sway of the Muslim religion, as it spread out from its Arabian birthplace starting in the seventh century AD, eventually stretching from the Atlantic to the Pacific and from the Balkans to Central Africa. Throughout this vast area there are gardens that vary greatly depending on the local culture but at the same time have certain features and symbols in common.

Roots of the paradise garden tradition

Islamic gardening drew on traditions going back to the very early civilization of ancient Mesopotamia. In the *Epic of Gilgamesh* (third millennium BC) there are descriptions of cities with lavish gardens and orchards. And we know from relief carvings and wall paintings that the later kingdoms of Assyria and Babylon were full of orchards and pleasure gardens, carefully irrigated and stocked with a wide variety of flowering shrubs and trees. Unfortunately no visual record remains

of the fabled Hanging Gardens of Babylon, one of the seven wonders of the world, built on a rising series of terraces by King Nebuchadnezzar II (ruled 605–562 BC), although many artists have attempted to depict them from imagination. The ancient Egyptians also had gardens (albeit mainly for practical purposes such as fruit growing), as did the Persians from about the sixth century BC – and it was the latter that most directly influenced the Islamic style of gardening.

A central idea which Islam took over from these earlier civilizations was that of the garden as an image of paradise. The Greek word *paradeisos* comes from the old Persian *pairidaeza*, meaning a walled enclosure, that is to say what we would today understand as a garden or park. Among the key features of paradise, as conceived by the ancients, were four rivers, which then flowed out to the four extremities of the world itself. Frequently paradise is identified with the Garden of Eden, the primal state of innocent bliss which the virtuous will regain after death. In the second chapter of Genesis we read: 'Now a river went out of Eden to water the garden, and from there it parted and became four riverheads.' And the Quran (47:15) refers to four rivers of wine, water, milk and honey. This concept merges conveniently with the classic quadripartite garden design (*chahar bagh* in Persian) dating back to ancient Mesopotamia, with four water channels formed by two crossed axes – being a practical way to irrigate a square or rectangular area – but it is also a reflection of the ancient idea that the whole world itself is divided by the four rivers. This quadripartite form is, in the view of C.G. Jung, one of the archetypal patterns that lie deep in the collective unconscious of the human race. The arrangement of four channels in the form of a cross, dividing the garden into quarters, which became the standard pattern for Islamic gardens, was therefore a powerfully meaningful one on a number of levels.

Idealized representations of paradise gardens can be seen depicted in Persian miniatures and woven into carpets, showing the traditional four channels, often with an octagonal pool at the centre. Islamic poets such as Rumi often use garden imagery in their work, and the Quran itself, which the Muslim believes to be the literal word of God, contains abundant references to gardens. To quote the horticultural writer, John Brookes:

> The garden is constantly cited as a symbol for paradise, with shade and water as its ideal elements. 'Gardens underneath which rivers flow' is a frequently used expression for the bliss

of the faithful, and occurs more than thirty times throughout the Quran. . . Also frequently mentioned are the abundant fruit trees in the paradise garden and the rich pavilions set among them, wherein the owners of the gardens and their friends might relax.[1]

Brookes emphasizes that 'God has actually defined paradise as a garden, and it is up to the individual not only to aspire to it in the after-life, but also to try to create its image here on earth'.[2] He identifies two contrasting ways in which the paradise garden concept was applied. One is the walled private garden, hidden away behind the house and providing a refreshing and meditative refuge from the crowded and busy streets of a Muslim city. This he characterizes as having a centripetal, or inwardly directed, quality. The other is the centrifugal, outwardly directed form, typified by the *chahar bagh*, with its four channels radiating outwards from a central pavilion and/or fountain.

> The enclosed garden thus becomes a defined space, encompassing within itself a total reflection of the cosmos and, hence, paradise. Within it, this concept fosters order and harmony and can be manifested to the senses through numbers, geometry, colour and, of course, materials. . . Within this space the traditional pool provides a centre and an upward-reflecting surface for directing the creative imagination.[3]

Sometimes the fourfold pattern became a symbol of worldly power as well as heavenly bliss. Timur (Tamerlaine) the first great Muslim conqueror of India, was fond of placing his throne at the centre of the garden; 'thus he symbolically ruled the four quarters'.[4]

I have already mentioned the symbolic importance of the entrance to a garden. In the Islamic tradition this is often expressed in the form of an intermediary structure, such as the porch-like building known in Iran as the *talar*. 'Metaphysically, the *talar* is viewed as the locus of the soul moving between garden and building, where the garden is spirit and the building body. It is therefore the transitional space between the spiritual and terrestrial worlds.'[5] Thus, the *talar* is an Islamic counterpart to the Chinese moon gate.

How was the idea of paradise represented, apart from the motif of the four rivers? Since Islam is monotheistic and has for most of its history forbade the depiction of human or animal images in sacred art and architecture, we find in Islamic gardens almost no counterparts to

the mythological figures that we shall discover later in the gardens of Renaissance Europe, no equivalent of the Chinese worship of rocks, and no concept of trees or plants as sacred to particular deities or objects of veneration in themselves – the only exceptions being where there was some surreptitious influence from earlier indigenous traditions, as happened to some extent in Mughal India. Instead we find the idea of paradise conveyed in various other ways. We have seen the importance of the four rivers, but this is only one example of the use of water, a virtually sacred element in the arid Middle East – water made to flow, ripple, dance, spurt from fountains and catch the light in a thousand ingenious ways. Water is surely the most sensual and seductive of the elements, and the garden of paradise is a highly sensual place. But in Islam even sensual pleasures are sanctioned by being part of a divinely ordered pattern. Hence the importance in the paradise garden of form, proportion, pattern, geometry and number.

Many Islamic gardens are built in terraces, ornamented by water chutes, which the visitor is meant to experience in ascending order, as though approaching heaven. There are some particularly fine examples in Kashmir, such as the Shalamar Bagh, built by the Mughal Emperor Jahangir (1569–1627) and his son Shah Jahan (1592–1666). At the entrance to the Shalamar Bagh is a quotation in Persian which reads: 'If there be a Paradise on the face of the earth, it is here, it is here, it is here.'[6] The number of terraces in a garden is significant. Eight is the number of the divisions of the Muslim heaven, with its corresponding eight pearl pavilions, while seven corresponds to the planets and 12 to the signs of the Zodiac. Many gardens with 12 terraces are found in Mughal India, an example being the Nishat Bagh in Kashmir not far from the Shalamar (although the terraces have now been reduced by a road that cuts through the garden). Eight is the number of glorietas, arbours of rose and jasmine, found in the garden of the Alcazar at Cordoba in Spain and probably representing the eight pearl pavilions of heaven. The number eight was also found in the form of the octagon, often used for pools, platforms and other garden features. 'The octagon as the circle squared – the circle symbolizing eternal perfection, the square symbolizing earthly order – represented man's wish for order.'[7]

The tradition in Mughal India

It is worth looking further at Mughal India, where the art of Islamic gardening was developed to a very high degree of refinement. Take,

for instance, the garden of the Red Fort in Delhi, built by the above-mentioned Mughal Emperor Shah Jahan, which I visited one December afternoon that would have competed in temperature with the warmest of European summers. In its heyday one of the most sumptuous gardens of Mughal India, it is now rather down at heel. The approach is down an avenue of souvenir shops and through a massive sandstone gate. Inside the garden, near the entrance, a knot of people was gathered around a *chai wallah*, who dispensed cups of thick, refreshing Darjeeling tea from an urn. A couple of aimless-looking teenage boys strolled along the dried-up waterways, past the delicate pavilions with their shady colonnades and across lawns that were once rich floral tapestries. Here, as was common in Mughal India, there were originally two gardens within the precinct: a Garden of Life with brightly coloured and medicinal plants, and a Moonlight Garden with pale, aromatic plants, such as jasmine, tuberoses, lilies and narcissus. Both were enclosed by rows of cypress trees and formed one design. The Moonlight Garden has vanished, but much of the Garden of Life remains. The latter, following the traditional paradise garden design, had a central pool with four canals radiating out from it, each terminating in a pavilion. Standing in one of these pavilions one can visualize water rippling out over a marble chute, moulding itself to the delicate criss-cross pattern carved into the stone, and one can still enjoy the shade of the colonnades with their delicately serrated arches – but a great deal of imagination is necessary to picture the garden in its full days of glory.

Shah Jahan's better-known creation, the Taj Mahal at Agra, is rightly known as one of the most beautiful buildings in the world. It is in fact a tomb, built for Shah Jahan's wife, who died while giving birth to her 15th child, but also serving as a last resting place for Jahan himself. Though Jahan was a devoted husband, he was also extremely ruthless in his pursuit of power. To secure his succession to the throne he ordered the murder of his nephew, his younger brother and two cousins. But we need not admire the man in order to admire his creation. The main approach to the precinct is through a south gate bearing a quotation from the Quran inviting one to enter paradise. And the quotation seems apt when one sees the Taj Mahal itself, built of white, delicately inlaid marble, its domes and minarets reflected in the waterways and central pool of a classical Islamic garden with the traditional fourfold scheme. On the other side the building overlooks the river Jumna, and on the opposite bank there was originally a

matching garden, where it is said that Shah Jahan intended to build a duplicate Taj Mahal in black marble. Although this dramatic idea must be treated as speculation, it sets one imagining possible parallels elsewhere: a black Versailles, for instance, dedicated to Pluto, ruler of the Underworld, as a counterpart to the palace of the Sun King and the Sun god Apollo.

The Taj Mahal is a striking example of the common Islamic practice of locating the tomb of a distinguished person in a garden, which of course goes together with the notion of the garden as a reflection of paradise. What could be more suitable than to have the deceased reposing in an earthly environment that corresponds to his heavenly abode? The Scottish Islamic scholar James Dickie writes: 'Burial in a garden amounts to a material anticipation of immaterial bliss, and the closer the garden approximates the Koranic model the more effective is the analogy. A Mughal garden, populated with nard-anointed houris and the air balmy from the perfume of too many flowers, must have approximated the divine archetype pretty closely.'[8] Often a garden which had been a pleasure resort during the lifetime of its owner became his tomb after his death, and his remains were laid to rest in the central building, which had once been used as a place of recreation and feasting.

> Sometimes his favourite wife lies with him; but more generally the family and relations are buried under the collatoral domes. When once used as a place of burial its vaults never again resound with festivity and mirth. The care of the building is handed over to priests and faquirs, who gain a scanty subsistence by the sale of the fruits of the garden, or the alms of those who come to visit the last resting-place of their friend or master. Perfect silence takes the place of festivity and mirth. The beauty of the surrounding objects combines with the repose of the place to produce an effect as graceful as it is solemn and appropriate.[9]

The Taj Mahal applies the tradition of the tomb in the paradise garden in an extremely faithful yet unusual way. Whereas in most cases the mausoleum is located in the middle of the garden, at the Taj Mahal it is at the end, liberating the space and creating a dramatic architectural climax to the view. In a deeply researched article on the subject, Wayne Begley reveals some fascinating dimensions to the design and the

thinking behind it.[10] He quotes an illuminating description of the garden by the eighteenth-century Persian historian Muhammad Salih:

> Below the large redstone platform (*kursi*), lies a Paradise-like garden (*bagh firdaus-a'in*) and a flower-garden (*gulshan*) decorated like Iram, measuring 368 *gaz* square [one gaz being approximately 31 inches], and abounding in various kinds of fruit-bearing trees and rare aromatic herbs.
>
> Verily, its environs are like the black mole on the forehead of the world's pleasure spots and each of its bounty-laced flowerbeds is pleasing and heart-captivating like the flowerbeds of the garden of the Keeper of Paradise (*Rizzwan*). Its attractive green trees are perennially fed with the water of life; and the stature of each tree, in respect to both quantity and quality, by every reckoning surpasses that of the celestial Lote-tree (*tauba*) [the tree separating humanity from God and whose branches grow downwards from the divine throne]. Within the four walkways laid out in the middle of the garden. . . there flows a water-channel. . . provided with light-sprinkling fountains. . .
>
> In the center of this garden, there is a platform (*chabutara*), 28 *gaz* square, around which the aforementioned channel runs; and in the midst of it is a tank (*hauz*), 16 *gaz* square, filled with water of the celestial Kausar, and provided with fountains all around it spouting jets of water – illuminating, as it were, the world-illuminating Day [of Judgement].[11]

Begley argues that the garden is not merely a suggestion of paradise but an attempt to depict as exactly as possible its terrain on the Day of Judgement.

> In the Taj's allegorical scheme, the four water channels of the *chahar bagh* garden, for example, must symbolize the four flowing rivers of paradise, mentioned in the Quran and Hadith literature: whereas the raised marble tank in the center of the garden is to be construed as a replica of the celestial tank of abundance, called *Hawd al-Kausar*, where, according to well-known Islamic tradition, the prophet Muhammad will stand before God on the Day of Judgement to intercede for the faithful.[12]

The vast mausoleum itself, towering over the garden, was intended, Begley maintains, as a 'symbolic replica of the heavenly throne of God ('Arsh), which Islamic tradition situates directly above Paradise, and upon which God will sit in judgment on the Day of Resurrection'.[13] In support of his argument he draws attention to a unique diagram by the thirteenth-century Spanish Sufi Ibn al-'Arabi, showing the 'Plain of Assembly' on the Day of Judgement, which closely corresponds to the layout of the Taj Mahal garden. He adds that 'there is a strong likelihood not only that Shah Jahan himself was probably familiar with Ibn al-'Arabi's mystical ideas but also that his architect Ustad Ahmad could have had ample opportunity. . . to consult a manuscript of the Futuhat containing the "Plain of Assembly" diagram'.[14]

Further, he points out: 'In view of the traditional Muslim belief that the celestial paradise shall be a place of eternal feasting and banqueting, the great feasts that Shah Jahan ordered to be held regularly in the Taj complex, on the death anniversaries of Mumtaz Mahal [his wife] and other occasions, appear to take on a new significance.'[15]

It is also important to realize how the Mughal gardeners were influenced by earlier Indian traditions. Although gardens as such did not exist in India before the Muslim invasion in the fourteenth century, there was a long tradition of veneration of plants, trees, and nature as a whole. Elizabeth Moynihan, in her book on Persian and Mughal gardens, writes:

> From ancient times, priests in India have maintained groves of flowering trees as temple sites; the blossoms are used in religious ritual. Certain trees and flowers were thought to symbolize the deities or to possess qualities which could enhance man's spiritual life. Planting a tree was an act of piety. Such was the sacred Bo-tree under which Gautama, the Buddha, attained perfect knowledge. . . An archaic religious symbol, the lotus, was adopted by the invading Aryans. Identified with Lakshmi, the lotus is also the cushion, pedestal or throne of Shiva; and Brahma, the God-creator, is shown on a thousand-leaved lotus.[16]

Thus, lotus flowers are found carved into the stonework of certain Mughal gardens, as are serpentine forms based on the Hindu tradition of the Nagas, legendary snakes that guard sacred springs and streams. Furthermore, the fourfold plan of the Islamic garden, with its central

focal point, merged with earlier Vedic conceptions of sacred geometry and geography. James Dickie writes:

> In Aryan villages two diagonal thoroughfares intersected at a spot marked by a tree underneath which the elders sat; the quarters served to separate the castes. In Hindu mythology this tree, the Tree of Knowledge, with Naga, the holy watersnake coiled around its roots, springs from a mound; the Mound is the Mount of Meru, down whose slopes, from a hidden spring, water runs out to the four cardinal points. The same tree appears as a stone umbrella (chahtri) atop Buddhist stupas. At Sikandra the entire garden is laid out on cosmic cross, with the four entrances facing the cardinal points and the tiered tomb at the center replacing the mountain.[17]

The role and symbolism of plants in Islamic gardens

On the subject of plants, John Brookes points out an equivocal attitude within Islamic culture:

> On the one hand there is a love of flowers, and their colours and scents, as well as the need for, and appreciation of, the shade of fruit trees, as outlined in the Quran; on the other, there is little concern for natural vegetation. . . Again, tradition and climate are at the root of this ambivalent attitude. Islamic literature does not manifest a great love of wild nature – rather it advises a walled retreat from it. Combine this with the fact that sub-tropical agriculture is a great source of disease. . . spread via irrigation channels – and one soon realizes that one is not likely to return refreshed and renewed from a day in the country![18]

Within the garden, however, plants have an important role both aesthetically and symbolically. One of the trees most frequently found in Islamic gardens is the cypress, which represents both death and eternal life – death, because it is the only tree which, once cut down to the trunk, never sprouts again; and eternal life, because of its evergreen nature and upward-thrusting shape. Flowering fruit trees – such as apples, plums and cherries – were also a common feature. Persian miniature paintings of paradise gardens often show rows of cypresses paired with flowering fruit trees, the bright blossoms and

bushy forms of the latter contrasting with the austere, slender outlines of the cypresses. As a graveyard tree, the cypress is also found in most of the countries bordering the Mediterranean. Myrtle is another plant found abundantly in gardens over much of the Islamic world.

One of the Islamic countries most devoted to flower growing was Turkey, which in the sixteenth century became the source of many of the familiar flowers and trees found in Western gardens. These included the hollyhock, white jasmine, scarlet campion, peony, opium poppy, day lily, hyacinth, *Lilium candidum*, anemone and, among trees, the oriental plane, the black mulberry and, indirectly, the walnut. Most treasured of all was the tulip, the symbol of pleasure and elegance, which was not only a garden plant but a much-loved motif in architecture and art.

'The other great love shared by Turks and Persians', as John Brookes writes, 'was the rose. For the Turks, roses were not merely flowers to look at and smell, ablaze even in the smallest garden: they ate them, drank them and bathed in them.'[19]

The rulers of Islamic Spain were also great collectors of plants, and during the period of Islamic occupation (from the early eighth century to the final expulsion in 1492) they sent their emissaries as far afield as India to find exotic species. It is thanks to them that the delicately scented jasmine blooms all over Spain. They also brought the pomegranate, the artichoke, the date palm, and many fruits such as the orange and the apricot. The great cities of Islamic Spain – Cordoba, Seville, Toledo and Granada – abounded in sumptuous gardens, built according to a design that was abandoned after the Christian reconquest. Typically the Hispano-Arab garden was divided by walls, often arranged in the classic fourfold pattern, which served both as walkways and as aqueducts to carry the water for irrigation. Thus, either one could stroll along the tops of the walls, looking down at the carpet of flowers and fruit trees below, or one could walk at the level of the beds in the pleasant shade of the foliage. Today the great Hispano-Arab gardens, such as the Alhambra and the Generalife, beautiful and sensual though they are, bear little resemblance to their original forms.

If we wish to picture the glories of Hispano-Arab gardens as they were, we have to rely on our imaginations or on descriptions like the following one by the medieval Islamic writer Ibn al-Khatīb:

Farms and gardens were in such number that Granada resembled a mother surrounded by children, with luxuriant herbiage

adorning her sides as if she had donned a necklace covering the upper part of her breasts, whilst winds embalmed her with zephyrs. Villas and royal properties encompassed the city like bracelets. Nuptial thrones [i.e. beds] were set up for the brides of the gardens [i.e. the flowers]. The Sultan of the Spring [i.e. the rose] took his seat to review the rebels [i.e. the other flowers]. The nightingale of the trees preached a sermon, whereupon [all] listeners fell attentive. [Acres of] vines waved like billows, and the [whole] neighbourhood overflowed with their juice. Like the sky of the world beautified with innumerable stars so lay [the plain] with towers of intricate construction and equipped with staircases. The winds exhaled perfumes, bringing Paradise to mind for whoso hopes for what God has in store for him by way of requital.[20]

4

GARDENS OF GODS AND GARDENS OF SAINTS: PAGAN AND CHRISTIAN MOTIFS IN EUROPEAN GARDENS

A curious paradox strikes us when we compare the gardens of Asia with those of Europe. Imagine a group of explorers from some far planet attempting to understand the civilizations of the Earth by studying their gardens. In the Far East and the Islamic world they would see a close connection between the gardens of those regions and their religions – Taoism, Shinto, Buddhism, Islam. But when the expedition visited Europe they would be likely to assume that its gardens were created by two different civilizations. In some gardens, such as those of churches and monasteries, the aliens would find images of Christ, the Virgin Mary and the saints. In others – especially those belonging to great palaces and country houses – they would see no Christian images, only statues of the gods and goddesses of ancient Greece and Rome. Even the park of Versailles, created for the ultra-Catholic monarch Louis XIV, is a celebration of the pagan gods, surrounding the figure of the Sun god Apollo, symbolizing the 'Sun King'. It is tempting to say that monotheism does not lend itself to being expressed in the setting of a garden. Yet the civilization of Islam, a distinctly monotheistic religion, has produced its own rich style of horticulture and garden design, whereas Judaism and Christianity have not – despite the various references to gardens in the Old and New Testaments. Perhaps the explanation has partly to do with the place of nature in religion. The deities of the ancient world are, to some extent, personifications of natural forces and therefore belong

in a natural environment. However, there are deeper reasons for the abundance of pagan imagery in gardens from the Renaissance onwards. Before discussing this in detail it would therefore be worth casting an eye back over the role that gardens, allegorical and real, played in the Christian Middle Ages.

Symbolism in the medieval garden

As Christopher Thacker writes in his *History of Gardens*, 'With the collapse of the Western Roman Empire, gardens and garden art dwindled to such an extent that we may say, without exaggeration, that they virtually disappeared. . . Great gardens are unheard of in the west for seven or eight hundred years, except in fantasy.'[1] Evidence of a revival from around AD 800 exists in the form of a handful of documents, including the poem *Hortulus*, written by a German monk, Walafrid Strabo (809–49). Although this work is mainly a practical treatise on gardening, at the end of the poem Walafrid writes of the mystical significance of the rose and the lily, as symbols of the blood of Christ and the purity of Christian belief.

The notion of the garden as a miniature Paradise was often invoked in the Christian Middle Ages, not only in written and pictorial allegory but also in architectural space.

> In the early church the open, pillared court (or *atrium*), where the catechumen waited before being received into the main body of the church and baptised, was called a Paradise, and in the middle ages there was often to be found, outside the church, a Paradise – an enclosed space for meditation and prayer. Benedictine monasteries all possessed Paradise gardens, and in the later Cistercian order every monk was allotted his own his own little plot or Paradise to look after.[2]

In religious houses a walled garden symbolized the virgin bride of Solomon's *Song of Songs* and, by implication, the Virgin Mary: 'A garden enclosed is my sister, my spouse; a spring shut up, a fountain sealed.'[3] Because of this association it is quite common to see Mary depicted in medieval manuscripts seated in a garden sheltered by a high wall. Situated inside and bordered by the cloister walls, the monastery garden served the practical needs of the religious community. It was generally divided into several sections. Part of it was

carefully laid out with herbs used for cooking and medicinal purposes. Another part might be used as a vegetable garden, while yet another section combined a vision of death and new life: fruit trees planted in the midst of the final resting place for the monks or nuns.

By the high Middle Ages a rich form of Christian flower symbolism had developed. John Prest in his study, *The Garden of Eden*, writes:

> The enclosed garden thus became 'a secret place, enclosing within it the mysteries of the Old and New Testaments'. . . and everything in this garden was then, in its turn, enveloped in allegory. Each individual flower illustrated some aspect of the Christian faith. . . Thus the rose, whose bud opened and whose blossom fell in a single day, put one in mind of the modesty of the Virgin, while the lily, with its white flowers, suggested her purity. . . The iris, universally recognized as the fleur de lys and the symbol of the Kings of France, also served to illuminate Christ's descent from the royal line of David, and to conjure up the image of Christ the King. The triple lobes of the leaves of strawberry put one in mind of the mysteries of the Trinity, and any number of plants, like St John's wort, which derived their names from the names of the Saints upon whose days their flowers were expected to open, were thought to possess either the courageous or the healing properties of their patrons. The whole garden served as a kind of surrogate Bible. It was rich in allegory, and the allegory extended beyond the flowers to the features. The straight raked paths and alleys reflected the conduct to be expected of a Christian, the summerhouse served as a garden chapel for reflection. . . and the enclosed garden itself, like the walls of a church, offered a refuge from the deformed world outside.[4]

Given enough knowledge of such symbolism, our space travellers would have no difficulty in finding medieval gardens with a Christian message. From as early as the eleventh century they would also find certain gardens of nobles influenced by the Islamic paradise garden tradition, brought back to Europe by travellers and crusaders. And of course they could always turn to the imaginary gardens of literature and to the abundance of biblical illustrations showing the Garden of Eden as a place of innocent and uncorrupted nature before the Fall. They would find an equally rich harvest of garden symbolism in the

works of the courtly love tradition. This tradition, which celebrated an idealized love between men and women, mysteriously entered European culture around the twelfth century, possibly from the Islamic world, and was spread by troubadours and love poets such as Chrétien de Troyes and Guillaume de Lorris in France and Hartmann von Aue in Germany. In the illustrations to their works, such as Guillaume de Lorris' *Roman de la Rose*, gardens are sensual places where lovers dally, minstrels play and groups of elegantly dressed men and women sit in the shade of fruit trees reading poetry or listening to the splash of water from a fountain or spring. Such a fountain is lovingly described in the *Roman de la Rose*:

> I lastly came to where I found
> A fountain 'neath a glorious pine. . .
> A pine so tall, straight-grown and fair
> And in a stone of marble there
> Had Nature's hand most deftly made
> A fountain 'neath that pine-tree's shade.[5]

As already mentioned, both the fountain and the single tree beside it are traditional features of paradise according to a tradition dating back thousands of years. The fountain is one of those multivalent symbols that we encounter again and again in the history of gardens. In illustrations of Christian inspiration it appears as a symbol of spiritual nourishment, while in those of the courtly love tradition it suggests femininity and the source of the life force itself.

The courtly love tradition, which in many ways ran counter to the mainstream of Christian orthodoxy, is one example of how gardens and garden symbolism were often the vehicle for unorthodox or even subversive currents. Another example is the alchemical tradition which, like the courtly love literature, celebrates the complementarity of male and female. Just as the lovers in the troubadour poems are often shown in gardens, so numerous alchemical illustrations show male and female alchemists carrying out their work of transformation in garden settings filled with carefully depicted symbols: trees with fruit in the form of stars and planets, roses and lilies standing for the red and the white tincture, fountains representing the alchemical process of circulation, birds symbolizing sublimation. There is in fact a close parallel between gardening and alchemy. In both activities nature is brought from its raw state into a condition of greater

refinement. Hence it is not surprising that gardens were favoured by the illustrators of alchemical texts.

The Renaissance garden: interplay between art and nature

As European civilization moved into what we call the Renaissance, there arose a new urge to celebrate nature – and what better place to do so than in a garden? While all gardens involve an interplay between art and nature, the Renaissance garden developed this interplay to an unprecedented degree of refinement. In the Renaissance the garden was sometimes referred to as a 'third nature' – that is, neither art nor nature but something different from either. Claudia Lazzaro, in her classic work on the Renaissance garden, writes:

> The essence of the Italian Renaissance garden is nature – selected, arranged and also fabricated into ornaments. . . The form they took. . . suggests that these ornaments express in varying ways the two fundamental views of nature – inherently ordered, and wild and disordered. They also. . . presented a catalogue of nature's creations since they were made of a wide variety of vegetation, products of the earth and sea, stones and minerals, coral and shells, and, last but hardly least, water. These ornaments of nature characterized the gardens of the fifteenth century and even the sixteenth just as much as fountains and classical architectural forms did. In the later grand gardens they were joined with sculpture but not replaced by it.[6]

The Greek province of Arcadia, as celebrated by poets and painters, represented an idealized vision of nature in its primal state – a sort of wild counterpart to the concept of the paradise garden. Arcadia, with its presiding deity, Pan, was also often invoked in the gardens of the Renaissance, along with a large variety of animals, both real and mythical – turtles, frogs, serpents, fish, dolphins, lions, elephants, dragons and unicorns.

Lazzaro goes on to point out that, in garden ornamentation, the distinction between order and disorder and between art and nature 'was constantly blurred . . . and assumptions about the two extremes playfully inverted'. Thus, for example, topiary was moulded to resemble sculpture and architecture, while other features, such as grottoes, were natural in appearance, but could serve for human

activities. 'Art was created out of the raw materials of nature, and the forms of the natural world were imitated by art.'[7]

The element of playfulness that is such a feature of Renaissance gardens was partly, Lazzaro suggests, intended to have a 'taming' function. 'Through these ornaments and their playful, ironic and witty presentation, natural phenomena were mastered and domesticated, so that in gardens humans could interact with the larger forces of nature in microcosm.'[8] Play was also present in the form of the practical joke – jets of water, for example, that spurted from benches or other unexpected places, drenching the unwary visitor.

Along with this playfulness went the element of permissiveness and the idea of the garden as a *locus amoenus*, a place for sensual enjoyment. Already present in the garden images of the courtly love tradition, as I have mentioned, this aspect came into full flowering during the Renaissance. The theme of sexuality, explicit or implicit, is ubiquitous. There are sirens with seductive female torsos and fish tails, sometimes with prominent vulvas, as in the example at Bomarzo. For the first time in history, female breasts become water spouts, and the figure of Venus appears again and again, often accompanied by her mischievous son Cupid with his bow and arrow. These images went together with a celebration of the fecundity of nature. But how genuinely pagan is the world view that they represent? Joscelyn Godwin, in his luminous work *The Pagan Dream of the Renaissance*, argues that 'some people during this period "dreamed" of being pagans. In their waking life they accepted the absurdities acknowledged as the essence and credenda of Christianity, all the while nurturing a longing for the world of antiquity and a secret affinity for the divinities of that world.' This feeling was never openly articulated, but 'that was all the more reason for it to manifest in the favourite language of the unconscious and of dreams: that of images'.[9]

While much of the mythological imagery in Renaissance gardens has a universal meaning (e.g. Hercules as courage and virtue, Pan as untamed nature and Venus as fertility and sexuality), other images are specifically local; for example the rivers or other features of a region are often represented allegorically – an instance of the pagan in its local manifestation. On another level, many motifs refer to the individual owner of the garden or to his or her family. Thus, for example, the sea-goat sculptures in the Boboli garden in Florence are a reference to the fact that Capricorn was the heraldic motif and astrological sign of Duke Cosimo I of Medici. Sometimes these levels

are combined, so that an image refers both to a family emblem and to a more general motif. An example of this is the statue of a dwarf mounted on a tortoise near one of the entrances to the Boboli. This is both a portrayal of one of Cosimo I's favourite dwarves, Morgante, and probably a playful representation of Cosimo's motto *Festina Lente* (hasten slowly).

Images of Aesculapius or Asclepius, the ancient god of medicine (recognizable by his staff with a serpent twined around it), appear in many Renaissance gardens (as they did in Roman gardens), usually placed near beds of medicinal plants or close to water from a wholesome source. At the Villa d'Este in Tivoli, for example, 'statues of Aesculapius and of his daughter Hygeia, goddess of health, indicate that the water in their fountains is from the Rivallese spring, as is that of the Fountain of Pegasus, while the majority of fountains are served by the much more abundant but undrinkable waters of the Aniene river'.[10] The use of Aesculapius in this way is a particularly clear example of statuary being used not merely for ornament but to tell the visitor: 'Here is drinking water' or 'Here are health-giving plants'.

The imagery in Renaissance gardens was of course borrowed to a large extent from classical mythology. Key literary sources for such motifs included Virgil's *Aeneid* and especially Ovid's *Metamorphoses*, dealing with myths of transformation – works that were standard references for any well-educated person of the Renaissance period. The period itself also produced various sources for the garden designers, notably the *Hypnerotomachia* or *Dream of Poliphilus*, written by Francesco Colonna and issued by the great Venetian publishing house of Aldus Manutius in 1499. This book, a marvel of typography and illustration, became one of the most important influences in the whole history of garden design, although in fact it is not a book about gardens *per se* but rather a complex allegorical love story, played out partly in a lavishly described setting of gardens and buildings.

The story of the *Hypnerotomachia* and its impact is a fascinating example of an unorthodox message combined with garden imagery. There is some controversy about the identity of the author, Francesco Colonna. Current scholarship favours the theory that he was a Dominican monk, but Princess Emanuela Kretzulesco, author of the classic work on the *Hypnerotomachia* and its influence, identifies him as a Prince Francesco Colonna, whose ancestral home was at Palestrina near Rome, the former Roman town of Praeneste, and

whose property included the remains of the Roman temple to Fortuna Primigenia, the goddess of Fortune in her capacity as the primal creator of life. Princess Kretzulesco argues that the work represents the world view of an enlightened, humanistic faction which had to go underground with the death of its papal supporter Pius II in 1464, bringing the eclipse of what she calls the 'Church of Light' and the advent of a more rigidly dogmatic papacy.[11]

Certainly the book takes the reader into a world that is very far from that of Christian orthodoxy. It is a celebration of the feminine principle and of a refined form of erotic love. The text, accompanied by richly evocative engravings, describes a dream in which the narrator goes in search of his loved one, Polia – hence the narrator's name, Poliphilus ('lover of Polia'). At the beginning he finds himself lying on a spacious plain dotted with flowers, then makes his way through a dark and frightening forest and comes to a hill covered with classical architecture – colonnades, pyramids, temples, obelisks – abounding in statuary, carved images, hieroglyphs and mysterious inscriptions. Later he passes through gardens containing pergolas, fountains, intricate parterres, elaborate topiary. On the way he en-counters nymphs, goddesses and various mythological figures who guide him through a series of initiatory experiences before he is finally brought together with his beloved Polia.

What is described here is clearly some kind of initiatory journey, evidently bringing together various different traditions. Emanuela Kretzulesco argues that the hill with the classical buildings is based on the sanctuary at Palestrina, where a vestige of the cult of Fortuna Primigenia had survived, and that in climbing up through these buildings Poliphilo is undergoing the kind of initiation into the ideals of nobility that would have been practised by the Colonna family. As for the images and deities that Poliphilus encounters on his journey, these can perhaps be understood in the context of Renaissance magic and memory systems, a subject which used to be little understood, but which has been greatly elucidated in recent decades by the work of scholars such as Frances Yates, D.P. Walker and Ioan P. Couliano.[12] The Renaissance magical system, as expounded by men such as Marsilio Ficino, was based on the idea of an omnipresent invisible substance called the *pneuma* ('breath' or 'spirit') which connected the soul to the body and caused a mutual interaction to take place between things or people possessing a spiritual or symbolic link. It was often referred to as 'eros', since one of its most obvious forms is

the erotic force, which attracts lovers to one another. Someone with a trained imagination and visual memory could influence things through the *pneuma* by the use of 'phantasms', that is images imprinted on the *pneuma* and representing different modes and energies within it. By way of analogy with modern information technology, the magician could activate certain icons on the computer screen of his mind and so send messages or instructions to other parts of cyberspace. These phantasms were drawn from traditional symbolic systems including astrology, classical mythology and Egyptian hieroglyphics. Evidently, what we see in the *Hypnerotomachia* is partly a description of the process of mastering and refining one's erotic urge through contemplating a succession of these phantasms. Very likely, the *Hypnerotomachia* is also based on the tradition of memory systems described in Frances Yates's *The Art of Memory*. That tradition can be traced back to ancient Roman times, when orators would memorize their speeches by seeing in their mind's eye a series of carefully placed images associated with the ideas that they wished to convey. The system was taken up by medieval scholastics and later by Renaissance writers, and its influences can be found, according to Yates, in certain buildings such as Shakespeare's Globe Theatre. In *The Art of Memory* she refers to the *Hypnerotomachia* as follows:

Perhaps an artificial memory gone out of control into wild imaginative indulgence might be one of the stimuli behind such a work as the *Hypnerotomachia Poliphili*. . . in which we meet, not only with Petrarchan triumphs and curious archaeology, but also with Hell, divided into places to suit the sins and their punishments, with explanatory inscriptions on them. This suggestion of artificial memory as a part of Prudence makes one wonder whether the mysterious inscriptions so characteristic of this work may owe something to the influence of visual alphabets and memory images, whether, that is to say, the dream archaeology of a humanist mingles with dream memory systems to form the strange fantasia.[13]

Curiously enough, Yates makes no mention of the possibility that the tradition of memory systems could have influenced the design of actual gardens. Yet this possibility is glaringly obvious. The imaginary settings used to assist the mind's eye in conjuring up these images

included gardens as well as buildings, as we have seen from the *Hypnerotomachia*. Furthermore we know that the *Hypnerotomachia* influenced the design of a number of gardens in Italy and elsewhere. Therefore it seems probable that real gardens, as well as imaginary ones, were used for the type of inner exercise that I have described.

But we can go even further and speculate that some images in gardens were in fact magical objects, deliberately charged with cosmic energy. The fifteenth century saw the introduction into Italy of the set of esoteric writings, originating from Hellenistic Egypt, known as the *Corpus Hermeticum*, through the translation from Greek into Latin by the Florentine scholar Marsilio Ficino (1463–94). In one of these writings, known as the *Asclepius*, there is a section dealing with the ancient Egyptian art of animating statues by drawing down cosmic energy into them. Ficino and other Renaissance hermetists were fascinated by this notion, and their interest was clearly more than academic. Therefore it is possible that some of the statues in Renaissance gardens were charged in this way, so that when you looked at one of them you were not merely reminded of the quality that it represented, but would actually receive something of that quality. It was perhaps for this reason that statues surviving from the ancient world were particularly prized as accoutrements for palaces and gardens.

Whether based on memory systems or influenced by Egyptian magic, we can safely say that the great gardens of the Renaissance were designed to provide richly symbolic journeys. Even imitations of these gardens, built by dilettantes of later centuries knowing nothing of the original tradition, preserve something of the mysteriously potent atmosphere that lingers among the avenues, terraces and fountains of the Villa d'Este or the Boboli. With this in mind, we can proceed to look at some particularly striking examples of Renaissance and Renaissance-style gardens.

5

ANCIENT MYSTERIES REVIVED: THE RENAISSANCE GARDEN IN ITALY

Whereas the average medieval garden is a modest enclosure with few decorative features, the Renaissance style of garden (appearing around the mid-fifteenth century) plays with space and design in a new way. Typically, it is divided into a number of discrete areas like outdoor rooms (*compartmenti*). While it took over certain features from the medieval style, such as the fountain and the pergola, it introduced a much wider visual vocabulary. The features one is likely to encounter in a Renaissance garden include flights of terraces, grottoes, topiary hedges, tunnel arbours, geometrical parterres, pavilions, secret corners, surprise vistas, labyrinths and, of course, an abundance of statuary and visual echoes of classical antiquity. In addition, thanks to importations from abroad, the Renaissance gardeners had at their disposal a far wider range of plants than had been available to their medieval predecessors. Clearly there is much greater scope here for symbolic meaning, as we shall see.

The gardens of the Renaissance are undoubtedly one of the supreme achievements of the period. In these gardens, as Joscelyn Godwin writes, there is a magic 'that descends especially on the solitary visitor, a trancelike atmosphere of suspended excitement beyond words or rational mind. In earlier times, when consciousness was less rigidified, it must have been stronger, leaving no doubt as to the presence of Pan and his retinue.'[1]

The Villa d'Este, Tivoli

It was at the Villa d'Este near Rome that I had my first revelation of

the riches of Italian Renaissance gardens on a school trip to Italy at the age of 14. It was a beautiful spring afternoon, and I remember wandering with my schoolmates up and down the terraces and leafy walkways, marvelling at the innumerable fountains and cascades, the play of sunlight on water, the grottoes, the profusion of statuary. I took black and white photographs with a simple box camera, sensing the powerful spirit of the place, though I could not have begun to say what its message was or even if it had one. Decades later, after I had learned something of the language of the garden, I returned there one afternoon in January when the fountains were silent and the monuments had an eerie quality in the fading winter sunlight. In its own way, that visit was also memorable.

The language of the Villa d'Este garden contains all the richness of idiom that became available to the garden builders of the Renaissance with the rediscovery of the world of classical antiquity, its gods and legends. The creator of the villa and garden, Cardinal Ippolito d'Este (1509–72), was well versed in that language, and he used it to construct a garden of carefully orchestrated symbolism. To understand the garden it is necessary to know something of Ippolito d'Este himself. The son of Alfonso d'Este, Duke of Ferrara, and Lucrezia Borgia, daughter of Pope Alexander VI, he was an archbishop at the age of ten, an ambassador to France at 27 and a cardinal at 29. Despite his great intelligence and political skill he just missed becoming Pope, but he collected numerous other high offices as well as a variety of residences in France and Italy. A man of great culture, he was throughout his life a generous patron of artists, architects, poets, composers and landscape gardeners. In 1550 Pope Julius III made him governor of Tivoli and its territories, which included Hadrian's Villa and various other Roman sites. His residence, a former monastery which he remodelled, overlooked a hillside sloping steeply downwards from the building into the valley. Here, over more than two decades, he built the sumptuous garden, piping water from the nearby river Aniene to supply the fountains which are Tivoli's greatest glory, and supplementing the decoration of the garden with pieces of statuary from excavations in the Roman villas of the territory.

The designer of the villa and garden was in all probability Piero Ligorio, who was also the cardinal's personal antiquary, responsible for excavating and making drawings of Hadrian's Villa, which in turn influenced the design of the Villa d'Este. Another likely influence on the design was the ancient sanctuary of Fortuna Primigenia at

Palestrina near Rome, which was also built on a series of massive terraces.

One key to the symbolism of the Villa d'Este garden lies in the cardinal's first name. Ippolito, or Hippolytus, was in Greek mythology the son of the Athenian hero Theseus and Hippolyte, Queen of the Amazons. His story is told in Ovid's *Metamorphoses*. Hippolytus had a chaste love for the goddess Diana and thus aroused the jealousy of Venus who caused Hippolytus' stepmother Phaedra, third wife of Theseus, to fall in love with him. Phaedra, being rejected, poisoned Theseus' mind against his son, and Theseus asked Neptune to punish him. Neptune then caused Hippolytus to come to a violent death while driving his chariot along a beach. He was, however, brought back to life by Aesculapius on the intercession of Diana.

Hippolytus is one of the figures to whom the garden is dedicated. The other is Hercules, a figure admired by the d'Este family, as well as by many other noble families, for his strength, courage and resourcefulness. In particular it is the 11th labour of Hercules that is evoked in the garden, namely his quest for the Golden Apples of the Hesperides, which were kept in a land in the far west and guarded by the hundred-headed dragon Ladonis. The apples, which are shown in the d'Este coat of arms, held by an eagle, are interpreted by Emanuela Kretzulesco as standing for the 'fruits of Knowledge which bestow immortality' and which were seized by Hercules despite the vigilance of the Dragon, charged with guarding the wisdom dating from the Golden Age.[2]

Descending the central axis of the garden from the villa, one crosses the Avenue of a Hundred Fountains and passes between two sphinxes, those familiar guardians of thresholds, before coming to the Fountain of the Dragons – actually the single Dragon of the Hesperides, shown with four heads. In the niche behind the fountain is a gigantic statue of Hercules holding a club. From this fountain pathways lead in various directions. In one direction lies the Grotto of Diana, suggesting chastity and containing images from the *Metamorphoses* that we encounter repeatedly in Renaissance gardens, including Daphne turning herself into a laurel to avoid the attentions of Apollo. In the opposite direction is the Grotto of Venus, suggesting sensual love.

Looking at a sixteenth-century engraving of the garden by Dupérac, we see at the lower end of the slope a paradise garden – a square area divided into four by intersecting tunnel pergolas, the centre emphasized by a hexagonal tower, and each quarter again divided into four by intersecting paths with a hexagonal arbour in the middle. The paradise

garden is flanked by labyrinths, two on each side, where travellers can lose their way if they stray to the right or left. The journey through the garden can therefore be seen as an exercise in finding the right path and avoiding the dangers and distractions of the world.

The Villa Castello, Florence

Characteristic of many Renaissance gardens is a tendency to play with polarities: darkness and light, water and fire, the primitive and the civilized. An example is the the garden of the Villa Castello, on the north-eastern outskirts of Florence, which belonged to Giovanni and Pierfrancesco de Medici, cousins of Lorenzo the Magnificent, and later to Grand Duke Cosimo I of Medici. It was Cosimo who, in the mid-1540s, commissioned Niccolò Pericoli to design the garden. Pericoli, known as 'il Tribolo', was later to work on the Boboli garden. Another who worked on the garden about a decade later was the great architect Georgio Vasari. No expense was spared to channel water by means of an aqueduct down from a spring in the Appenines and into an artificial lake on the hill above and outside the formal garden. In the middle of the lake is an island of jagged rock with a great bearded figure representing the Appenines, rising up in the middle. Such primal images, suggesting the beginning of the created world, are often found linked with grottoes and fountains of this period.

From the lake the water flows into a grotto and fountain set into an alcove in the north wall of the garden, with three niches – one facing the entrance and one at each side. Set into these niches is a collection of animals. On one level this is perhaps, as Emanuela Kretzulesco suggests, an allusion to a description in Ovid's *Metamorphoses* of the moment when the waters of the great flood receded and the Sun shone on the moist mud, causing it to produce a great profusion of life. In a very alchemical-sounding passage, Ovid writes: 'Although fire and water are always opposites, nonetheless moist heat is the source of everything, and this discordant harmony is suited to creation.'[3] The animals in the grotto were chosen for a variety of reasons. There are exotic beasts, such as a giraffe and an elephant, like those presented to various members of the Medici family. There are also animals that appear as Medici heraldic motifs, such as the lion, the goat, the ram and the rhinoceros. The only mythical animal is the unicorn, occupying pride of place in the central niche directly above the lion and perhaps signifying the purity of the spring water.

The main part of the garden has unfortunately been much altered over the centuries. The *compartimenti*, surprise vistas and secret places, so typical of the Renaissance garden, were swept away in the eighteenth century, to be replaced by the present open and rather bare design. In its heyday it had as its focal point a labyrinth of cypresses and other trees with a fountain, known as the Fountain of Florence, at the centre surmounted by a figure of Venus, stooping to wring out her hair, from which water cascaded down. Goats' heads on the shaft of the fountain alluded to Cosimo's emblem and astrological sign. The symbolism here has different dimensions. On one level Venus, standing for Florence, proclaims that the city is fertile because of the river flowing past her and the water flowing into her through conduits built thanks to the beneficence of the Medici family. The water can also been seen as symbolic of the wise rule of the Medicis. Further symbolic layers of the figure and the labyrinth around it are described by Claudia Lazzaro:

> Both the labyrinth and the plant materials, all evergreen, allude to the city of Florence that she personifies, Venus whose form she borrows, and also springtime, over which the goddess presides. Cypress trees are appropriate for a labyrinth, since they originated in Crete, the site of the famous labyrinth built by Daedalus. . . Also forming part of the labyrinth were arbutus trees (associated in ancient literature with the Golden Age), the laurel of Parnassus, and myrtle, sacred to Venus.[4]

Lazzaro further points out that the combination of myrtle and cypress is also found in an imaginary labyrinth on Cythera, the island of love sacred to Venus, which is described in the *Hypnerotomachia*. Both that labyrinth and the one at Castello were arranged in concentric circles.

Between the labyrinth and the villa was another fountain, depicting an episode from the legend of Hercules. Returning from his quest for the Golden Apples of the Hesperides, Hercules was confronted by the giant Antaeus, who was invincible as long as his feet touched the earth. Hercules, however, lifted him from the ground and was able to crush him to death. The sculpture on top of the fountain's column showed Hercules holding Antaeus, the latter with head flung back and water pouring from his mouth as though to represent the life force flowing out of him. Hercules was often invoked as an embodiment of virtue and courage – as we have seen, he appears in this role at the

Villa d'Este. Cosimo associated himself with the hero and used the motif of Hercules and Antaeus on his medals. Again, as Claudia Lazzaro says, the symbolism of the figure can be interpreted in various ways: the triumph of virtue over evil, or the act of shifting earth to bring water, as Cosimo did when he brought water to Castello and later to Florence.[5] The same motif, incidentally, appears in the Mirabell Garden in Salzburg, where it represents the element earth and stands with three other sculptures representing air, fire and water.

Neither fountain is now its original position. The Fountain of Florence was transferred in 1788 to another villa, and the Fountain of Hercules was moved into its place. Unfortunately it now lacks the sculpture of Hercules and Antaeus.

In the layout of the garden Emanuela Kretzulesco sees an itinerary, which involved the traveller passing through the labyrinth and refreshing himself at one of the fountains, as Poliphilus does in a river when he leaves the forest, as described in the *Hypnerotomachia*. Such an itinerary would also have brought the traveller face to face with many statues of classical deities and heroes, each of which would have conveyed a message. Few of the original statues remain – one that does is another statue of Hercules, with his club – and many were never installed. In an adjacent herb garden there was to have been a wall fountain with a statue of Aesculapius, god of health. Tribolo's plan also included images of the four seasons as well as 12 statues symbolizing the virtues and greatness of the house of Medici. On the east side were to be ranged the virtues of liberality, wisdom, nobility, bravery, piety and justice, while on the west were to be sculptures representing the spheres of the arts, language, science, arms, peace and law. Above the niches were to have been busts of members of the Medici family. 'Altogether this sculpture would have proclaimed that in Florence, throughout the seasons, virtue flourishes under the rule of Cosimo as it did under that of the earlier Medici.'[6]

If it is true, as I have speculated, that certain images in Renaissance gardens were talismans intended to transmit particular energies to the viewer, then the statues at Castello would seem to be likely examples of this.

The Boboli, Florence

Behind the massively imposing and somewhat forbidding Pitti Palace in Florence, with its cyclopean blocks of rough-hewn stone, lies a

garden of many enchantments and rich iconography – the Boboli, spreading out over a hillside to the south-east of the palace and extending to a lower section in the south-west. The garden took its present shape over a period of about three centuries. In 1549 Princess Eleonora of Toledo, wife of Grand Duke Cosimo I of Tuscany, acquired the palace and engaged the same landscape architect, Tribolo, who had designed the garden of Castello. Tribolo died a year later, and the work was carried on sporadically, with subsequent owners adding and removing features according to the taste of the era. A key period was the first half of the seventeenth century under Grand Duke Cosimo II and his successor Ferdinand II, during which time the landscaping work was carried out by Guilio Parigi and later by his son Alfonso.

Water is one of the central themes of the Boboli – water channelled down from the hills, through the cavernous grotto in the courtyard of the palace and out into the city, as a tangible symbol of the munificence of the Medicis. It is a theme that is repeated again and again in various fountains, grottoes and water channels. However, as Claudia Lazzaro points out: 'The fountains were planned at different times and for different purposes. There is none of the geographical specificity and thematic unity of the images at Castello.'[7]

The best way to look at the Boboli is perhaps as a story written by many different authors – indeed written anew by every visitor who looks at it with a fresh eye. Seen in this way, the Boboli will yield a rich harvest of meaning. Here are many of the images and motifs encountered earlier, including the grotto, the labyrinth and the paradise garden.

A good place to begin is at the north-east corner, where one is greeted by a jovial naked dwarf sitting on a tortoise, with one hand raised as though telling the visitor to slow down and take the garden at a leisurely speed. As mentioned in the previous chapter, this is both a portrait of Cosimo's favourite dwarf, Morgante, and a visual re-presentation of his motto *Festina Lente* (hasten slowly). A few paces to the north-east brings one to the Great Grotto, created in the second half of the sixteenth century by Georgio Vasari and later by Bernardo Buontalenti. This grotto, like so many others, strikes a basic, primeval and elemental note. Its motifs are taken once again largely from the story of the flood in Ovid's *Metamorphoses*. Originally the skylight in the domed ceiling was fitted with a glass fish tank, so that one looked symbolically up through the flood waters. The images around

the walls of the grotto illustrate Ovid's account of Deucalian and his wife Pyrrha, the only two human beings left after the flood, who were advised by the goddess Themis to take the bones of their mother (i.e. the stones of the earth) and throw them behind their backs. This they did, and the stones turned into human beings, who became the progenitors of a new human race. The two primal human beings who emerged from the stones are represented by two half-finished statues by Michelangelo that were conveniently found in the artist's studio after his death.

Progressing up the hillside to the south-east, one has the choice of two parallel axes. One leads to a delightful coffee house in the form of a little domed pavilion, built in the eighteenth century by the Habsburg Grand Duke Peter Leopold. The other axis leads through a spacious amphitheatre, constructed in the early seventeenth century for sports and festivities, in the middle of which is an Egyptian obelisk (seen by the Roman writer Pliny the Elder as symbolizing a ray of sunlight) standing beside a massive granite basin. It is tempting to see here the symbols for fire and water, the two elements, according to Ovid, from which life was regenerated after the flood. However, the original centrepiece of the amphitheatre was the great fountain of Oceanus, which now stands at the south-western end of the garden.

We continue up the hill and then turn to the south-west down a long, straight avenue of cypresses lined with statues of classical deities: Jupiter and Ganymede, Mercury, Hygieia, Aesculapius, Hippolytus and others. Between this avenue and the southern boundary of the garden lies an area that was originally laid out in the form of three labyrinths side by side. These labyrinths, created in the early seventeenth century, were destroyed in the early nineteenth. However, their centres remain, reached by paths that meander between thickly planted groves of bay trees, the half-human shapes of their trunks eerily reminiscent of the legend of Daphne and Apollo. Were these trees also perhaps deliberately chosen for their symbolism? And were the labyrinths intended to represent the distractions of worldly pleasures?

The labyrinths lead by a winding, circuitous route to the same point that the avenue reaches directly, namely the entrance to the Vasca dell' Isola, an oval lake in the middle of which is an island on which now stands the Fountain to Oceanus, the god of the primal river that was said once to encircle the earth. Below Oceanus are figures representing three other rivers, the Ganges, the Nile and the Euphrates. So here is

another version of the four rivers of paradise, emphasized by the four paths that converge on the basin.

The route I have described takes one from the Great Grotto to the Oceanus Fountain, situated at opposite extremes of the garden. Although this placing was not part of the original plan, and any symbolism involved is probably fortuitous, I like to think of it as representing two different visions of our beginnings: one in the primal mud left behind by the flood, the other in the innocent perfection of the Garden of Eden. We can choose which one we prefer, but it is in the route between them that the magic of the Boboli lies.

The Villa Garzoni, Collodi: the ascent to fame

On a Tuscan hillside 15 kilometres to the east of Lucca lies Collodi, birthplace of Carlo Lorenzini, author of *Pinocchio*, who took the surname Collodi in honour of his home town. Here stands the Villa Garzoni with its magnificent garden. The original house was built by the Garzoni family in the fourteenth century, and the garden took shape in various phases over the following centuries. One of the earlier features was a topiary labyrinth, which still exists although it has evidently been somewhat altered from its original form. Also still existing is a stone bridge over the labyrinth, from which one could look down and observe anyone bold enough to attempt to thread their way through the puzzle. It is said that the labyrinth was used for amorous games of hide and seek and that sometimes the owners of the palace and their guests would watch with the amusement while peasants and servants lost their way in the maze or were sprayed by the jets of water that were added in the seventeenth century. However, it is hard to believe that the labyrinth was created only for such frivolous purposes. Its real purpose surely lay in the deeper significance of the labyrinth as symbolizing a pilgrimage through the snares and dangers of the world to the centre where illumination is found.

The most striking part of the garden is a series of richly ornamented terraces rising steeply up a hillside. This was built in the eighteenth century for Romano Garzoni by his friend Ottaviano Diodati, a remarkable scholar and historian as well as a garden architect of genius. Although built much later than the Renaissance period, Garzoni's creation has the hallmarks of a Renaissance garden of pilgrimage, in which the pilgrim is led through a series of carefully chosen images. For the figures that he placed in the garden Diodati

chose to use not marble but terracotta painted to look like marble. This was probably not a cost-saving measure but a statement about illusion and reality: all earthly magnificence is transient, doomed to decay.

Entering the garden at its lowest level from a street in the town, one crosses a wide level area divided up into parterres. Before coming to the flight of terraces one passes two statues illustrating a story from Ovid's *Metamorphoses*: on the right Daphne being turned into a laurel tree to escape the attentions of Apollo; and on the left Apollo himself in pursuit. I share the interpretation of these statues given in Hansmartin Decker-Hauff's book *Gärten und Schicksale*: 'In this garden only refined self-control is permitted. . . At this threshold a rule of polite society is visibly presented to anyone entering the park: Here you must behave with propriety, fineness and cultivated manners.'[8] The disappointed Apollo responded by dedicating the laurel tree to his own cult, and the tree came to represent fame or glory. An added message of these figures could therefore be that only by proper self-restraint can the aristocrat attain the fame that is his goal.

Moving on up the slope one passes a fountain in the form of a peasant pouring water from a barrel, and further up is another fountain depicting a peasant holding a turkey with water spouting from its mouth. Here the intention might be to remind the nobleman to keep a sense of humility and to bear in mind that very little divides him from the peasant unless he follows a quest to some higher ideal – a quest which is represented by the journey up through the garden itself. A similar injunction to humility could be intended by the series of monkeys on the balustrades – a reminder that the human arts are only aping God.

Another message is conveyed by the contrast between the flight of terraces and the terrain on either side. Here Diodati expressly intended to create a visible division between light and dark. To quote Decker-Hauff again: 'The staircase is all joyful playfulness and light. But to the left and right loom dark woods with thick masses of laurel and oleander, creating an impression of almost menacing gloom.'[9] Significantly, just at the point where the woods begin, the staircase is flanked by two satyrs, a male and a female. These hybrid creatures, half-human, half-goat, are intermediaries between the wild, untamed aspect of nature represented by the woods and the cultivated environment of the formal garden. Human beings have an animal nature, they tell us, which should not be rejected but rather kept within boundaries.

Other features strike one as one passes up the terraces: a Neptune grotto, figures symbolizing the four seasons, busts of Roman emperors, statues representing the two rivers of the region, and, at the very top, a towering female figure holding a trumpet and blowing into a seashell, who represents fame or glory, the ultimate goal of the nobleman.

Bomarzo: the art of melancholy

Bomarzo, the most instantly recognizable of Italian gardens, is also the most untypical – indeed it is unique and impossible to categorize. Its weird monsters, giants, gaping mouths and lopsided architecture would seem more at home in the paintings of Salvador Dali or the pages of H.P. Lovecraft than in the peaceful countryside of the Latium. Located near Viterbo, the palace of Bomarzo, at the town of the same name, belonged to the Orsini family, and the garden was created by one of its most eccentric members, Vicino Orsini. Born in about 1516, Vicino grew into a colourful and talented young man who sired a number of illegitimate children before marrying in 1544 the beautiful noblewoman Guilia Farnese. He had a distinguished diplomatic and military career before being captured in battle in 1553 by the forces of the Habsburg Emperor Charles V and held to ransom for three years. Orazio Farnese, his closest friend, was killed in the same battle, and shortly after he was freed from imprisonment his beloved young bride also died. In his grief he became a recluse and began obsessively to build one of the world's most bizarre gardens.

Why did he create such an extraordinary place? The explanation may have something to do with his friend Cristoforo Madruzzo, a brilliant, worldly aristocrat and Church potentate who lived not far away in the palace of Bagnaia at the town of Soriano. Hansmartin Decker-Hauff, in an essay on Bomarzo, speculates that the two men entered into a kind of competition: Cristoforo Madruzzo set out to create at Bagnaia a garden of beauty, harmony and light, while Vicino Orsini at Bomarzo created one of gloom, disharmony and weirdness, reflecting his melancholy state of mind.[10] However, I would suggest that the explanation is perhaps more complex. There are two opposite approaches to dealing with the condition of melancholy. One is to attempt to banish the melancholy by subjecting oneself to cheerful stimuli. The other is to do the opposite, namely to surround oneself with sad and gloomy things, thus giving oneself a kind of homeopathic

dose of melancholy to stimulate a counter-reaction. As an example of the latter approach, the writer Colin Wilson has described how, as a young man, when he returned home from a tedious day's work feeling depressed, he would retire to his bedroom and read the gloomiest poetry he could find. Inevitably, after a while he would begin to cheer up and be able to put the gloomy reading aside. This method was surely known to the Renaissance, and would provide a convincing explanation for Vicino's creation of the Bomarzo garden.

It has also been claimed that the figures at Bomarzo, most of them carved out of natural pieces of rock on the site, are alchemical images. Vicino was deeply interested in alchemy and corresponded with the French alchemist Jean Drouet,[11] and certainly a number of the figures could be given an alchemical interpretation. Others, however, appear to have no obvious connection with alchemy.

Probably the most penetrating and detailed study of Bomarzo and its creator is Horst Bredekamp's *Vicino Orsini und der heilige Wald von Bomarzo* (Vicino Orisini and the Sacred Wood of Bomarzo), illustrated with wonderfully evocative photographs by Wolfram Janzer.[12] Bredekamp sees much of the meaning of Bomarzo as lying in Vicino's Epicurean world view, which led him to seek solace in sensual pleasure and the joys of nature and to rebel against the Counter-Reformation orthodoxy of his day by plunging into an extravagant world of the imagination, full of weird and bizarre images. Bredekamp also explains many of the features of Bomarzo as being intended to commemorate Guilia Farnese.

An interesting fictional treatment of Vicino's life, written in the form of an autobiography and clearly based on thorough research, is the novel *Bomarzo* by the Argentinian writer Manuel Mujica Lainez.[13] As Lainez portrays him, Vicino created the garden as a kind of inner portrait of himself, a 'book in stone', deliberately enigmatic. Writing of the rocks before they were carved, he says: 'Each rock contained an enigma in its structure, and each of these enigmas was also a secret of my past and my character. I only had to uncover them, to strip each rock of the crust that covered its essential image.'[14]

The approach to the garden of Bomarzo takes one first past two sphinxes, which underline the mysterious nature of what the visitor is about to see. An inscription on one of them reads:

TU CH'ENTRI QUI CON MENTE
PARTE A PARTE

ET DIMMI POI SE TANTE
MARAVIGLIE
SIEN FATTE PER INGANNO
O PUR PER ARTE.

(You who enter this place, observe it piece by piece and tell me afterwards whether so many marvels were created for deception or purely for art.)

Here the word 'art' could possibly be taken to mean the alchemical art.

Passing between the sphinxes the visitor comes to a small house, built deliberately so that it leans disconcertingly to one side. Bredekamp sees this as one of the memorials to Guilia Farnese. The pictorial source for the house he identifies as a contemporary emblem book by Achille Bocchi, where a similar leaning building signifies 'a woman who, with great steadfastness during her husband's absence at war, preserves the family house from collapse'.[15] More strange images follow: a huge scowling face with a gaping mouth leading to a cave (perhaps the most famous of Bomarzo's features), an androygne (possibly an alchemical image) being held upside down and ripped apart by a giant, a mermaid with two tails (again an image found in many alchemical treatises), a dragon attacking a deer, a giant tortoise carrying a globe surmounted by a female figure with a trumpet, and numerous other marvels.

Possibly the creation of the garden served many purposes – part memorial to Vicino's deceased wife, part therapy for melancholy, part autobiography in stone, part collection of alchemical symbols, part mannerist experiment. The sculptures lay forgotten for centuries, gathering moss, until in the twentieth century they began to attract the attention of art historians, artists and writers. The writer Manuel Mujica Lainez has already been mentioned. The artists that the garden has inspired include Niki de Saint Phalle (whose Tarot Garden will be described in Chapter 10) and the Spanish surrealist Salvador Dali, who incorporated some of its images into his paintings and who was once photographed holding a candle and talking to a white cat in the jaws of Bomarzo's largest monster. The spectacle perhaps drew a wry smile from the ghost of Vicino Orsini.

6

ROSICRUCIAN MARVELS
AND RECREATIONS OF EDEN:
LATE RENAISSANCE GARDENS
IN EUROPE

As the Renaissance style of gardening spread into the countries of
northern Europe it mingled with a new outlook that was emerging
through the discoveries of voyagers as well as through important
developments in science, philosophy and religion that increasingly
gathered momentum from about the mid-sixteenth century onwards.
It now became possible to use gardens to convey new scientific ideas
while still couching them in the visual imagery inherited from the
Renaissance, from the Christian tradition and from classical antiquity.
To this period, for example, belongs the emergence of the great
botanical gardens of Europe. The first of these was established at
Padua in 1545, to be followed by those at Leyden, Paris, Oxford and
other cities. The world view that lay behind the creation of these bot-
anical gardens is interestingly described in John Prest's *The Garden
of Eden*.[1] One important element in this world view concerned the
search for the original Garden of Eden. Ever since the time of the early
Church Fathers people had been debating as to the nature of the
original Garden of Eden: whether it was an allegory or had literally
existed, how it was related to the concept of Paradise and where it
might be located if it did exist. Many believed that the virtuous when
they died were received into an earthly Paradise, identifiable with the
Garden of Eden, to await the final judgement, when they would be

taken up into the heavenly Paradise. In the Middle Ages this garden would have been regarded as beyond the reach of any traveller, but this changed with the coming of the age of exploration. When Columbus set out for America in 1492 he believed that he would find the territory described in the Old Testament. For this reason he took with him a converted Jew, Luis de Torres, who knew Hebrew, Arabic and Chaldaic and would therefore be able to converse with the inhabitants. By the time he made his third voyage, to South America, Columbus had become convinced that he had found the region of the original Garden of Eden – although not yet the Garden itself.[2] Others located the Garden in Africa or on the Persian Gulf. Collecting flora, fauna and other specimens from these regions thus became an exercise in reassembling the Garden of Eden in microcosm. The English writer and gardener John Evelyn was one of the most influential figures in spreading this idea. 'In the *Kalendarium* he said that our gardens should be made "as near as we can contrive them" to the Garden of Eden.'[3]

To the wider geographical perspectives opened up by men like Columbus were added new scientific perspectives opened up from the early seventeenth century with the beginnings of modern science. Many believed that it was possible through science to obtain mastery of nature and so find our way back to the Edenic state that had been lost through the Fall of Adam. One of the most enthusiastic proponents of this view was Sir Francis Bacon, who 'was bent on the attainment of the Biblical promise to man of dominion over nature'.[4] To Bacon, horticulture was the perfect expression of this enterprise. It is in this context that we must see Bacon's fondness for motifs such as the paradise mount.

When it came to the study of the plants themselves that were collected in the gardens of this era, much use was made of the old doctrine of 'signatures', going back to medieval times, whereby the medicinal or other properties of a plant were indicated by its shape, colouring or some other feature. Thus the walnut, which is shaped like a human head, was thought to be good for head wounds or for the brain. Maidenhair fern was believed to be a remedy for baldness, plants with yellow flowers would cure jaundice, and triple-leaved plants were good for the triple genital parts of the male. This doctrine could be applied as easily to plants imported from around the world as to native European species.

In the gardens of the sixteenth and seventeenth centuries are written the new hopes, ideals and scientific theories of the age, mingled with

older ideas and beliefs. Thus, for example, in many of the great botanical gardens the old fourfold scheme was adopted in such a way that the four quarters represented the four regions of the earth and were planted accordingly. The mood of that age – its mixture of tradition and progressive optimism – has passed, but many of the gardens that emerged from it remain.

The Hortus Palatinus, Heidelberg

The great garden at Heidelberg Castle, built in the early seventeenth century for the Elector Frederick V of the Palatinate, was one of the wonders of its age, and its almost total destruction is a major tragedy in the history of gardens. Fortunately we have a detailed record of it in the form of a book by its designer Salomon de Caus in 1620, with a short descriptive text by the author and a series of beautiful engravings by Matthaeus Merian, including a panoramic view of the garden.[5] To understand the dense symbolism revealed in the book one has to know something of the events of the period and the world view that lay behind the creation of the garden.[6]

Heidelberg was the scene of a brief idyll of enlightenment, culture, learning and toleration during the years 1612–20 under the rulership of the Protestant Elector Frederick V of the Palatinate, who was married to Elisabeth, daughter of King James I of England. Tragically the idyll came to an end in 1620, in the early stages of the Thirty Years War, when Frederick made a bid for the crown of Bohemia and was defeated by the forces of the Catholic Habsburgs, who subsequently sacked Heidelberg and used the garden as an artillery base for bombarding the castle. Plundering and vandalism over the centuries have left only the bare bones of the garden and a few remnants of its original decorations.

Still, it is a moving experience to visit the castle and garden today. The great L-shaped expanse of terraces on the hillside overlooking the river Neckar is still there, along with some balustrades, pillars and the remains of some fountains and grottoes. Soon after entering the garden one comes upon an octagonal stone basin, which is all that remains of a fountain. However, the octagonal form immediately gives us a clue to the message of the garden, for eight, the octave, is the number of musical completion and wholeness, and the musical theme is one that is repeatedly taken up in de Caus's design. De Caus, a French Huguenot, was much more than a garden designer. He was

an architect, engineer, composer of music, builder of ingenious mech-
anical devices, and an immensely learned man, well versed in classical
literature and philosophy and deeply influenced by the Pythagorean
and Platonic traditions. As such, he was a kindred spirit to Frederick
V, whose reign marked the high point of what Frances Yates has called
the 'Rosicrucian Enlightenment'.[7]

Rosicrucianism arose in Germany in the early seventeenth century
as a movement based on what we would now call a 'holistic' world
view. It was sparked off by the publication in 1614 of a mysterious
text called the *Fama Fraternitatis*, which told of a sage called Christian
Rosenkreuz who founded an esoteric brotherhood, lived to the age
of 106 and was buried in a secret vault. Allegedly, the discovery of
the vault in 1604 was taken as the signal for the brotherhood to
declare itself to the world. In a Europe plagued by religious conflict
and at a time when new vistas were beginning to open up in science,
the followers of the Rosicrucian movement believed that a universal
vision, based on a union of the arts, science and religion, would heal
sectarian divisions and bring about a new and more genuine refor-
mation. The notion of 'reading the book of nature' was an important
element in their programme, as they believed that divine truth is
revealed in nature as clearly as in scripture. The whole universe, in
this view, is constructed according to sacred proportions and vibrates
with divine harmony. Also important to the Rosicrucians was the
belief in an ancient tradition of secret wisdom handed down over the
centuries. These notions often went hand in hand with the view,
already described, that it was possible through science to rediscover
or recreate the lost paradise, the Garden of Eden. Something of the
spirit of this world view is also to be discerned in the garden designs
of the Flemish architect Vredeman de Vries, who lived and worked
for much of his life in Prague at the court of the occult-minded
Emperor Rudolf II.

It is in the light of these ideas that we must understand de Caus's
plan for the Heidelberg garden, as is apparent from the richly symbolic
frontispiece to his book, which I would argue can be interpreted as
follows. The title area is flanked by goat-legged satyrs, a male and a
female, naked save for girdles of leafy tendrils. These surely represent
nature in its primal state of rawness and innocence. Below them, on
a bench are Pallas Athene and Hermes suggesting, respectively,
exoteric wisdom and the esoteric hermetic tradition. Between them
are the five Platonic solids, the basic divine building blocks of creation

according to Plato's *Timaeus*. These are, from left to right: the tetra-
hedron (with four triangular faces), the cube (with six square faces),
the dodecahedron (with 12 pentagonal faces), the icosohedron (with
20 triangular faces), and the octohedron (with eight triangular faces).
Above, held by two cherubs, is a sphere of stars, a reminder of the
notion of 'as above, so below', that is to say everything on earth has
its counterpart in the heavens. Perching at the sides are two more
cherubs, each dangling with one hand a collection of instruments of
science and technology. One cherub also holds a torch of knowledge,
while the other holds a mirror, signifying that the human arts are
merely a reflection of divine creation. The whole image enjoins us to
'read the book of nature' and to discern within it the existence of a
divine order with the aid of science, learning and hermetic wisdom.

In de Caus's world view, divine musical harmonies pervade the
universe, including the spheres of the heavens and the world of nature
around us, although these harmonies are only perceptible to those
with the right knowledge. They are based on divine mathematical
ratios and proportions. Similarly the laws that govern the orbits of
the heavenly bodies and underlie the workings of man-made machines
are also of divine origin and related to the laws of harmony. De Caus's
intention in the garden was to present the visitor with a vision of this
divine order operating within nature, but a nature refined and uplifted
– in a sense, a paradise regained. And, since nature is so diffuse and
multifarious, he used certain standard images from mythology to
illustrate its various aspects. Thus the garden combined music, math-
ematics, geometry, architecture, mechanics and mythological icon-
ography. In a richly detailed analysis of the garden's symbolism,
Richard Patterson has written that 'in the Hortus Palatinus de Caus
was concerned to articulate a path which would reconnect humanity
to Nature in some absolute sense. Reform in a general and compre-
hensive way was to be initiated simultaneously in the individual
through an original and undistorted insight and in the world in the
creation of a rational, measured image of the original garden.'[8]

To visit the Heidelberg garden in its heyday must have been a deeply
transforming experience. When we look at the plans of the garden
today we have to imagine it on two levels: as it actually was, and as
de Caus intended it to be. Among the features that remained un-
realized was a series of waterworks and ingenious mechanical figures
that were to have been placed in a 275-foot-long vault, built into the
hillside. One hydraulic machine was to have produced the three modes

of ancient music, the diatonic, the enharmonic and the chromatic. There was also to have been a satyr or Pan figure playing a flageolet and symbolizing for de Caus the musical voice of nature, 'the passionate, rude and inarticulate origin out of which refined melody might emerge',[9] as well as other fountains with sculptures. The musical theme is continued in the eightfold patterns that appear throughout the garden. For example, along one of the axes there were eight parterres arranged so that the spaces between them are in the sequence AABAABAA, 'that is to say, in the form of a modal scale or an octave of dimensions which complete one harmonic interval'.[10] And the Orange Parterre incorporated the form of an eight-pointed star. Another interesting feature was the Flower Garden, a large oblong rectangle, centring on a fountain with a rocky, wooded mountain in the centre, with water flowing from four sides, evidently an allusion to the paradise mount. The fountain was at the centre of a circle of flower beds divided into four segments to represent the seasons. Other features included a labyrinth (planned but never built) and a hothouse for keeping oranges in the winter – evoking the idea of the eternal spring which the inhabitants of Paradise enjoyed. The Heidelberg garden was therefore a complex visual text, designed to convey its message on many different levels.

A Scottish garden of emblems

A remarkable and very rare example of a late Renaissance garden in Britain is the so-called 'Garden of the Planets' at Edzell Castle in the Scottish county of Angus. Although the castle is a ruin, and the cultivated part of the garden has long since lost its original character, the stone enclosure remains along with some fine emblematic reliefs arranged on three of the walls. The three series of images represent, respectively, the seven planetary deities, the seven liberal arts and the seven cardinal virtues. Standing in this garden one senses strongly its initiatic character, especially when one knows something of its history. At the time when the garden was created, the castle was the home of Sir David Lindsay, Earl of Balcarres (1585–1641), a man steeped in the study of hermeticism, alchemy and Rosicrucianism. Indeed, he appears to have played a key role in transmitting the Rosicrucian current to Britain. The Scottish hermetic scholar Adam McLean has written of Sir David Lindsay: 'He had connections with the Rosicrucians during the early part of the seventeenth century, and

there are still preserved copies in his own hand of his alchemical notebooks, which include a translation of the *Fama Fraternitatis*, the first Rosicrucian Manifesto.' McLean writes of the garden as follows:

> We can find something woven into its symbolic carvings reflecting the atmosphere which permeates the Rosicrucian document, *The Chymical Wedding of Christian Rosenkreuz*, an allegory of initiation, an important part of which is the leading of the candidate before various sculptures and other ritual items which he has to contemplate to absorb their significance. . . So it is my thesis that the Edzell Garden of the Planets should be seen as early seventeenth century Mystery Temple connected with the hermetic revival. A carved plaque over the entrance bears the date 1604 (most likely the year of its foundation). . . Edzell was possibly a place of instruction in hermetic and alchemical philosophy and may have been a centre of Rosicrucian activity.[11]

There is also a possible Rosicrucian significance to the date 1604, for that was the year of the opening of Christian Rosenkreuz's tomb according to the account in the *Fama Fraternitatis*.

7

THEATRES OF TRANSFORMATION: SYMBOLISM IN BAROQUE AND ROCOCO GARDENS

Whereas the classic Renaissance garden is compartmental, rich in detail, and can achieve its effect just as easily in a small courtyard as in a large park, the Baroque garden leans towards grand visual rhetoric, dramatic vistas and generous perspectives. Dating roughly from the early seventeenth to the early eighteenth century, this style encompasses many variations. While it took on a particularly grandiose form in France, striking examples of it are also found in Germany, Austria, Spain, Portugal and elsewhere. The Rococo style, which followed it and lasted up to about 1800, is lighter, gayer and more sensual. Within both styles there are many examples of the use of sacred, symbolic and mythical motifs.

Versailles: *splendor solis*

I have always felt ambivalent about Versailles. It smacks of *folie de grandeur*, and yet in its own way it is magnificent. From the palace with its Hall of Mirrors, its ponderous chandeliers and its acres of murals, tapestries and gold leaf, you pass into the gardens via a terrace along the west front from which you can look down the main axis, a great avenue with serried ranks of classical gods in white marble, and beyond it a canal stretching away almost to the horizon. In the foreground is the Fountain of Latona, mother of Apollo, and at the end of the avenue, forming the focal point of the garden, is the Fountain

of Apollo himself, a gold figure in a gold chariot emerging out of the waters at dawn.

This garden, created in its essentials between 1662 and the late 1680s, is chiefly the work of the great garden architect André Le Nôtre. It is a representation of a divinely sanctioned order presided over by the Sun god Apollo, just as the court and country were presided over by Louis XIV, the 'Sun King'. Here nature is dominated by art, just as the King's subjects were dominated by his rule. One might expect the effect to be oppressive, but it is not. Such was the genius of Le Nôtre that the garden still moves us with its grandeur. And there is not only grandeur here but also rich symbolism where, once again, we find the influence of Ovid's *Metamorphoses*.

In his comprehensive study *Versailles: the History of the Gardens and their Sculpture*,[1] Stéphane Pincas divides the history of the gardens into three phases.

Drawing upon the Italian humanist tradition, it has been suggested, the gardens of Versailles could be interpreted as a sort of initiatory journey leading to self-knowledge. The visitor assumed the identity of the equestrian figure of the king at the entrance to the Bassin de Neptune, who revealed to him the mystery of the origin of life, and he then went on to overcome the forces of his own unconscious at the Bassin du Dragon. Led through the stages of the formation of the universe at the Allée d'Eau, the visitor was accorded a new birth at the Bains des Nymphes de Diane, and eventually entered into communication with the world at the Bassin de la Pyramide. His walk finally led him to the Orangerie, image of the Garden of the Hesperides and representation of paradise.[2]

The Bassin de Neptune, where the above itinerary begins, is the largest basin in the park, a semi-circular lake dominated by figures of Neptune, his wife Amphitrite, his son Proteus, and cupids riding sea-dragons. Immediately above it is the much smaller Bassin du Dragon, with a fearsome, bat-winged dragon rearing up and spouting a vertical jet of water. From here the route leads up along the Allée d'Eau, with a charming series of small fountains supported by groups of cherub-like figures. According to Pincas, these 'illustrate the evolution of matter: from mineral to vegetable, then from the marine world to the animal and human kingdoms'.[3] More aquatic motifs await the visitor

at the Bassin des Nymphes de Diane, where a stone relief of the
nymphs is veiled by a waterfall, and at the Bassin de la Pyramide,
where the 'pyramid' is actually a four-tiered fountain graced by
tritons, shellfish and dolphins.

In the second phase of the garden's history, the intention was to
convey an impression of regal power and magnificence, and the
initiatory journey was turned 'into an elegant stroll, entirely dedicated
to the glory of Louis XIV'.[4] The third phase ensued after the Sun
King's death, when the lighter and more purely decorative Rococo
style took over. The first two phases merge into each other, and
perhaps one should not try too hard to distinguish them but rather
let the gardens speak to us as an entirety.

The solar motif, which is the key to the whole complex, begins with
the palace itself, which was intended to be compared with the palace
of the Sun as described in the *Metamorphoses*. There Ovid recounts
how Phaeton, son of Apollo and Clymene, goes to the palace to seek
confirmation that the Sun god is his father.

> The sun, dressed in a purple robe, was sitting on a throne bright
> with shining emeralds. On his right hand and on his left stood
> Day, Month, Year, the Generations and the Hours, all ranged at
> equal intervals. Young spring was there, his head encircled with
> a flowery garland, and summer, lightly clad, crowned with a
> wreath of corn ears; autumn too, stained purple with treading
> out the vintage; and icy winter, with white and shaggy locks.[5]

This description is echoed in the carvings of the keystones above the
windows on the east front of the palace. As you progress along the
front, from south to north, the faces become progressively older, repre-
senting the life cycle of the year.

Louis XIV himself was the author of a brief guide to the gardens –
about ten pages in length – of which he wrote six different versions
between 1689 and 1705.[6] He recommends beginning at the obvious
point, by the west front of the palace, pausing to take in the view
towards the Fountain of Apollo, turning to look at the palace, then
going south to visit the Orangery with its parterre and the large
artificial lake beyond it called the Lac des Suisses. From there he
guides the visitor through a labyrinth, now vanished, which was
decorated with fountains and sculptures illustrating morally instruc-
tive scenes from La Fontaine's *Fables*. Emerging from the labyrinth,

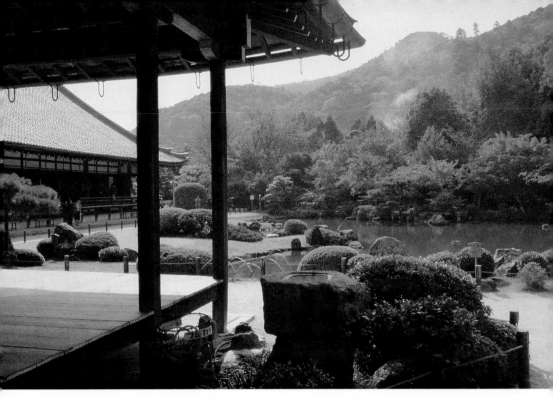

1. The garden of the Tenryu-ji Zen Buddhist temple, Kyoto, Japan. The appearance of natural and effortless harmony is in fact carefully contrived

2. Sand garden at the Ryoan-ji temple, Kyoto, one of the finest examples of the genre. It consists essentially of an area of pale sand carefully raked into a pattern of parallel lines, the surface broken only by 15 carefully placed stones

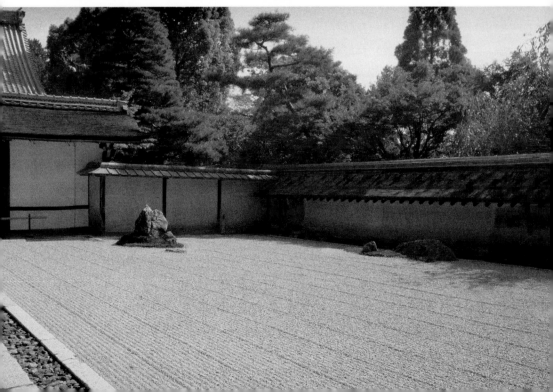

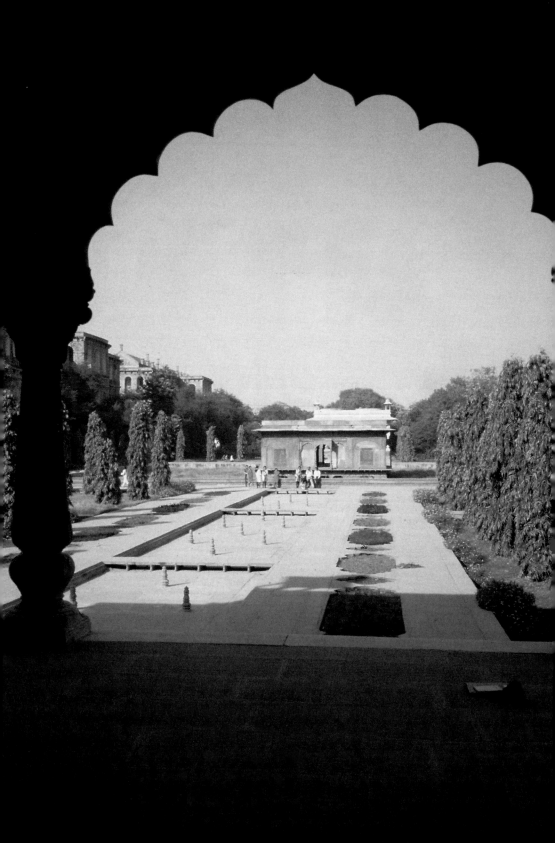

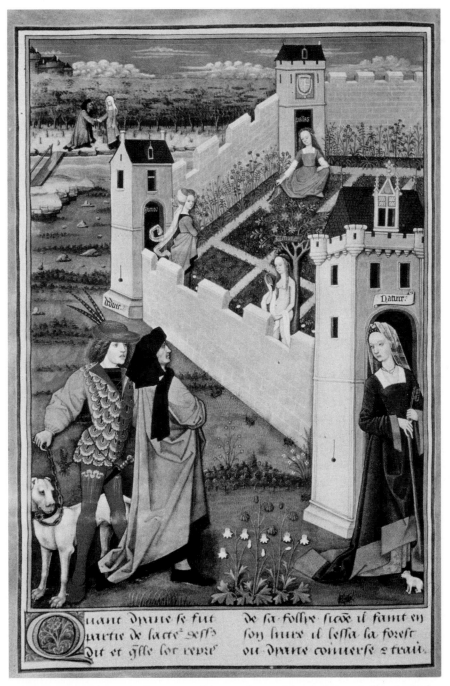

Within the image, inscribed labels include:

Juno (on the tower), **nobilia**, **Natur.**, **adult.**



Quant Opinie se fuit
Quertir de lacte selss
Oit et gsse lor repos'

De sa folsie siage il faint en
son hure il lessa la foresf
ou Opinie couuerse e trait.

3. *Opposite:* Looking out from one of the pavilions of the Red Fort garden, Delhi

4. *Above:* Image from a French sixteenth-century manuscript evidently illustrating the story of the Judgement of Paris and showing an enclosed garden in the medieval style

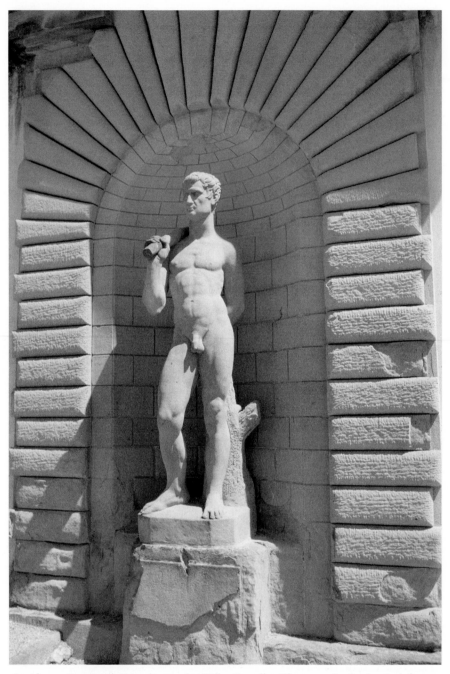

5. *Above:* Statue of Hercules at the Villa Castello, Florence. Such classical figures represented qualities worthy of emulation

6. *Opposite:* The Fountain of Oceanus in the Boboli garden, Florence. Oceanus was the god of the primal river that was said to have once encircled the earth

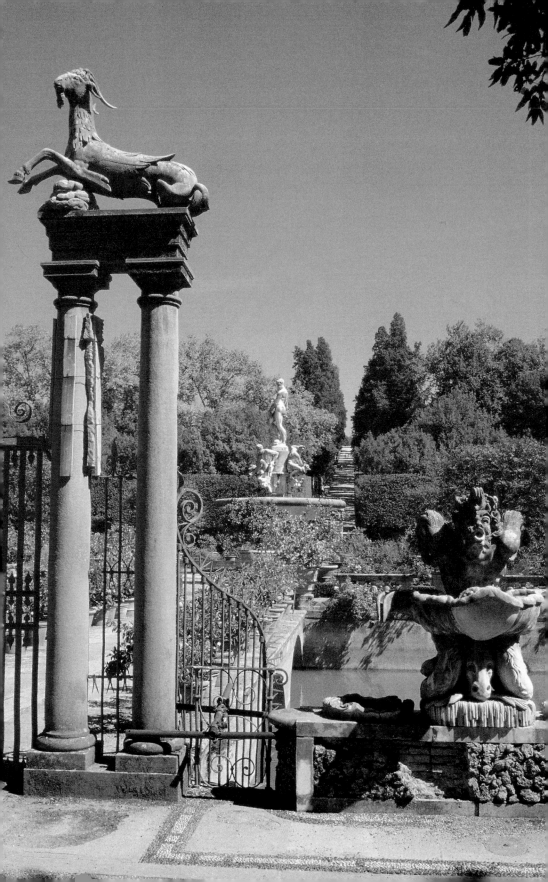

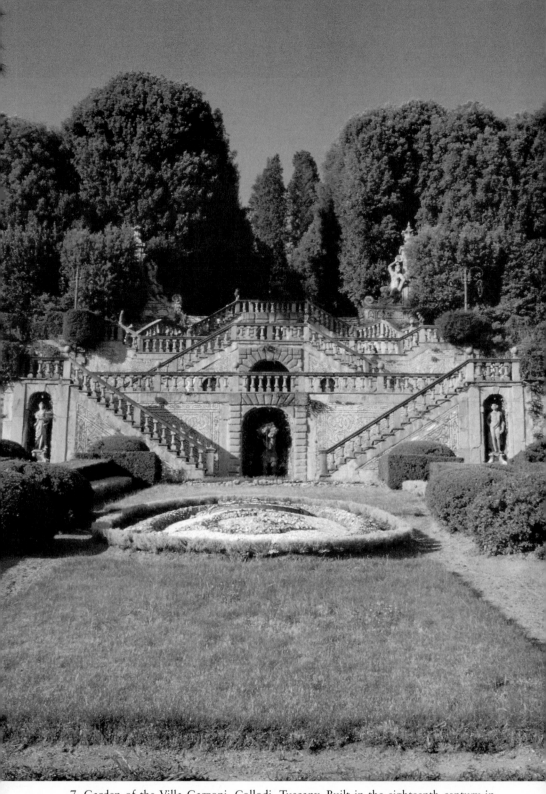

7. Garden of the Villa Garzoni, Collodi, Tuscany. Built in the eighteenth century in Renaissance style, it leads the visitor through a series of carefully chosen images

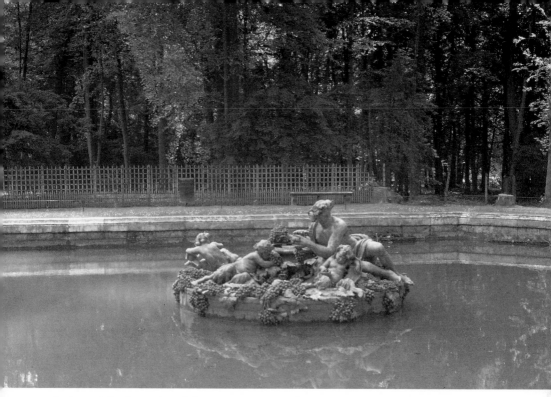

8. One of the fountains of the seasons at Versailles: Autumn

9. The Gothic Temple at Stowe, Buckinghamshire, England. Created by Viscount Cobham in the eighteenth century, the garden is a grand political and philosophical statement

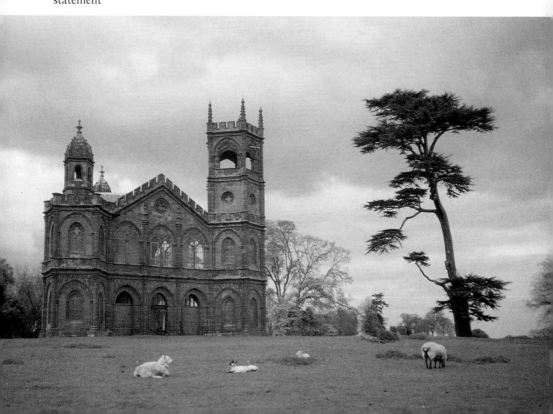

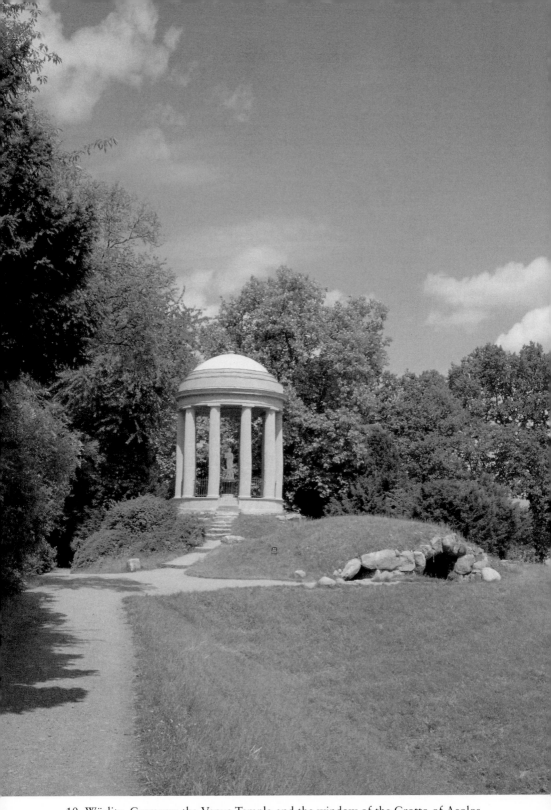

10. Wörlitz, Germany: the Venus Temple and the window of the Grotto of Aeolos

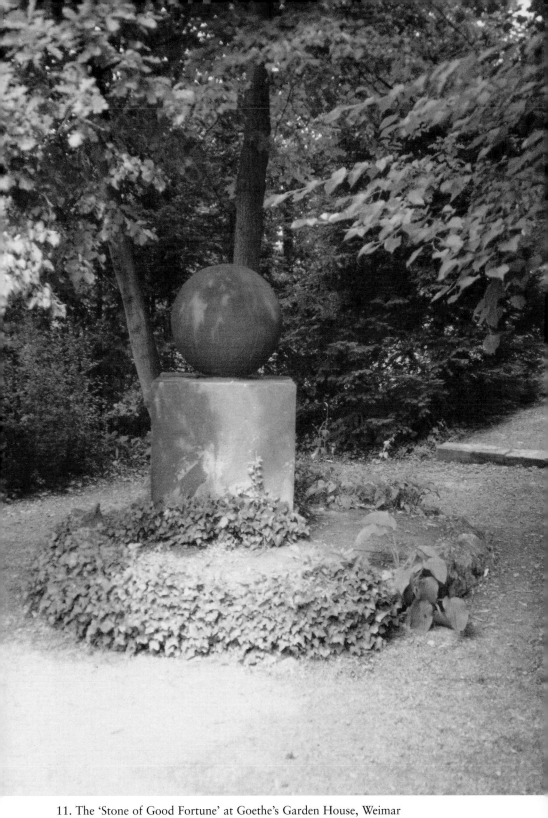

11. The 'Stone of Good Fortune' at Goethe's Garden House, Weimar

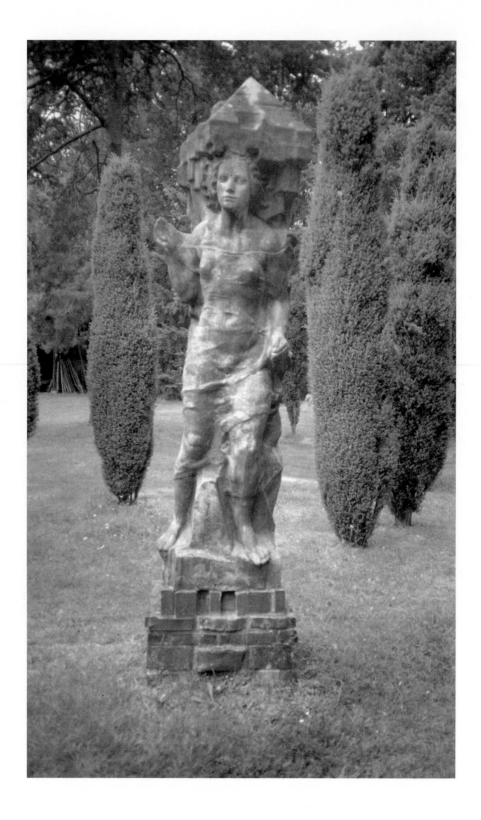

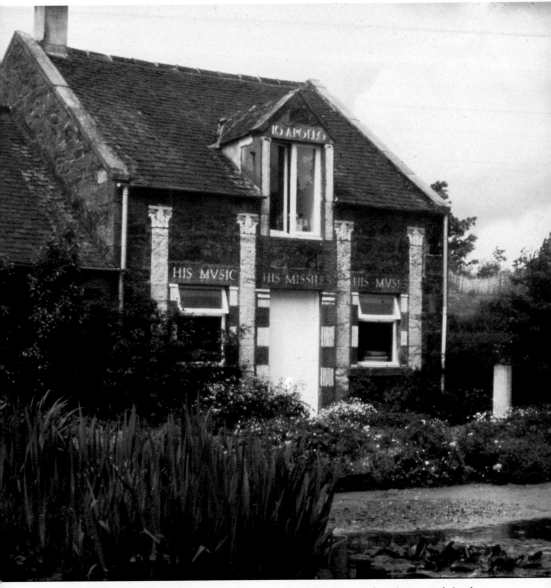

12. *Opposite:* Allegorical figure of Spring, one of a group of sculptures of the four seasons in the garden of the Bossard Temple, Lüneburg Heath, Germany

13. *Above:* Little Sparta, the garden in Lanarkshire, Scotland, created by the poet and artist Ian Hamilton Finlay: view across the pond to the Apollo Temple

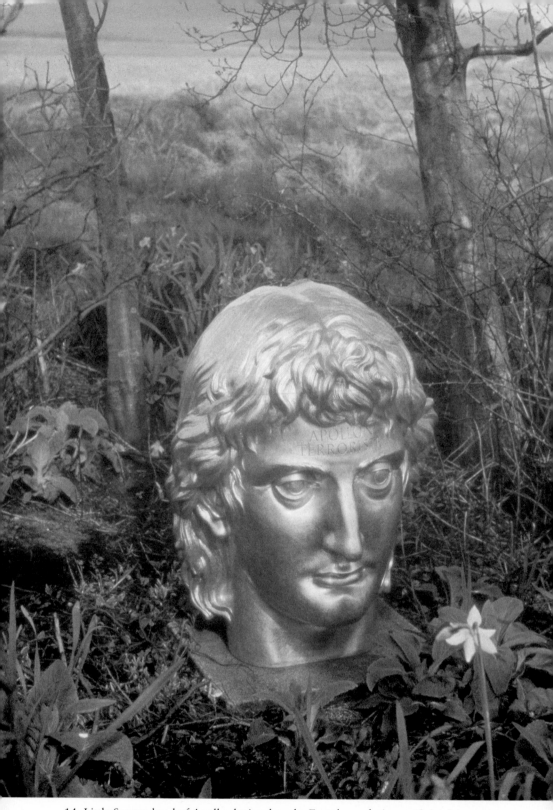

14. Little Sparta: head of Apollo depicted as the French revolutionary Saint Just

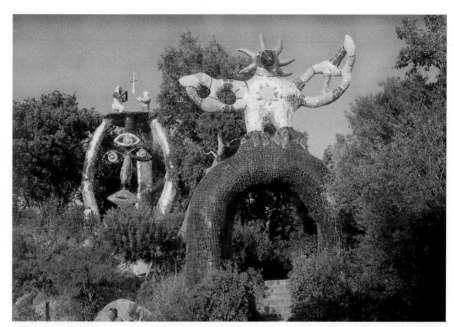

15. The garden in Tuscany with images from the Tarot trumps, created by the French artist Niki de Saint Phalle. Shown here are the images of the Sun (foreground) and the Hierophant

16. Dumbarton Oaks, Washington DC: the Star Garden

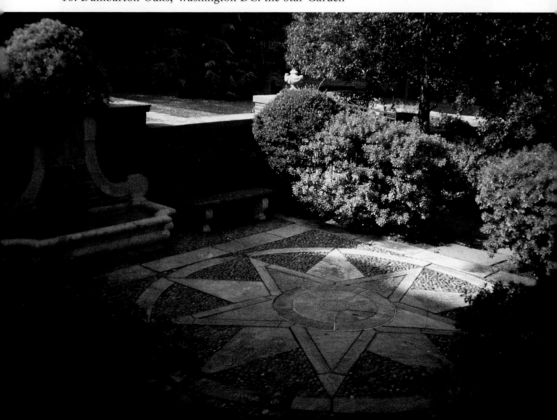

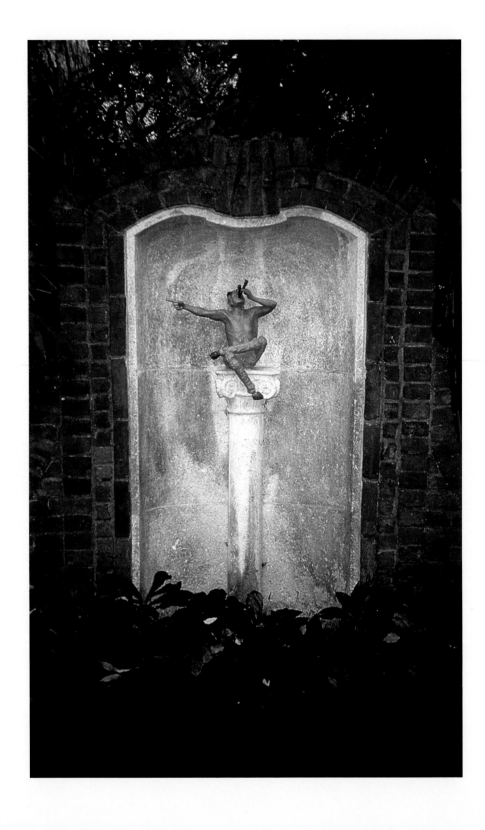

17. *Opposite:* A figure of Pan points the way in the Dumbarton Oaks garden

18. *Above:* Renaissance garden designed in the 1990s by Neill Clark at a teachers' study centre in Cullowhee, North Carolina, USA. The gazebo has a cross of Lorraine and a motto from the *Hypnerotomachia* (*photo by Connie Hanna*)

19. Paving at the entrance to the Cullowhee garden. The motto *le temps revient* (time returns) is that of the Renaissance luminary Lorenzo de Medici; the figure eight signifies eternity (*Connie Hanna*)

20. A fish-eye view of The Hide, Ohio, USA: a drawing by Jan Heynike, who created the garden with his son Charl in the late 1990s

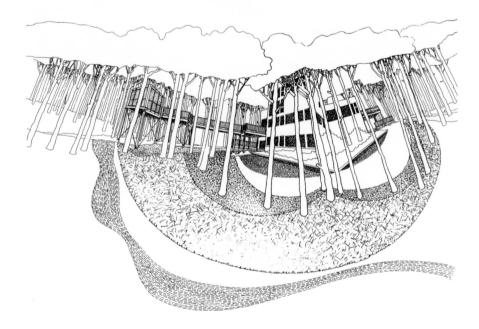

the visitor is then brought back to the main axis of the garden to continue the tour. This route is different from the initiatic one described by Pincas. Be that as it may, Louis XIV clearly intended the message of the garden to unfold in a carefully planned sequence of images and vistas, although his text is frustratingly short on detail and any clues as to the symbolic meaning of the garden's features.

The pair of winged bronze cherubs or cupids mounted on marble sphinxes on two piers of a wall, located on the Parterre du Midi close to the south front of the palace, were the very first pieces of sculpture designed for the gardens, and they were clearly not placed there merely for decoration. Stéphane Pincas interprets them as follows:

> The groups represent religious revelation and philosophical enquiry, indicating that knowledge of the divine is achieved through knowledge of nature. The cupid on the eastern pier points to the ground signifying *hinc et nunc* (here and now): only the present moment is real. The cupid on the western pier holds his hand open, palm downward, in a gesture signifying *festina lente* (make haste slowly): only a combination of impulse and reflection will lead to knowledge.[7]

Attractive though this interpretation is, the cupids and the sphinxes retain for me an enigmatic quality. Other motifs in the garden would have been so familiar to any educated person of the time that they would have required no explanation. The Fountain of Latona, for example, illustrates Ovid's account of how Apollo's mother, during a journey through Lycia, became thirsty and asked the peasants to allow her to drink from a lake. When they refused she punished them by turning them into frogs. The statuary decorating the fountain shows this event, with most of the peasants already turned into frogs, but some still partially human. The Fountain of Apollo itself would also have needed no explanation, nor would the throng of marble statues of gods and goddesses surrounding it – Pan, Bacchus, Flora, Zeus and others – paying homage to the Sun god just as the courtiers at Versailles paid homage to the Sun King.

The solar motif is continued by the fountains of the four seasons, located in the woody areas on either side of the main avenue: the Fountain of Spring with playful cherubs representing the rebirth of nature; the Fountain of Summer with a Flora-like figure and garlands of flowers; the Fountain of Autumn with more cherubs, an autumnal

goddess and bunches of grapes; and the Fountain of Winter with an aged Father Time figure and cherubs dozing off to sleep.

Distinctly more earthy and elemental in emphasis is a fountain located in a secluded clearing to the north of the avenue leading to the Fountain of Apollo. It shows a figure of a giant desperately struggling up out of a mass of lava. This represents Enceladus, one of the Titans who warred against the gods and was so strong that he had to be buried beneath Mount Etna in order to subdue him. The image is perhaps intended as a warning to those who would rebel against the divine or the monarchical order.

While the central message of Versailles is clear, its deeper levels of meaning remain a matter of speculation. Emanuela Kretzulesco sees in many of its features the influence of the *Hypnerotomachia* or *Dream of Poliphilus* (discussed in Chapter 4). 'Louis XIV', she writes, 'must have known about *Poliphilus*, as his mentor Mazarin possessed not only the French editions of Jacques Kerver, dating from 1546, but also copies of the two printings of the original Venetian edition. . . Thus we find, in the park of Versailles, the principal elements of the *Dream of Poliphilus*.'[8] Kretzulesco goes even further than this, suggesting that the palace and the gardens whisper of Pythagorean mysteries and a tradition of divine monarchy reaching back to ancient Egypt. 'The King's Chamber', she writes, 'is at the heart of the palace of Versailles, as it is at the heart of the Great Pyramid of Egypt.'[9] She finds evidence to support her thesis in various images in the garden, such as the sphinxes (specifically mentioned in the King's guide) with their bronze cherubs (perhaps representing ancient wisdom and initiatic rebirth), as well as a figure of Melancholy, one of a series of the four temperaments, in which the left knee is bared in the style of an initiate of the Pythagorean brotherhood. She also draws attention to the frontispiece of Mme de Scudéry's book *La Promenade de Versailles* (published in 1669) which shows a winged genius reclining against a wall in the gardens, his right index finger pointing to his lips in the sign of silence and secrecy. Her claims may be true, but we should perhaps heed the sign of the winged genius and not try to make Versailles yield up its most intimate secrets.

Gardens with a Christian message

So far we have paid little attention to gardens containing an overtly Christian message, so it is perhaps time to mention a few. First, a

glance at a delightful design that was possibly never built: the Little Paradise Garden of Joseph Furttenbach, an architect and garden designer of the first half of the seventeenth century. Born in the German city of Ulm, Furttenbach trained there as an architect, spent ten years in Italy and returned eager to work for the good of his native city. The Little Paradise Garden was part of a design for a school. The garden, as Furttenbach wrote, was to 'awaken good thoughts in the children' and to encourage them 'as they walked in Paradise, to practise their Christianity as well as other good, useful and worthy activities'.[10] The enclosure was square, with four entrances and four main paths forming a cross (no doubt alluding to the Christian symbol but also possibly to the classic paradise garden pattern), at the centre of which was a pavilion where the children were to take their examinations. The four sections of the garden between the arms of the cross were planted with flowers and fruit trees and were divided into four sub-sections by tunnel arbours with a fountain at each intersection, thus creating four smaller paradise gardens. Images in the garden included Adam and Eve, with an inscription in stone reminding the children of the Fall, and a statue of Jesus Christ, with another inscription heralding him as the Redeemer.[11]

Although falling within the Baroque period, Furttenbach's garden is really a late Renaissance design – and in fact it is strikingly similar to the paradise garden at the Villa d'Este, mentioned in Chapter 5. More Baroque in style, but dating from the eighteenth century, is the garden of the church of Bom Jesus do Monte in northern Portugal. The church, with its twin bell towers and classical portico, stands at the top of a hill, and the way up was clearly intended to be seen as a kind of pilgrimage route. The visitor passes first along a wooded path with chapels illustrating the Stations of the Cross, emerging at the foot of a dramatic stairway leading up to the church and lined on either side by terraced flower beds and dense banks of trees and flowering shrubs. The symbolism is equally dense. The pillars flanking the foot of the stairway have serpents twined around them in a spiral pattern (an allusion to the serpent in the Garden of Eden, or perhaps an alchemical motif?). The stair proceeds upwards in a zig-zag pattern through a series of seven terraces, each with a fountain. The first five fountains have stone reliefs of human figures representing the five senses, each sense being indicated by the place from which the water flows – the eyes for sight, the ears for hearing, etc. Then comes a fountain with a pair of young children. Of this motif, Cirlot writes:

> Psychologically speaking, the child is of the soul, the product of the *coniunctio* between the unconscious and consciousness: one dreams of a child when some great spiritual change is about to take place under favourable circumstances. . . In alchemy, the child wearing a crown or regal garments is a symbol of the philosopher's stone, that is, of the supreme realization of mystic identification with the 'god within us' and with the eternal.[12]

According to another source:

> Childhood symbolizes innocence, which is the state anterior to Original Sin and hence a paradisical state.[13]

Finally at the very top comes a fountain with a pelican biting its breast, a symbol of Christ but also of the alchemical process of distillation, which takes place in a pelican-shaped flask.

The seven terraces with their fountains, through which the visitor progresses on his way up to the church, are reminiscent of the seven spheres through which, in certain cosmologies, the soul was believed to descend to birth and reascend to heaven. They also remind us of the terraces found in Islamic gardens, corresponding to the divisions of the Islamic heaven. Indeed, perhaps we can tentatively discern a distant Islamic echo here, bearing in mind the long Arab occupation of the Iberian Peninsula. The overall message is perhaps that, as one ascends the stairway one transcends the physical senses and experiences a spiritual rebirth (represented by the children) in Christ (symbolized by the pelican).

Equally Christian in its message is the landscape created in the second and third decades of the eighteenth century by Count von Sporck, a devout Catholic with mystical leanings, in the forest of Neuwald in Bohemia. He named the area Bethlehem. Here he began by setting up three hermitages, dedicated to St Paul, St Anthony and St Bruno, and installing real hermits in them. After a short time the hermits were accused of heresy by the local ecclesiastical authorities and Sporck was forced to sack them, but he proceeded undaunted with his religious landscape: 'In the 1720s he commissioned a sculptor, Matthias Braun, to carve the numerous outcrops in the forest with the figures of saints and penitents. . . most of the sculptures, which are of large and even gigantic proportions, still lurk in the thickets of Neuwald.'[14]

Magic island: Sanspareil, Bavaria

A couple of decades after the creation of Sporck's Bethlehem, a similarly rocky and wooded area near Bayreuth in Bavaria was converted into a symbolic landscape of a different kind. Named Sanspareil, it was created in the 1740s by the Margravine Wilhelmine von Bayreuth, sister of Frederick the Great of Prussia. The cliffs, caves and grottoes of the forest were transformed into a series of tableaux illustrating the story of Telemachus, the hero of the educational novel *Les Aventures de Télémaque* by the French seventeenth-century writer and cleric, Fénélon. Christopher Thacker writes: 'In the history of gardens it is a most unusual development, comparable only with the activities in England of Henry Hoare at Stourhead and William Shenstone at the Leasowes, at roughly the same time, each imagining that the landscape might "resemble an epic poem".'[15]

In Homer's *Odyssey*, Telemachus is the son of Odysseus. Fénélon focuses on the episode on the magic island of Ogygia, where Odysseus was shipwrecked and spent seven years. He takes the story further than Homer by describing how Telemachus goes in search of his father and is stranded on this same island, accompanied by his wise fellow traveller Mentor, who is really the goddess Pallas Athene in disguise. On the island they receive a friendly welcome from the nymph Calypso, who falls in love with Telemachus, as she had with his father, and tries every means to keep him on the island. Under the influence of Mentor, he repels all her temptations and finally, when no other means of escape seem possible, he and Mentor leap off a cliff into the sea and swim to a ship that lies becalmed off shore.

This story, as well as some earlier episodes from Telemachus' life, are illustrated by the various features in the park. There are grottoes of Calypso, Mentor and Diana, a Vulcan's Cave, a Seat of Pan, a Temple of Aeolos and – as the *pièce de résistance* – a 'Ruined' Theatre with the stage framed by massive arches of rough stone. This was the scene of performances elaborating the story told by the garden as a whole.

8

VISIONS OF A NEW ELYSIUM: SYMBOLISM AND ALLEGORY IN GARDENS OF THE EIGHTEENTH CENTURY

Among English gardens we will look in vain for the equivalent of Bomarzo, Collodi or the Villa d'Este. One of the few remnants in Britain of the Renaissance emblematic type of garden is that of the walled Garden of the Planets at Edzell Castle in Scotland, already described. Although a number of similar gardens were created in Britain,[1] they later gave way to the style of landscaping that we now think of as typical of the English country house, with its sweeping lawns, ha-has and generous vistas, a style which became firmly established during the eighteenth century and was typified by the work of Lancelot 'Capability' Brown (1716–83). However, this style did not preclude the use of the garden to convey a message. On the contrary, there are a number of examples of English gardens of the period that use architecture, sculpture, iconography and landscape features to construct a rich fabric of meaning, which is often closely bound up with the philosophical, cultural and political movements of the age. While this subject has been covered many time in more general histories of gardening, it is worth mentioning briefly at this point some of the main currents that fed into English eighteenth-century gardening, resulting in one of the most fascinating and creative periods in garden history.

A highly seminal figure early in the century was, significantly, not a garden architect but a philosopher and writer, Anthony Ashley

Cooper, Third Earl of Shaftesbury (1671–1713). Shaftesbury was one of the early advocates of the new reverence for nature that was a key feature of the Enlightenment. Repeatedly in his writings he drew a contrast between that which was natural, free and unspoiled and that which was artificial, constrained and ordered by human hand. These ideas were echoed by the essayist Joseph Addison. He railed, for example, against the art of topiary because it took away all the pleas-ant irregularities of a tree and substituted geometrical forms. At the same time Addison did not advocate a complete surrender to nature but rather a judicious and harmonious application of human art. Another who thought similarly was the poet Alexander Pope (1688–1744). In one of his poems he wrote:

> In all, let Nature never be forgot.
> But treat the Goddess like a modest fair,
> Nor over-dress, nor leave her wholly bare;
> Let not each beauty ev'rywhere be spy'd,
> Where half the skill is decently to hide.[2]

Pope himself created a famous garden at his Twickenham home, featuring a tunnel-grotto under the road that separated the garden from the house, a temple decorated with shells, and a memorial to his mother in the form of an obelisk set among cypress trees.

The polarity between nature and artifice was paralleled by other polarities to which attention was often drawn – between the informal and the formal, liberty and tyranny, the Gothic and the classical. Thus the ultra-formal gardens of Versailles, with their parterres, topiary and geometrical plan, were seen as what they in fact were – an expression of an autocratic world view. To find alternatives, English garden architects and their patrons looked partly to the romanticized images of Arcadian landscapes typified by the French painter Claude Lorrain (1600–82), partly to an earlier and more harmonious period of Italian garden architecture and partly to notions of a 'Gothic' world, organic, close to nature and full of moodiness and feeling. Gardens began to be filled with follies and artificial ruins – sometimes Gothic, sometimes classical – and were re-shaped to create rugged or dramatic features rivalling the wild landscapes that were now admired, whereas before they had often been shunned as rude and primitive.

This new fondness for ruggedness owed much to the writings of the philosopher and politician Edmund Burke, who developed the

theory that there are two kinds of beauty: one which delights us with harmony, lightness and pleasing proportion, the other which stirs us to awe with images that are looming, excessive, primeval, violent. Using a term already familiar to the age, he named the latter kind of beauty 'sublime'. His ideas overlapped with those of Sir William Chambers, who had travelled in China and whose writings contributed to a growing interest in Chinese gardens. Echoing Burke's concept of the sublime, he wrote admiringly of the 'terrifying' prospects that could be found in Chinese gardens.

The fashion for such landscapes, for Gothic follies and romantic ruins reached its apogee in the figure of William Beckford (1760–1844), an eccentric man of enormous inherited wealth who also wrote Gothic fiction. On his estate at Fonthill in Wiltshire he built himself a Gothic house, Fonthill Abbey, with the tallest spire in England, and filled the grounds with artificial lakes, caves, grottoes, hermitages and imitation prehistoric remains. The whole creation was a folly to end all follies – in more senses than one. Beckford exhausted his fortune and sold up, leaving Fonthill Abbey to fall into ruin. Other English eighteenth-century gardens, less extravagant but equally interesting, have remained to delight us with their beauty and layers of meaning.

Stowe: a celebration of the Gothic and the classical

A classic example of an English garden with meaning is that of Stowe in the county of Buckinghamshire. The approach to it already holds a promise of magic. A long avenue points, arrow-straight, towards a triumphal arch, open to the sky on a distant rise, hinting at some still invisible Shangri La beyond it. The road dips down into a valley, and the arch disappears, only to reappear framing a view of the main house, now the home of a famous public school. One is about to enter another world – a world embodying the ideals, dreams and fantasies of a brilliant English aristocrat, Richard Temple, Viscount Cobham (1677–1749), a leading member of the Whig establishment. Stowe, administered by the National Trust, is both an outstanding English landscape garden of the Enlightenment period and one of the most impressive examples of a garden that conveys meaning on a grand scale. Lord Cobham made the garden his life's task. Working with architects like William Kent and landscape designers like Capability Brown, he landscaped 205 acres, built over three dozen temples, created eight lakes or ponds and filled the garden with innumerable

statues, inscriptions and other features. Areas of the garden were given names such as the Elysian Fields and the Grecian Vale. Everything was linked by an overall vision.[3] The guide book to the garden explains how the idea for it originated in a dream (corresponding features at Stowe are indicated in brackets):

> The origin of the new garden was almost certainly an essay by Joseph Addison in the *Tatler* (No. 123, 21 January 1710), describing an allegorical dream. After falling asleep, Addison relates that he found himself in a huge wood, which had many paths and was full of people. He joined a group of middle-aged men marching 'behind the standard of ambition', and describes the route he took and the buildings he saw. The essential features of the Elysian Fields are all there: a long straight path (the Great Cross Walk at Stowe) was terminated by a temple of virtue (Ancient Virtue), beyond which (over the river) lay a temple of honour (British Worthies); nearby was a ruinous temple of vanity (Modern Virtue). The classes of people mentioned in the dream, and the effigies too, correspond to the statues actually set up in the gardens.[4]

The design of the garden was linked with an ideal Whig vision of government. Cobham had become an opponent of the Whig prime minister, Sir Robert Walpole, and of the monarch, George II. He had joined a splinter group of Whigs who called themselves the Patriots and admired the Prince of Wales, Frederick, who had quarrelled with his father and set up an independent court. Cobham and the Patriots upheld a vision of democratic, uncorrupted government, rooted in a robust, Anglo-Saxon tradition of liberty and defiance of tyranny. The iconography and symbolism in the garden have to be seen in this context.

Thus, the Temple of Ancient Virtue, a domed rotunda set at the edge of the Elysian Fields, evokes ancient Greece rather than Rome, as the latter was made analogous to French and Stuart despotism. Statues in the temple include Homer, Socrates and Lycurgus, who was said to have established at Sparta the balanced constitutional monarchy that the eighteenth-century Whigs admired. Similar messages can be found in the Temple of British Worthies, a crescent-shaped monument facing the Elysian Fields across a stretch of water, with 16 busts in niches. Here we find the philosopher John Locke, admired by the

Whigs for his writings on government, King Alfred who, according to the inscription 'crush'd corruption, guarded liberty and was the founder of the English constitution' and thus represented everything that George II was not. Also included is Edward, the medieval 'Black Prince', intended as an encoded image of Frederick, Prince of Wales, who made a well-publicized visit to Stowe in 1737, thus underlining the political message of the place. The monument is surmounted by a stepped pyramid with an oval niche, in which originally stood a now vanished marble bust of Mercury or Hermes, in his role as psycho-pomp, conductor of the souls of chosen mortals across the river Styx. Possibly the bust was also intended to denote hermetic wisdom, and the pyramid seems to suggest the origins of Hermes in Hellenistic Egypt.

A particularly imposing monument in the garden is the Gothic Temple, a triangular building standing on its own on a high point of the garden. To Cobham's circle 'Gothic' was a broad concept denoting the Germanic peoples, whose vigour and love of liberty were said to have been brought over to Britain by the Saxon invaders. Their way of life was contrasted with the servility of the Latin peoples and the decadence and tyranny of their rulers. To emphasize the point, Cobham had inscribed over the entrance a quotation from Corneille's play *Horace*, in which one of the characters declares: 'Je rends grace aux Dieux de n'estre pas Romain' (I thank the Gods that I am not a Roman). Furthermore, the building was surrounded by seven statues (no longer there), sculpted by Rysbrack and depicting the 'seven Saxon Deities' corresponding to the days of the week: Sunna, Mona, Tiw, Woden, Thuner, Friga and Seatern (the first and last being attempts at Saxon versions of the Sun and Saturn). Each one stood by a yew tree.

Many of the other monuments, however, distinctly evoke the world of classical Greece and Rome – notably the splendid Temple of Concord and Victory, celebrating British military glory, and the Temple of Venus, which pays homage to the goddess of love but at the same time cautions against worshipping her too fervently (the decoration includes busts of the debauched Roman emperors Nero and Vespasian and the adulteresses Cleopatra and Faustina).[5] Other features in the garden include a Temple of Friendship, a Chinese House, a grotto, a hermitage, Dido's Cave (alluding to Virgil's *Aeneid*), the Palladian Bridge and monuments to various individuals associated with Lord Cobham.

Although other hands have also shaped the garden at Stowe, it chiefly breathes the spirit of Viscount Cobham, and we can still share the sentiments of Cobham's friend the poet Alexander Pope, who wrote to him: 'If anything under Paradise could set me beyond all Earthly Cogitations; Stowe might do it.'[6]

Stourhead: evocation of a hero's journey

In the 1740s, as Lord Cobham was nearing the end of his life, another remarkable garden was being created at Stourhead in Wiltshire, in the south-west of England. This time the creator was not an aristocrat but a banker, Henry Hoare II (1705–85), who had not only a flair for making money but also a classical education and a refined aesthetic sense nourished by a sojourn in Italy. In 1741 he inherited Stourhead with its Palladian house and surrounding estate, and in 1743, after the death of his second wife, he began a bold programme of building and landscaping. This involved damming the head of the river Stour to create an artificial lake, around which he built a series of temples and other features, connected by meandering, undulating paths. The *Leitmotif* of the garden was provided by Virgil's narrative poem, the *Aeneid*. This tells of the Trojan hero Aeneas who, after the fall of Troy, made a long voyage around the Mediterranean by way of Carthage, finally landing in Italy where he eventually, according to the story, became the founder of Rome. Aeneas' journey is reproduced allegorically in the garden, mingled with other motifs from classical mythology.

If one progresses anti-clockwise around the lake, the theme of Aeneas' journey is introduced at an early stage by an inscription on the portico of a small building known as the Temple of Flora. The inscription reads: 'Procul, o procul este profani' (Begone from here, you profane ones, begone!). These are the words spoken to Aeneas by a Cumaean oracle before she leads him into the Underworld where the future history of Rome is revealed to him. It may seem strange that the inscription is placed on the Temple of Flora rather than on the entrance to a cave or grotto. Nevertheless, the significance of the quotation seems clear. It is both a way of introducing the theme of Aeneas' journey and a reminder to the visitor that he or she should proceed in a spirit of reverence.

Further along the path leading around the lake one comes to a grotto containing a figure of a sleeping nymph, a copy of a famous

statue in the Belvedere Garden of the Vatican, alluding to the cave of the nymphs at the spot where Aeneas lands in North Africa. In another part of the grotto is a statue depicting the god of the river Tiber, pouring water from an urn. This illustrates a scene in Virgil's story where Father Tiber appears to Aeneas, prophesying his victory and telling him to make an alliance with the Arcadians. The statue points towards another building in the garden known as the Pantheon, formerly called the Temple of Hercules. Here again there is a direct connection to Virgil's text, which describes how Aeneas follows Tiber's advice and seeks out the Arcadian king whom he finds engaged in rites of worship at an altar dedicated to Hercules. Further confirmation of the didactic intention of these features comes in a letter from Henry Hoare to his daughter, where he writes: 'I have made the passage up from the Sousterrain serpentine and will make it easier of access facilis descensus Averno.' Here he echoes the words of the oracle: 'Light is the descent into Avernus, but to recall thy step and issue to the upper air, there is the toil and there the task.'[7]

9

THE SYMBOL-STREWN LANDSCAPE: INITIATIC THEMES IN EUROPEAN GARDENS OF THE EIGHTEENTH, NINETEENTH AND EARLY TWENTIETH CENTURIES

An orangery in Postdam built to look like an Egyptian temple; a serpent curled around a pillar near Goethe's Garden House in Weimar; Osiris peering from the foliage of a Florentine garden; sphinxes guarding the approaches to terraces; pentagrams set into paving stones, pyramids, labyrinths, obelisks and more obelisks – are these mere follies and antiquarian whimsies, or do they hold a deeper meaning? We are in the era when the English style of gardening spread to the continent of Europe along with another phenomenon of British origin, namely Freemasonry. Although its origins have never been precisely determined, Freemasonry is believed to have emerged out of the medieval stonemasons' guilds, eventually losing its connection with practical stonemasonry and turning into an ethical and philosophical system based on the symbolism of architecture and building. The landmark date in its early history is 1717 when the first Grand Lodge (governing body) was established in London. From England, Freemasonry spread rapidly to France and then all over continental Europe. For some people it was associated with Enlightenment ideas of egalitarianism and democracy. For others, especially outside England, it took on a more mystical and esoteric character.

Many of the nobles and landowners who became Freemasons were also builders of gardens. The question therefore arises whether any of their gardens were influenced by masonic ideas or symbolism. This question has been the subject of some heated debate. James Stevens Curl, in his book *The Art and Architecture of Freemasonry*,[1] gives many examples of gardens, including Stowe, Stourhead and Wörlitz, that he argues were designed to convey a masonic message. Others have argued, unconvincingly, that the idea of masonic garden design is largely a misconception and that the garden features which might be interpreted as masonic – sphinxes, pyramids, temples, labyrinths, etc – were in fact part of a standard visual vocabulary, drawn from classical antiquity and ancient Egypt and familiar to any culturally educated person, whether a Freemason or not.[2] Admittedly it is often difficult to say that a sphinx or an obelisk is specifically masonic. Among those in search of ancient wisdom, the subject of Egypt became fashionable in the eighteenth century through works such as the Abbé Terrasson's novel *Sethos* (1731), which masqueraded as an initiatory story drawn from Egyptian monuments, and later through genuine accounts such as Richard Pococke's *Observations on Egypt* of 1743. It was of course not only Freemasons who were caught up in the enthusiasm for things Egyptian. However, Freemasons, with their interest in the notion of ancient wisdom and in metaphors taken from architecture, would have been particularly drawn to Egyptian motifs. It would be most surprising if these and other masonic themes had not found their way into gardens. Indeed, in the case of certain gardens there is clear evidence of masonic influence in the design.

It might seem strange that, among the gardens with masonic elements, few of them show evidence of any attempt to represent an actual masonic lodge. However, it only takes a moment's reflection to realize why this is so. The lodge is a private space where only the specially invited are allowed to enter, whereas a garden is a place that is difficult to make totally secret. So what we would expect to find in a masonic garden would be rather a symbolic reflection of the ideas and world view of the Mason. What are some of the motifs of this world view? The central motif is that of architecture and building, in particular the building of King Solomon's Temple as described in the Old Testament, which is treated as a metaphor for the inner work of moral development undertaken by the individual Mason. Along with this goes the idea of the search for the lost wisdom which informed the great architecture of the ancient civilizations, such as those of

Egypt and Greece. In the minds of many Masons, especially those of more esoteric leanings, this lost knowledge was linked with traditions such as hermeticism, alchemy, Kabbalah and astrology. Another motif is that of the symbolic, initiatory journey undertaken by the Mason. It is these motifs that we find represented in the gardens built for masonic patrons.

One visual source for these gardens could have been the numerous masonic allegorical illustrations of the kind that appear on the diplomas of initiates, on masonic aprons or on the title pages of books on Masonry. For example, a Master's apron of the early nineteenth century, illustrated in Jaques Chailley's *The Magic Flute Unveiled*,[3] depicts *inter alia* a domed pantheon with a classical portico, a sphinx, some pyramids and obelisks, and a snake curled about a round stone or globe.[4] In other illustrations we find ruined arches, broken columns, half-buried pieces of stonework, and symbolic beasts such as lions and peacocks. These objects and creatures are often strewn about the landscape in a deceptively random manner which belies the careful way in which they must have been chosen by artist. It is precisely this feeling of a symbol-strewn landscape that is characteristic of the gardens that we will now look at, including examples informed both by Freemasonry and by other initiatic and symbolic themes.

Many visitors to Paris are intrigued by the curious monuments found in the Parc de Monceau – an island of fantasy in the stolid, Proustian world of the 8th and 17th arondissements. From the Boulevard des Courcelles you pass through a gateway in a tall railing and find yourself walking past a Roman colonnade by a lake, a pyramid, a stone archway, an obelisk and other features, set in an informally landscaped garden. This is what remains of a much larger and more extravagant garden complex designed between 1773 and 1778 by the writer and painter Louis Carrogis, known as Carmontelle, for the Duc de Chartres. One of his sources of inspiration was Thomas Whately's *Observations on Gardening*, published in Paris in 1771, in which the Englishman advocated the 'picturesque' and 'theatrical' uses of the garden. Carmontelle's idea was to make his garden a kind of visual encyclopedia of different ages and parts of the world, bringing together Roman, Egyptian, Middle Eastern, Chinese, medieval and prehistoric elements. These were intended to be experienced in a two-hour promenade, full of delight and surprise. It is tempting to see masonic influences in this assemblage, with its itinerary and its evocation of ancient architectural grandeur, especially as it is known

that the Duke de Chartres was a leading Freemason. However, in the absence of solid evidence, let us leave Monceau to its enigmas and pass on to an equally remarkable garden created by another French Freemason.

François de Monville, a rich courtier with a love of the arts and a penchant for landscape architecture, acquired in 1774 a rugged piece of woodland at Retz near Marly where, over the next decade, he proceeded to create one of the most richly theatrical gardens of its day, somewhat misleadingly known as the Désert de Retz. Concerning the possible masonic connection, William Howard Adams, in his study of French gardens, writes:

> De Monville, like Chartres, was a prominent member of the Freemasons, and it has also been suggested that Masonic ritual and symbolism entered into the layout of both the Désert and Monceau. Rousseau had earlier proposed the natural landscape as the place for man to begin his regeneration, so that the use of de Monville's garden for the initiatory rite of Freemasonry is quite plausible and would explain the ceremonial route connecting the various garden structures. The 'primitive' form of the grotto entrance at the Désert might well be the starting point through the ritual of traversing the history of civilization via the forms of architecture, beginning in the cave and ending in a temple of utopian dreams.[5]

Adams goes on to describe the route as follows: 'If one entered the park through a heavy rusticated gate on the forest side, the opposite face of the entrance turned out to be the opening of a grotto built of loose stones piled up as a natural rockery. The opening was guarded and illuminated by torch-bearing satyrs placed on either side.' Here we pick up a familiar theme: that of a threshold marked by hybrid figures. Like the satyrs flanking the terraces at Collodi, these suggest the boundary between the world of untamed nature and that of human civilization – in masonic terms, the rough stone waiting to be made smooth. Adams' description of the route continues: 'A drive wound down the natural slope, past a pyramid that served as an ice-house and on to the center compositional piece, a gigantic broken column of the Tuscan order embedded in the side of the hill. Inside its fluted plaster walls was concealed an elegant house of five main floors, the residence of the owner.'[6]

The broken column was a familiar feature of the symbol-strewn landscapes of masonic illustration, representing a remnant of the lost knowledge that the Mason seeks. Again, we cannot definitively say that Retz is a 'masonic' garden, but what could be more satisfying to a Mason than to actually live in a broken column in the midst of a symbolic landscape?

We can more confidently use the word 'masonic' when describing certain gardens in Italy. Among these is the Torrigiani Garden in Florence, created in the early nineteenth century by the Marquess Pietro Torrigiani and his architect Luigi Cambray Digny, both members of the masonic Napoleon Lodge, established in Florence in 1808. To quote Paola Maresca in her book *Boschi sacri e giardini incantati*:

> The symbolic route, winding its way past allegorical features of sculpture, architecture and vegetation, was profoundly redolent of esoteric knowledge. Indicative of this is the fact that at the original entrance was a statue of Osiris, the god of death and resurrection. . . In the garden it was possible to admire a whole series of features, now largely vanished, including a Gothic basilica,. . . a sepulchre and a colossal statue of Saturn, god of time and of death. . . The initiatory itinerary ended at the neo-Gothic tower. . . dominating the high point of the garden. . . The tower is reminiscent of the one described in Goethe's *Wilhelm Meister*, inhabited by a wise and mysterious abbot.[7]

Another Italian garden with possible associations is the Puccini Garden at Scornia near Pistoia created in the years 1825–45. Its owner, Niccolò Puccini, filled it with messages of a revolutionary nature as well as pagan and esoteric motifs. Its features included a Pantheon to illustrious men of the past and the ruins of a Temple of Pythagoras, whose portico was inscribed with the motto: 'Always to speak the truth and to work for the good.'[8]

The combination of English garden design and initiatic motifs found particularly fertile ground in the German lands, where the esoteric traditions had a long and rich history. One of the few significant German writers on gardening in the eighteenth century was Christian Cay Lorenz Hirschfeld, author of a massive five-volume work entitled *Theorie der Gartenkunst* (Theory of Horticulture), published between 1779 and 1785 and dedicated to the Danish

Crown Prince, Frederick. Hirschfeld attacked the formal French gardening style as a coercion of nature and praised the English manner – although he had never actually visited England, he had evidently read Shaftesbury, Addison and other great English writers on the subject of gardens. For Hirschfeld gardens, with their unique combination of nature and art, were places that could both refresh the soul and ennoble the character. His work had a profound influence on German garden design, of which we shall now look at some examples.

Wörlitz – a garden of symbolic journeys

An idealistic young German prince, accompanied by his mistress and illegitimate son, visited England for the first time in 1763, eager to see the country he had come to think of as the promised land of enlightenment, democracy and progress – and good garden design. His name was Leopold Friedrich Franz von Anhalt-Dessau, ruler of a small principality bordering the river Elbe in what is now the German state of Sachsen-Anhalt. Aged 23 and anxious to be a modern, enlightened ruler, he looked to England for inspiration. He wanted to engage with English minds, study English agriculture and – not least – to visit English gardens. His visit was to have far-reaching consequences for the development of garden design in central Europe through the remarkable garden that he created on his estate at Wörlitz.

If he could return to Wörlitz today Prince Franz would be pleased at the way it has weathered numerous wars, the years under the German Democratic Republic and the estimated 1 million visitors who descend on the place every year. From the quiet little town, with its new cafés and hotels and smartly restored stucco facades, you pass from the south into the park of the Schloss, a crisp, white building in a modest neo-classical style. As you continue past the Schloss to the north, the full splendour of the park is suddenly spread out before you. It is as much a waterscape as a landscape – a series of lakes, canals and inlets formed by a salient of the river Elbe. The park is laid out around the water's edge and on numerous islands, large and small, reached by ferries and bridges. It was created over the years from 1765 to 1800 by the Prince and his architectural adviser and friend Friedrich Wilhelm von Erdmannsdorff.

This was the first major German garden to be built in the English style, and it set a fashion that was to be widely imitated in Germany.

Prince Franz intentionally affirmed his admiration for English Enlightenment ideals by choosing this style of landscaping in preference to the French formal style with its autocratic associations and dominance of nature. His debt to Stowe and Stourhead are obvious in the flowing curves of the park and in many of the features, such as the Pantheon, the Gothic House and the Temple of Flora. As befitted an enlightened prince, he allowed freedom of worship on his domains and erected a small synagogue in the park for his Jewish subjects. It stands there today at the edge of the lake, a beautiful circular building on a hillock.

In his religious tolerance, the Prince may have been influenced by masonic ideals of universal brotherhood. Whether the Prince himself was ever initiated into Freemasonry is not recorded, but we do know that he was in contact with a number of Freemasons. One was the poet Goethe, whom he often visited at Weimar. Another was the explorer and naturalist Georg Forster, who donated to the Prince a collection of objects brought back from the Pacific when he accompanied Captain Cook on his second voyage around the world.

Freemasonry, as I have mentioned, had two sides: an enlightened, progressive, democratic side; and a mystical, esoteric, initiatic side. The two were not mutually exclusive, and – especially in the German lands – were often manifested together in the same individual. If Prince Franz was a Mason, then he was certainly one who combined both aspects of Freemasonry. In the park at Wörlitz we find that the initiatic theme is strongly present. This emerges clearly from a remarkably detailed and vivid guide book to the park, first published in 1788.[9] Its author was August von Rode, whose role at Prince Franz's court was similar to that of Goethe at Weimar. A prolific writer and classical scholar, Rode began his court career as tutor to the Prince's children and later became his privy counsellor and friend. In addition to his numerous official duties, Rode found time to translate numerous Latin literary works into German, including *The Golden Ass* of Apuleius, one of the great initiatory stories of classical literature. Whether or not Rode was himself a Freemason, he was clearly fascinated by the ancient mystery traditions, and he must have had some influence on the design of the Wörlitz park, especially as he and Erdmannsdorff were close friends. Using Rode's loving description as a guide, let us take a look at some of the features that have an initiatic or spiritual meaning, which are concentrated in two places: the island known as Neumark's Garden, at the south-west end of the main lake; and the

environs of the Venus Temple in the north-western part of the park.

In one part of Neumark's Garden is a labyrinth of rough stone passages and arches, deliberately gloomy, with dark, overshadowing pine trees and few flowers. In his guide book Rode makes it clear that the labyrinth represents the individual's journey (and to some extent the Prince's own journey) through the difficulties and distractions of life. If he treads carefully and steadfastly he will sometimes be rewarded by a happy prospect. At one point, for example, a narrow path opens out into a round clearing, shaded by acacia trees. The choice of the acacia is significant, bearing in mind that this tree plays a sacred role in ancient Egyptian mythology as well as in Jewish and Arab traditions and in masonic symbolism where it is connected with the legend of Hiram Abiff. It is a tree of both death and resurrection. 'In Hermetic doctrine, according to Gérard de Nerval in his *Voyage en Orient*, it symbolizes the testament of Hiram which teaches that "one must know how to die in order to live again in eternity".'[10] Facing the clearing are three sandstone niches, one of them empty, the other two containing busts. One of these depicts the Swiss pastor, physiognomist and Christian mystical writer Johann Caspar Lavater and bears the inscription 'May my purpose be Thine' (DASS MEIN SINN DEM DEINEM GLEICHE). The other bust is of the poet Christian Fürchtegott Gellert, whose inscription says: 'Hail to Thee, for Thou hast saved my life and soul!' (HEIL DIR, DENN DU HAST MEIN LEBEN; DIE SEELE MIR GERETTET, DU!). These writers represent two of the friends who inspired the Prince on his life's journey. The empty niche must surely be intended for the visitor to fill in his or her imagination with some important friend or mentor.

Leaving the clearing, one walks along another narrow path, which passes under a rocky arch bearing the inscription: 'Wanderer, choose your way with reason' (WÄHLE WANDERER DEINEN WEG MIT VERNUNFT). 'Suspiciously one goes on', writes Rode. 'The frightening features increase. The jagged rocks become higher. The ground becomes rougher and rises.'[11] Then one is confronted by a tunnel entrance in a high, rocky wall with a plaque bearing the words: 'Here the choice becomes difficult but decisive' (HIER WIRD DIE WAHL SCHWER ABER ENTSCHEIDEND). At the end of the tunnel one glimpses a white figure illuminated by daylight. The figure turns out to be a plaster copy of a statue of Leda and the Swan from the Capitoline Museum in Rome. The daylight comes from a side opening, where

one sees the inscription: 'Turn quickly back' (KEHRE BALD WIEDER ZURÜCK). The reason for the warning is clear: the opening is in a brick wall which drops abruptly down to a canal. Turning back, one comes to a low, narrow side tunnel leading off to the right. Following this, one comes out into the open and finds oneself entering a grassy clearing known as Elysium and surrounded by a variety of attractive trees and bushes. Rode describes the mood of this place as follows: 'Now one truly believes oneself to have been transported into the joyous realm of the blessed.' In a footnote he adds that the Roman Emperor Hadrian also had an Elysium at his villa, approached by an underground passage.[12]

As at Stourhead, the visitor to Wörlitz experiences a continual alternation between light and darkness, airy heights and underground passages, places of 'truth' and places of 'the vital enigma'.[13] This contrast is even more pronounced in another part of the park known as Schoch's Garden, where the initiatic theme is again strongly present. The features include a Hermitage, a Mystagogue's Cell and a Temple of Venus with underground grottoes. Here it is worth quoting Rode's guide book more extensively:

A dark, underground corridor leads us to a grotto with large, vaulted, window-like openings that reach down to the ground. Around the walls are stone benches, a stone table and niches with funerary urns – memento mori! These things soon suggest to us that we are in a hermitage. At the end of it is an exit, from which some steps lead down to the Canal. . .

We turn back along the underground corridor. Yet before we reach the end of it we see, by the faint glimmer of daylight, a similar passageway. This we follow and come up to a circular place known as the Oratory of the Hermit. In this low-lying spot, shaded by planes, ashes and other trees, and surrounded by black walls of rock dominated by high, dark evergreens, the dominant mood is one of solemn isolation that brings a feeling of pious reverence. This feeling is strengthened when we see to one side the remnants of a crude stone altar. . .

We leave this place and follow another underground corridor to the left leading to a similar, but larger space, with a surrounding wall built of coarse pieces of stone. Here begins the mystical stage.

A kind of cell, constructed of crude stone fragments, emerges on the left hand side, shaded by trees of various kinds. I call this the Cell of the Initiator into the Sacred Mysteries – the Mystagogue. Two ways lead out from here. One, leading to the right, can be compared to the unreflective, toilsome way of the person without knowledge or intellectual culture. . .

The other way, to the left, is the arcane path of the mystic, the apprentice in exalted wisdom. . . It soon passes into a cave, in places very dark, in other places dimly lit from above or somewhat more brightly from high apertures. In these wanderings one can believe that one speaks the language of the mysteries and that one is standing on the threshold of Proserpine, the boundary between life and death.

At last we come out into the daylight in a pleasant valley with high rocky sides adorned by greenery. The first thing that we see, on the summit of a cliff opposite us, is a round temple, the mysterious sanctum of the heavenly Venus who, in the primal beginning of all things, through her almighty child Amor, begot the sexes and thus brought about the reproduction of humankind. . .

We go now under the rock on which the temple stands, passing through a high, vaulted opening and finding two grottoes, one on the right, the other on the left. The first, round like the temple under which it lies, is dedicated to Vulcan, god of fire and husband of Venus. Apart from the flaming altar of the fire god in the middle, this grotto will be decorated with murals and ceiling paintings illustrating the workings of the elements of fire and earth [these paintings were never carried out or have disappeared]. . . A circular opening in the domed ceiling looks into the pedestal of Venus, which is glazed with yellow glass, allowing a faint light to fall into the grotto, resembling the light of the sun during an eclipse.[14]

Here Rode gives us a striking image that is strongly reminiscent of alchemical symbolism. For the alchemists the gleam of gold in the earth was analogous to rays of divine sunshine penetrating the depths of matter. Similar imagery appears in the painting *Der Morgen*

(1808) by the German Romantic painter Friedrich Otto Runge, where a Venus-like female figure floats in the sky, a newborn child lies on a meadow below her, and down below the ground an eclipsed sun is flanked by cherubs. Clearly Runge spoke the same symbolic language that informed the design of the Venus Temple and other features of the Wörlitz garden. We encounter here that rich mixture of alchemy, Rosicrucianism, esoteric Freemasonry, mystical pietism and *Naturphilosophie* that pervades much of German culture during the eighteenth and nineteenth centuries.

Continuing with Rode's conducted tour:

> The other grotto, dedicated to Neptune and Aeolos, is square and has, opposite the entrance and close to the vaulted ceiling, a large, semicircular window extending across the whole width of the grotto and approached by some steps. From here, as far as the eye can reach, one sees only meadows, stretching between the Wörlitz forest and the Elbe dyke on which, in the distance, rises the Pantheon.

Rode goes on to describe how, when the Elbe overflows its banks, one sees from the grotto a huge expanse of water.

> This water, reflected in the mirrors that are intended to line the walls, will give an impression of the sea, the symbol of the water element. The statue of the [water] god in the middle will seem to rise up out of the waters. At the same time one will be able to hear the enchanting music of an aeolian harp, placed in a round opening. Its strings, touched only by the swift, airy fingers of the wind gods, will create divine melodies redolent of the air element.[15]

Today, unfortunately, one sees neither mirrors nor aeolian harp. Perhaps they were never installed. But what a wonderful experience it would have been, having passed through a subterranean initiation into the elements of earth, fire and water, to experience the final initiation into air while listening to the unearthly strains of an aeolian harp.

The Pantheon that can be seen in the distance from the Temple of Venus is another example of the dichotomy mentioned earlier. It is a smallish, round building with a classical portico, standing on the dyke

that protects the park from the Elbe waters. The upper storeys contain works of classical antiquity, while the cellar, entered by a grotto-like entrance set into the dyke, contains plaster images of the Egyptian deities Isis, Osiris, Horus and Anubis. Here we have a possible reflection of the interest in ancient Egyptian mystery cults which was taken up in Freemasonry around the 1780s. A detail worth noting is that Horus is depicted as a youth raising his right index finger to his lips – a gesture of secrecy which is often found in masonic imagery.

The Wörlitz park is thus exceptionally multi-layered in the messages it conveys, and it brings together strikingly diverse motifs. They include: Christian mystical piety (the busts of Lavater and Gellert and the quotations from their works), asceticism (the Hermitage), the chthonic mysteries (underground passages and grottoes), Apollonian clarity (the Pantheon), the theme of the feminine, das '*ewig Weibliche*' (the Temple of Venus and the statue of Leda), and possibly Freemasonry (the Egyptian images in the Pantheon and theme of initiation into the four elements). Indeed the world of Mozart's *Magic Flute*, with its themes of darkness and light, its elemental initiations and its invocation to Isis and Osiris, appears to echo the world of the Wörlitz garden in many ways.

Goethe's Weimar

One of the early imitators of Prince Franz's park at Wörlitz was his friend Duke Carl August of Weimar, patron of the poet Johann Wolfgang von Goethe. Horticulture was one of their common interests, and many ideas as well as plants and seeds went back and forth between Weimar and Wörlitz. Under the influence of the Wörlitz park, Goethe and Carl August together created an enchanting park of similarly English informality along the banks of the river Ilm. As a tribute to Prince Franz, a monument to him was placed in the Weimar park, a monolith of rough, pitted stone with an inscription to the Prince in Latin.

Goethe, as the Duke's adviser, played an important part in the layout and ornamentation of the park. For some years he lived in a modest house near the river, which he called his Garden House – a little white building out of one of Grimms' fairy tales with tiny windows and a high roof. Even after moving to a grander house in the town he continued to use the Garden House as a refuge. At the end of the garden stands a sandstone monument that is striking in its

Platonic simplicity: a cube surmounted by a sphere. Known as the Stone of Good Fortune (*der Stein des guten Glücks*), this monument, erected in 1777, has been the subject of much debate as to its meaning. Goethe called it 'agathe Tyche', referring to the Greek goddess of Fate, whose Roman counterpart, Fortuna, is usually shown balancing on a sphere, as in a statuette in Goethe's town residence. Perhaps this motif connects with the cult of Fortuna Primigenia, which, as we have seen, may be behind the images of Fortuna in certain Italian gardens. It has also been suggested that the cube and the sphere refer respectively to the fixed and movable principles in nature. Furthermore it seems likely that the image is connected with Freemasonry, in which Goethe had a strong interest, later becoming an active member of the Weimar Lodge Anna Amalia. Another feature that can be given a masonic or perhaps a magical interpretation is the pentagram formed in the paving stones in front of one of the gates leading out of the garden.

In the park along both sides of the river there are further features that hint at an esoteric meaning – although it is not clear how many Goethe actually had a hand in choosing. There is a now ruined 'Templar House' with a row of pentagrams in the stonework, a grotto with a sphinx reclining in it, and – most striking of all – a stone pillar with a snake wound around it, which stands in a leafy spot where two paths meet. On the stone is the inscription 'GENIO HUIUS LOCI' (to the spirit or genius of this place). This must be partly an allusion to the river Ilm with its winding, serpentine course through the meadows, but the serpent may also be intended as a symbol of Hermetic wisdom and perhaps a reference to alchemy, in which Goethe himself had more than a passing interest.

The garden of a Rosicrucian monarch

Hints of initiatic mysteries are also present in the New Garden at Potsdam, created for King Frederick William II of Prussia (reigned 1786–97), a monarch deeply immersed in esoteric ideas and an active member of the Golden and Rosy Cross Order, a neo-Rosicrucian high-degree masonic rite with strong alchemical leanings. History has not been kind to Frederick William, seeing him as a weak and unworthy successor to his uncle Frederick the Great. Certainly he was very different from his spartan uncle, but it is hard not to find him an engaging figure, a curious combination of libertine, mystic and aesthete

whose portrait reveals him to be a portly man with a fleshy, sensual face and bulging eyes. He was renowned for his mistresses and bigamous marriages but still found time to be a patron to composers such as Beethoven and Mozart, to keep a private orchestra with a European reputation and to create a charming palace and park on the shores of the Holy Lake (Heiliger See) at Potsdam. The park is known as the New Garden (Neuer Garten), to distinguish it from the park of Sanssouci, created by Frederick the Great. It is recorded that the King himself planted some acacia trees in the park, which later stood partially in the way of the Marble Palace that was to be built by the lake. The King refused to allow the trees to be felled, and the bank had to be extended into the lake so that the site of the palace could be shifted to make room for the acacias.[16] Was it perhaps because of the masonic associations of the acacia that Frederick William was so insistent on saving the trees?

Frederick William was in friendly contact with Prince Franz von Anhalt-Dessau, and very likely they shared the same esoteric and masonic interests. It was to Prince Franz that Frederick William turned when he needed a landscape architect to work on his Potsdam garden, and the Prince sent him the 25-year-old Johann August Eyserbeck, who created a park of great beauty and variety. During the course of his reign Frederick William commissioned a succession of architects to fill the park with buildings, statues and monuments, many of which have an esoteric or masonic character.

Entering the park from the south-west and walking towards the lake, one would formerly have passed a many-breasted sandstone figure of Isis, which stood in a grove of conifers but had to be moved to a room in the Marble Palace to prevent deterioration. Continuing towards the palace, one passes an orangery, which has a sphinx over the portico and two Egyptian gods in black marble flanking the doorway. Near to the palace is another Egyptian feature, an obelisk designed by C.G. Langhans. On the faces of the obelisk are relief medallions of four heads of different ages representing the four seasons. Continuing northwards from the palace one comes to an icehouse in the form of a pyramid, similar to the one in François de Monville's garden at Retz. The sides of the pyramid are adorned with obviously imaginary hieroglyphs, but over the doorway are seven gilded alchemical sigils, accurately represented – a reminder of the important role that alchemy played in the Golden and Rosy Cross Order. Certain other features of the garden, such as the grotto, and

the hermitage with a painted ceiling with images representing the planets, have since disappeared or fallen into ruin.

Et in Arcadia ego

A famous painting by Nicolas Poussin, *Les Bergers d'Arcadie*, usually interpreted as a *memento mori*, shows a group of Arcadian peasants pushing aside some foliage to reveal a tomb inscribed with the words 'Et in Arcadia ego' (I too was, or am, in Arcadia). The idea of placing graves and memorials to the dead in beautiful landscape or garden settings is one that appears in many cultures. We have seen how it features in Islamic tradition, the most striking example being the Taj Mahal. We also find it in China, where 'five trees were symbolically grown in cemeteries: pines for the ruler, *Thuja* for princes, the summer-flowering *Koelreuteria* for governors, *Sophora japonica* for scholars, and poplars for commoners'.[17] In Korea, graves marked by slender stone pillars are to be seen on the lower slopes of mountains, where they are placed so that the dead can be in touch with the Mountain Spirit, San-Shin.

In Europe, the tradition of the landscaped cemetery is of relatively recent origin. Examples such as Père Lachaise in Paris or the incomparably atmospheric Highgate Cemetery in London, have their antecedents in the eighteenth century, when tombs in suitably elegiac settings went with a new tendency to poeticize the landscape. There was a mausoleum at Castle Howard in Yorkshire and another on Sir Francis Dashwood's estate at West Wycombe in Berkshire. At Stowe, as we have seen, was a Temple of British Worthies and a 'river Styx', and William Shenstone at The Leasowes had an urn set among foliage and inscribed 'Et in Arcadia Ego'.

Particularly seminal in this respect was the park laid out in the second half of the eighteenth century, at Ermenonville to the north of Paris, by the Marquis de Girardin, an admirer of the informal English gardening style and a friend and disciple of the philosopher Jean-Jacques Rousseau. The Marquis set out his ideas on gardening in his book *De la Composition des paysages*, published in 1777. William Howard Adams writes of Girardin as follows: 'Girardin took as his point of departure Rousseau's *Nouvelle Héloise*, laying out winding paths around the lake, but linked together in an un-Rousseauian fashion by a series of prospects and structures loaded with associative views intended to recall the works of admired painters.'[18] In this respect he foreshadowed Ian Hamilton Finlay's technique of composing parts of

his garden at Little Sparta in the styles of various well-known artists (see Chapter 10). Girardin even maintained that a professional painter should accompany the garden designer as he toured the site, sizing it up for interestingly composed prospects. He also applied stage set techniques to his garden designs, using *trompe l'oeil* effects to create an illusion of distance and framing his prospects with massed woods.

When Rousseau died during a visit to Ermenonville, the Marquis took the opportunity to create a sort of shrine to him in the form of a tomb overlooked by poplar trees and set on a little island in a lake. This serene and picturesque feature was later copied elsewhere, notably in the park created at Wörlitz for Prince Franz von Anhalt-Dessau, already described, where Rousseau is similarly commemorated by a monument set on an island with poplar trees in an equally beautiful setting. In the same spirit, Prince Franz commemorated his deceased daughter by placing an urn in gilt sandstone on the bank of a little river where it still forms a striking focal point from various different angles. Prince Franz also created what James Stevens Curl has described as 'the first non-denominational and communal cemetery in all Germany', the *Stadtgottesacker* (literally 'the town's God's acre'), an ancestor of the grand garden cemeteries of later eras, such as Père Lachaise.[19]

Curl sees Freemasonry as one of the influences in the development of cemeteries and cites as an example 'the extraordinary and imaginative garden of the Comte d'Albon, partly inspired by his friend Court de Gébelin, at Francoville-la-Garenne, laid out in the early 1780s'. As Gébelin was a prominent Mason, Curl's theory is credible. 'The gardens', he writes, 'contained a pantheon-like temple (a Masonic idea . . .), an obelisk, a Temple of the Muses, a *Bosquet de l'Amitié* [grove of friendship] (very Masonic),. . . a Primitive Hut, a Priapus, an Isle, a Chinese Kiosk, rock-work, a fountain, a statue of Pan, the Devil's Bridge, an Asylum for Shepherds, a column, and a pyramid which was a memorial to Albon's ancestors.' On Gébelin's death, the Count erected a tomb to his friend in the garden. He also installed a bust to Benjamin Franklin, another prominent Freemason.[20]

Curl also sees evidence of masonic influence at Père Lachaise, with its Allée des Acacias, the acacia being a marker of graves and connected with the Hiramic legend in Freemasonry.[21]

Vigeland Park, Oslo

Moving into the early part of the twentieth century, one of the most

interesting, and yet undeservedly little-known, examples of landscape design combined with richly symbolic sculpture is the Vigeland Park in Oslo, Norway – in fact part of a larger complex called the Frogner Park. Its creator Gustav Vigeland (1869–1943), the son of a joiner with pietistic religious leanings, grew up with an appreciation of spiritual realities and was early in his life drawn to the world of classical mythology. During a sojourn in Paris in the 1890s, the heyday of symbolist art, he came strongly under the influence of the great sculptor Auguste Rodin and is likely to have exhibited at the Salons de la Rose Croix, founded by the eccentric Rosicrucian magus Josephin Péladan. Among English artists he admired, not surprisingly, Edward Burne-Jones, Aubrey Beardsley and, above all, George Frederick Watts. He also enjoyed friendships with his fellow Scandinavians Edvard Munch and August Strindberg.

By the time he was commissioned, in the early 1900s, to extend and remodel the Frogner Park, Vigeland had developed a grand spiritual vision of humanity and human destiny, which he expressed on a gargantuan scale in the park, where he created both the landscape design and the works of art. Arranged along a 650-metre axis, rising gently up a hillside, the park contains 650 figures executed by Vigeland and an army of 192 sculptors.

Entering from the lower part of the park and passing along an avenue, you come to the entrance to a bridge flanked by two sculp-tures on columns. One shows a female figure wrestling with a kind of prehistoric lizard, which she is straining to push away from her. On the opposite side is a similar group, except that the woman is embracing the lizard. Here Vigeland shows us humanity confronting its primal, instinctive nature, which we can either struggle to reject or embrace with joyful acceptance. Along the balustrades of the bridge are bronze figures of children and youths leaping and dancing, lovers embracing, mothers with babies, old men and women – all infused with intense vitality.

At the centre of the axis is a fountain surrounded by 20 bronze sculptures depicting trees in which human figures are standing, sitting or climbing, sometimes almost merging with the branches. Vigeland here invokes the tree symbolism that he was familiar with from his study of Greek, Nordic and other myths. In many of these myths a tree is linked with the figure of a young woman. An example is the story of Apollo and Daphne. Another is that of Phyllis and Demophon, related by Ovid and depicted by Burne-Jones among others, in which

a young bride is left waiting forlorn at the altar and turns herself into a tree. Vigeland, by directly or indirectly invoking the world of Ovid's *Metamorphoses*, links his park with Versailles and with the Italian gardens of the Renaissance. Set into the pavement around the fountain is a complex labyrinth with a path 3,000 metres long, which complements the sculptures in the park by symbolizing the course of life with all its blind alleys and turnings.

From the fountain one passes up a flight of terraces to the climax of the whole park, a huge, phallic monolith in pale granite made up of a writhing mass of human figures. The monolith is set in the middle of a circular, stepped mound on which are 36 more granite sculpture groups set on plinths and depicting human beings at all stages of life. Vigeland himself stated that he intended the 36 groups to represent life, whereas the monolith represented the world of the imagination.[22] The groups are arranged in three circles of 12, suggesting an astrological connection, which is reinforced by the nearby armillary sphere set on a plinth with reliefs of the zodiacal signs.

Vigeland's park – with its grandeur and monumental sweep, its mythological and astrological references, its labyrinth pavement, fountain and towering monolith – has echoes of many of the gardens described earlier, combined with its own primal, archetypal quality. Although a century old it remains vigorously modern and yet timeless.

The Thiele Garden, Bremerhaven

The workaday German port of Bremerhaven, where American troop ships used to dock and where Elvis Presley stepped ashore as a GI, is hardly the place where one would expect to find a garden of exotic fantasy. Yet such is the Thiele Garden, tucked away in the quiet residential suburb of Leherheide and filled with a remarkable assortment of sculptures and monuments. If you wander in here unprepared you will be surprised by what you see. After you have passed a curious Moorish house beside which are two naked wrestlers, one path takes you past a rock on which is perched a jolly goat-legged figure with enormous ears and a mischievously smiling face. Further on you come to other sculptures and features, mythical and mundane: a girl whispering into the ear of a shaggy elf-like creature, a Pan quietly playing his pipe by a lake, a pair of footballers contending for the ball, fountains where humans and half-humans with fishy tails cavort together, the 'ruins' of Roman colonnades, a domed temple by a lake,

and numerous statues of the same woman in different roles – as Daphne turning into a tree, as a Sun-worshipping priestess, as an ordinary woman sponging herself in a bath. This haunting place was created by the brothers Gustav and Georg Thiele and Georg's wife Grete – it is Grete who appears in the garden in so many guises. The story of this trio and their creation is a striking example of the dogged pursuit of a personal dream in the face of much difficulty and discouragement.[23]

Gustav and Georg Thiele were born in 1877 and 1886 respectively into a family that lived in a small town on the river Weser and earned their living as bargees but later moved into Bremerhaven in search of other work because of competition from the railway. The family was musical and the atmosphere in the home encouraged a versatile, autodidactic outlook which the brothers retained throughout their lives. Nurturing artistic ambitions but without the financial means for a course of study at an art school, they set up a successful photographic business in Bremerhaven, while in their spare time Gustav sculpted and Georg painted. In 1923 they bought a piece of land on the northern edge of the town where they unsuccessfully attempted to set up a small building firm.

In 1925 came the decisive moment in their lives. Inspired by an article in the popular gardening magazine *Gartenschönheit*, they decided to use their piece of land to create a sculpture garden. Gustav, his creativity released from the confines of his old studio, began to sculpt an exuberant series of life-size cement figures, while Georg created around them a landscape garden out of his painter's vision, with artificial lakes, groves, winding paths and secret places. In 1929 Georg married Grete Itzen, a highly spirited woman who had worked as an assistant in the brothers' photography studio. She modelled for Gustav's sculptures and Georg's paintings, inspired them with new ideas for the garden and later became its public spokeswoman. In due course they built a small weekend house on the site in the Middle Eastern style of architecture that Georg had fallen in love with while serving in Palestine during the First World War. This became their full-time home in 1944 when their Bremerhaven house and studio were destroyed by a bomb. After the Second World War they opened the garden to the public and in the early 1950s offered to sell it to the City of Bremerhaven. The local Art Association, however, advised against the purchase, condemning the garden as 'kitsch', and the City turned down the offer, although among the Bremerhaven public it had

become a much-loved place. Fortunately a wealthy friend of the Thieles, a local builder, bought and extended the property, allowing the Thieles to continue living there and developing the garden. Georg died at the age of 82 in 1968, and Gustav at the age of 92 the following year. Grete lived on in the garden with a female friend until her death in 1990 at the age of nearly 85. Meanwhile the garden had finally been acquired by the town and given protected status.

What, if any, is the message of the Thieles' garden? It is not a mere whimsy, thrown together at random. The Thieles, albeit self-educated, were obviously well informed not only about gardening but about art, architecture, mythology and many other things. It would be fascinating to know what books inspired their work over the years, but unfortunately their library was sold off uncatalogued after Grete's death. On the other hand, perhaps it is just as well that the message remains a secret – or as many secrets as there are visitors willing to open themselves to the light and playful spirit of the place. One possible interpretation might be that the garden is intended as a meeting place between the world of human beings and the world of the gods and nature spirits. The wrestlers, the footballers and the woman bathing belong to the former; the Pan, the Sun priestess and the elves to the latter. And in some of the groups the two worlds interact – most poignantly in the sculpture of the young girl whispering into the ear of the elf, as the garden itself whispers to us if we listen carefully.

A garden of the Nordic gods: the Bossard Temple

A couple of hours drive to the south-east of Bremerhaven, situated in the depths of Lüneburg Heath, lies the Kunststätte Bossard (the Bossard 'art place'), also known as the Bossard Temple, created by the Swiss-born sculptor and painter Michael Bossard and his wife Jutta over roughly the same time-span as the Thiele Garden and marked by the same kind of personal vision and passion, although totally different in style and content. The Bossards' creation, preserved today as a museum, is informed by the nineteenth-century concept of the *Gesamtkunstwerk* (total work of art), paralleled in the world of music and drama by the works of Wagner. They made it their home, studio, gallery, sculpture garden and temple all in one complex, and they strove to encompass as many of the arts as they could, including poetry and music, for Bossard wrote poems to

accompany his paintings, and his wife played the piano and composed music.

Bossard was already 37 years old and a professor of sculpture at the School for Applied Arts in Hamburg when he bought in 1911 a piece of land of 3,000 square metres in a remote wooded area of the Lüneburg Heath where he began to build a house and studio. In 1926 he married his pupil Jutta Krull, a woman many years his junior, who also became his equal partner in the creation of the *Gesamtkunstwerk*, sharing in the building work and contributing numerous murals and reliefs. Bossard died in 1950, and Jutta lived on at the house for nearly half a century longer. I remember meeting her there, a spirited and energetic old lady in her early 90s.

The site is a long strip of land running north-west to south-east. Entering from the east and passing through a gallery devoted to Bossard and his contemporaries, you come to an area of lawn flanked by the house and a striking row of sculptures: heroic stone heads, female figures, curious abstract shapes in ceramic. Built on to the side of the house is the Edda Hall, with an interior richly ornamented with murals, reliefs and sculptures of motifs from Nordic mythology. A prominent figure is that of the one-eyed Odin, supreme god of the Nordic pantheon and essentially the presiding deity of the whole place. Bossard, who had lost an eye early in life, identified himself with Odin and never tired of painting or sculpting his image. Next to the Edda Hall is the Temple of Art (Kunsttempel) a striking building in dark red brick, set with rich ceramic and terracotta ornamentation and decorated inside with a remarkable series of murals drawn largely from classical mythology.

In the garden, however, it is not the classical gods but those of the north who reign supreme. Here you feel yourself to be in the mist-laden Germanic and Celtic world of the sacred forest and the megalith. There is a 'prehistoric' semi-circle of stones, full of druidic magic, and beyond it a square area fringed by fir trees, which Bossard called the Tree Temple. Next to this is another prehistoric-looking feature, a double row of standing stones at the end of which is a massive boulder marking Bossard's grave – clearly he had planned this as his burial place many years before his death. There are also four stone figures, sculpted by Bossard, representing the four seasons: Spring, a young woman pushing forward and throwing off a diaphanous garment; Summer, a naked and more buxom woman; Autumn and Winter, two older men (it is hard to tell which is which).

For decades Michael and Jutta Bossard's work was little known and unappreciated by the artistic establishment. Now, however, it is coming back into its own, and more and more people are discovering the Kunststätte and the garden that forms an integral part of it.

10

THE PRESENT AGE

How would our traveller from outer space judge the gardens of the late twentieth and early twenty-first centuries? One of the things that would strike him would be their eclecticism. Strolling suitably disguised through the ornament section of a garden centre in Sydney, Sydenham or San Francisco, he might see Japanese lanterns thrown together with Chinese dragons, cherubs, dwarves with pointed hats, Greek goddesses, lion-head fountains and perhaps the occasional Egyptian sphinx – a veritable supermarket of symbols. He would also find an array of plants from all over the world, both indoor and outdoor, that would have been envied by the gardeners of earlier centuries. Looking at the gardens themselves he would certainly find much kitsch and much lack of imagination in exploiting the riches available to the modern gardener. He might also regret that the age of the great private estates, and of gardeners like Le Nôtre, is past. At the same time he would find in today's world quite a number of remarkable gardens of symbolism and meaning, some of them continuing the traditions I have described earlier, others using a more contemporary idiom, many carried out with great flair and imagination. One development that he might find particularly exciting – as I do – is the application of computer technology to horticulture, something which is still in its infancy. At any rate, he would see that, even at the outset of the twenty-first century, the gods still dwell in gardens.

Little Sparta, Scotland

The concept of a garden and temple combined in a *Gesamtkunstwerk*, as exemplified by the Bossard Temple mentioned in the last chapter, has also been applied in a different way at Ian Hamilton Finlay's Little Sparta in the Lanarkshire hills of Scotland, a garden that has become world famous for its unique combination of poetry, art and horticulture linked to a cultural and spiritual vision. As mentioned earlier, it was my encounter with Finlay and his garden in 1976 that brought me to the study of gardens. Over the years I was to make many visits there, and before me as I write is a searching PhD thesis on his work written by my former wife Katherine Kurs, partly based on taped interviews with Finlay, which we conducted together.[1]

In my diary I recorded my impressions of my first visit to Stonypath, as it was then called before Finlay re-named it Little Sparta.

> Just past the hamlet of Dunsyre you come to the entrance to a driveway with a sign saying 'Stonypath' and underneath a quotation from Heraclitus: 'The way up is the same as the way down' [now no longer there]. About half way up a potholy drive – aptly named 'Stonypath' – I came to a cluster of low grey stone buildings. Finlay came out to the car to meet me. A wiry man with short, dark hair, greying slightly, and dark eyes.

When Finlay and his then wife Sue moved to Stonypath in the early 1960s, he was already well known in literary circles as a concrete poet. It was the era of the 'beat poets', of the hippie movement, of poetry and jazz sessions in smoky basement cafés. But Finlay was destined to go down a very different road. At Stonypath he turned to the combining of poetry and landscape. The property that he and Sue had moved into was a run-down farm, consisting of a cottage, some barns and cowsheds and about four acres of wild, windswept land. By the time I saw it some ten years later it was already transformed into an oasis of great beauty. The farmyard had become a pond, surrounded by lawns and banks of flowers and shrubs, and beside it a former barn had become a gallery housing Finlay's works. In the former wilderness outside, another pond and a small loch had been created. Everywhere there were what Finlay called 'image poems' – sculptures, small monuments, inscriptions and images on wood, stone or other material – each serving as the 'presiding deity' of its carefully chosen setting.

Most of these objects were conceived by Finlay and executed, according to his precise instructions, by sculptors, monumental masons and other craftspeople.

In one corner of the Front Garden, to the south of the house, were sculptures of ships: a submarine which also served as a bird bath, and two aircraft carriers which served as bird-tables – typical of the visual puns that Finlay is fond of. He said he derived great delight from watching birds instead of aeroplanes landing to pick up crumbs. Near this spot was a little grove of trees with a wooden pole set into the ground on which was inscribed one of Finlay's highly compact poems:

> WIND SONG WOOD
> SONG WIND WOOD
> WOOD-WIND SONG

In another place was a small sunken garden set with stone slabs, also inscribed with Finlay's poems. Here the poetic form was one that he had developed as a variation of the Japanese *haiku*, but consisting of just one word and a title. The one that struck me particularly was:

> One orange arm of the world's oldest windmill
> Autumn

– an image that subtly suggests the revolving of the four seasons with their respective predominant colours.

As one moved through the garden, the mood changed subtly from one spot to the next – now serene and lyrical, now startling, even slightly shocking. Near a grove of wild cherries stood a little stone slab with a classical pediment bearing the slogan 'BRING BACK THE BIRCH', and nearby was a similar slab with a skull and crossbones and the German words 'ACHTUNG MINEN' (danger, mines) – the Stonypath equivalent of 'Please keep off the grass'. Finlay has a way of combining the provocative with a puckish humour. And Stonypath/ Little Sparta is pervaded by the quality of playfulness that we have seen in many of the great gardens of the past. Examples of the visual puns that one can find in the garden today include a marble 'paper' boat, wooden posts with false shadows in brick, trees fitted with stone column bases, gate posts topped by hand grenades instead of pineapples, and a piece of stone incised with Albrecht Dürer's

monogram and set into the ground as though in Dürer's watercolour *The Great Piece of Turf*. In other parts of the garden Finlay has gone even further and 'composed' the landscape in the style of particular painters such as Claude Lorrain and Salvator Rosa.

In the process of creating the garden Finlay underwent a transformation which he described himself in one of the interviews conducted by myself and Katherine Kurs:

> This thing just rose up in me and I began to conceive of the garden in a really sort of classical way, which was a great surprise to me because I'd generally been associated with the avant-garde through concrete poetry.[2]

Through trial and error, he found that classical lettering was the most natural kind for inscriptions cut into stone, and this in turn influenced his manner of composing the inscriptions. By the same token, he discovered that the classical approach was the most practical way of siting objects in a garden. Thus, increasingly, he found himself thinking and creating in a classical way and drawing on the classical inheritance, seeing it as a spiritual, religious and moral tradition as well as a cultural one.

Although at the time of my first visit the garden had existed for a decade it was still at an early stage in its development as a place of symbolic meaning. From the mid-1970s Finlay increasingly began to use the garden and its works of art as weapons in a polemic against the shallow, spiritually rootless culture of today, whose zealous cohorts he named the 'secular terror'. He re-named the property Little Sparta, and began what he called a 'Five Year Hellenization Plan'.[3] While continuing to feature military motifs, subjects from classical mythology and themes from Western culture in general, and while keeping his unique sense of playfulness and humour, Finlay developed a profound interest in the events of the French Revolution and a particular admiration for the revolutionary leader Antoine de Saint-Just, after whom he named a group of Finlay supporters called the Saint-Just Vigilantes. Revolutionary motifs, skilfully allegorized, were incorporated into the symbolic arsenal of Little Sparta, which now became not only a sacred space but a fortress, or rather a kind of battleship with its guns pointed at the secular terrorists. The presiding deity was now Apollo, identified with Saint-Just, whose gilt head, inscribed with the words 'Apollon, terroriste' gleamed startlingly from

the shrubbery near the upper pond. As the focal point of the whole complex, the gallery was named the Temple of Apollo, and an inscription on the facade said: 'To Apollo, his music, his missiles, his muses'.

In the late 1970s Little Sparta came under attack from the then local authority, Strathclyde Regional Council, which attempted to levy rates (local taxes) on the Temple on the grounds that it was a commercial art gallery and not a religious building as Finlay insisted. The dispute turned into a long-running confrontation, which Finlay skilfully publicized, presenting it as fundamentally a struggle between the inherited values of Western culture, represented by Little Sparta, and the barbarians of the secular terror, represented by the officials of Strathclyde Region. When, on 4 February 1983, the Region sent a sheriff officer authorized to seize works of art from the Temple in lieu of rates, he found Little Sparta turned into a battle zone, swarming with press and television reporters and complete with military check point, Red Cross tent and great-coated Vigilantes with binoculars on the roof of the house. Although the sheriff officer went away empty handed he returned with an associate the following month and made off with works valued at over £5,000, which subsequently proved to be the property of various private collectors, who had lent them back to the Finlays. The dispute, one of a number of legal battles in which Finlay has been involved, continued and has not been fully resolved to this day.

Finlay's use of the word 'temple' was not intended in a merely metaphorical sense, for Little Sparta is a profoundly religious place – it is indeed a 'garden of the gods'. In one of our interviews Katherine Kurs and I asked him what the gods meant to him, and the following exchange took place:

IHF: They [the gods] are fixed things that people can't change. Opposed to that democratic, secular, 'flower-power' type thing that assumes that *everything* can change.

CM: Are they actual entities to you?

KK: Do they feel like forces or ideals?

IHF: Forces! Forces! – which can't be changed – democracy takes for granted that they don't exist.

CM: Are they cultural ideals? Conscious or not?

IHF: No, *forces*! I don't know what you mean about forces being conscious or not – it doesn't worry me. It's not a question that a force would ask itself.

CM: You've invoked Apollo here in the garden.

IHF: Yes.

CM: Do you feel that in some sense Apollo is present here? That you have actually drawn some force down?

IHF: No, I just feel that I have brought the force to notice. It's there and the trouble with our age is that it wishes to pretend a whole lot of things are *not* there.

KK: And 'there' is – ?

IHF: In the universe.

KK: And in us?

IHF: And in us, of course, because we are part of the universe.[4]

Arcane theme park: the Tarot Garden, Tuscany

There was a time when visitors to the vicinity of Capalbio in southern Tuscany would get suspicious looks from the locals if they asked the way to the Tarot Garden – but that was some years ago. Now you will be directed politely, even with a hint of pride. 'Take the road towards Pescia Fiorentina. . . can't miss it. . . you'll see the bright colours above the treetops.' These days they are used to such enquiries, for the Tarot Garden is one of the most visited features of the region. In a remarkably short time it has become a legendary place, and its images are on their way to becoming part of our store of universally recognized cultural icons – like the melting watches of Salvador Dali or the sunflowers of Van Gogh – an astonishing garden, created by an equally astonishing woman, the French sculptress Niki de Saint Phalle, together with her former second husband, the Swiss

sculptor Jean Tinguely, who remained her close collaborator until his death. A self-taught artist, Niki de Saint Phalle passed through a phase of creating paintings by hanging pots of colour in front of the canvas and then blasting away at them with a rifle. She later developed the style for which she has become famous, featuring fantastic, dazzlingly colourful creatures and figures, including the bulbous, large-breasted women that she calls 'Nanas'.

The germ of the idea for the garden came to her when she encountered the work of the Catalan architect Antonio Gaudí, as she herself recounts:

> In 1955 I went to Barcelona. There I saw the beautiful Park Guell of Gaudi. I met both my master and my destiny. I trembled all over. I knew that I was meant one day to build my own Garden of Joy. A little corner of Paradise. A meeting place between man and nature. Twenty four years later I would embark on the biggest adventure of my life, the Tarot Garden. . . As soon as I started the tarot I realized it would be a perilous journey fraught with great difficulties. I was struck by rheumatoid arthritis and could barely walk or use my hands. Yet I went on. Nothing could stop me. I was bewitched. I also felt it was my destiny to make this garden no matter how great the difficulties.[5]

The potent symbolism of the Tarot had long been an obsession for her, and she saw it not only as a game and a divinatory device but also an initiatory system of great antiquity. The pack has 56 'minor arcana', that is cards divided into suits, plus 22 trumps or 'major arcana'. It is the trumps, with their deeply powerful images that are the basis for the figures in the garden. Twenty-two is also the number of letters in the Hebrew alphabet and a key number in the Jewish Kabbalah. Arguably there are also ancient Egyptian and alchemical echoes in the cards, although their origin has essentially remained a mystery.

'The tarot', writes Niki de Saint Phalle, 'has given me a greater understanding of the spiritual world and of life's problems, and also the awareness that each difficulty must be overcome, so that one can go on to the next hurdle and finally reach inner peace and the garden of paradise.'[6]

She began the Tarot Garden in 1979 after receiving the six-acre site as a gift from Italian friends. The considerable sum of money needed

for the project came from the royalties she received for designing a bottle top for a brand of perfume. Over the years the garden took shape with the help of a small army of craftspeople – builders, ceramists, welders, painters. In their hands the figures turned from eerie shapes in wire mesh to what they are today with their dazzling colours and glittering mosaics of ceramic and fragments of mirror. For many of the sculptures Jean Tinguely made ingenious pieces of zany machinery, which was his hallmark.

Today the visitor must pass through a deliciously forbidding entrance, designed by the architect Mario Botta in deliberately stark contrast to the garden itself. It takes the form of a bare, fortress-like wall built of the local honey-coloured stone, with an enormous Chinese moon gate in the middle – as mentioned earlier, the circular form of the moon gate, representing heavenly perfection, emphasizes that one is passing through into a different realm.

From the gate one progresses uphill between groves of olive and eucalyptus. The first main figure to come into full view is the High Priestess – a vast, turquoise head, surmounted by another head covered in mirror glass and with a hand poking up out of its empty skull. The round, gaping mouth forms a cave deliberately reminiscent of Bomarzo, from which water tumbles down a flight of steps flanked by a snake and into a basin in the middle of which is a piece of Tinguely machinery representing the Wheel of Fortune. Inside the head of the High Priestess is a dark, purple cavern with a mysterious female figure concealed by a purple shroud. According to Niki de Saint Phalle's own description, the Priestess represents intuitive feminine power. 'This feminine intuition is one of the "Keys" of wisdom. She represents the irrational unconscious with all its potential.'[7]

The way leads on under an arch of blue mosaic surmounted by a great exotic bird with outstretched wings, representing the Sun card, past the Hierophant, whose eyes, nose and mouth are suspended in mid-air between pillars of mirror glass, and up a flight of 22 numbered steps to the Justice figure, a large black and white female whose breasts double as scales and whose womb is a cavern behind a pad-locked iron door, with rusty iron machinery by Tinguely, which creaks into action automatically as one approaches (symbolic of injustice). Nearby is the Hanged Man, suspended upside down inside a hydra-headed monster, and the Emperor, a Gaudiesque castle with walls and turrets leaning at all angles and a peaceful inner courtyard with olive trees and a fountain with two Nanas having a bath. Next to the

Emperor is the Falling Tower, faced in mirror glass, the top two storeys half demolished by a lightning bolt represented by another Tinguely machine-sculpture.

Perhaps the most striking of all the figures is the Empress, a sphinx with a black face resembling Queen Victoria. The nipples in the vast breasts double as windows, for the figure is also a house, in which the artist lived when she visited the garden, the interior an igloo of kaleidoscopic mirror glass. 'The Empress is the Great Goddess', she writes. 'She is the Queen of the Sky. Mother. Whore. Emotion. Sacred Magic and Civilization.'[8]

As you wander off into the periphery of the garden you come across other figures, large and small, among the trees and in half-hidden clearings: the Lovers; the Hermit, an austere form in mirror glass with the head of a space alien; Death, a gold Nana with a skeletal head holding a scythe and mounted on a black horse with a starry canopy; the Devil, a sinister, bat-winged apparition with a phallus shaped like a gold claw – the card of 'Magnetism, Energy and Sex. . . also the loss of personal freedom through addictions of any kind'; the Fool, representing 'man on his spiritual quest. . . the hero of the fairy tales who appears dim witted but is able to find the "treasure" where others have failed'; and the World, a blue Nana standing on a gold egg encircled by a snake and surmounting a Tinguely machine – 'the card of the splendour of interior life. It is the last card of the Major Arcana, and the spiritual exercise of the game.'[9]

Working with these images convinced the artist that they are not merely decorative whimsies but contain powerful energies. 'When we did the Falling Tower – in tarot the sign of betrayal – everything that could go wrong went wrong. Betrayal, theft, illness, everything.'[10] And when she worked on the Devil she had 'visions of hundreds of devils swarming around the Sphinx'.[11] More mundane problems, including financial ones, plagued her constantly during the building work. 'Today', she writes, 'I see these difficulties as part of the initiation I had to go through for the privilege of making this garden.'[12] Sadly, Niki de Saint Phalle died in 2002.

Geomancy and modern physics in a Scottish garden: Portrack House, Dumfriesshire

The remarkable garden at Portrack House in Dumfriesshire, Scotland, was created by the architect Charles Jenks and his wife

Maggie Keswick, who was the author of a standard work on Chinese gardens (quoted in Chapter 2). They worked together on the gardens from 1989 until Maggie Keswick's untimely death from cancer in 1995, and her husband has since continued the project as a tribute to her. Maggie was interested in the art of *feng shui*, while her husband was fascinated by physics, chaos theory and fractal geometry, and the garden reflects both of their approaches. Not having yet visited the garden, I must rely on the descriptions of others. Anita Pereire, in her book *Gardens for the 21st Century*,[13] describes it is follows:

> The feeling here is of invigorating, surrealistic beauty, linked to an inescapable sense of logic. There is much interest today in cosmology and chaos theory and in others of the sciences which can be characterized as 'non-linear dynamics'. . . This is a garden which represents nothing less than the story of the universe, not from the point of view of the planting, nor from a religious or historical angle, nor a Darwinian perspective, but by translating into a visual formula these new scientific preoccupations.

I quote from a description of the garden by Inge Westbroek in the German magazine *Blätterrauschen*:

> Directly in front of the house begins a long lawn, divided from the adjacent park by an undulating ha-ha. . . The surprises begin when one approaches the ha-ha. The 'Giant Dragon Ha-Ha', as it is called, is built from two contrasting types of stone, placed in diagonal layers, and divides not far from the house to form the 'Symmetry Break Terrace'. Here alternate stripes of grass and gravel symbolize the four great leaps that have taken place since the beginning of the world, namely the creation of energy, matter, life and consciousness.

Other features include a 'Physics Garden' (a pun on the term 'physick garden'), with 'large models of the atom and the universe and a figure of the Earth Goddess, Gaia', as well as a greenhouse whose roof ridge is decorated with a metal frieze bearing scientific formulae relating to Heisenberg's uncertainty principle and other concepts from modern physics.[14]

A Renaissance garden in the New World:
Dumbarton Oaks, Washington DC

The United States of America has some remarkable gardens that deserve a place in this book, although what follows is nothing more than a tiny sampling. As you would expect, it is possible to find in the USA examples of many different gardening styles from around the world, imaginatively adapted to the American environment.

Dumbarton Oaks in Washington DC is one of those potently magical gardens where the magic cannot be precisely defined. It lies in the quiet district of Georgetown, with its steep, tree-lined streets, brick pavements and crisp Georgian houses with neat beds of *Impatiens* in front. The garden belongs to a mansion which used to be the home of the diplomat Robert Woods Bliss and his wife Mildred. It is now an outpost of Harvard University and houses collections of pre-Columbian and Byzantine art as well as a garden library and a department of landscape architecture. Built on a slope, with numerous terraces and *compartimenti*, the garden is essentially a twentieth-century adaptation of the Italian Renaissance style.

Mr and Mrs Bliss bought the house in 1920, along with a generous piece of land sloping gently away to the south and plunging steeply downwards to the east and north. They commissioned Beatrix Farrand, 'the Gertrude Jekyll of America', to design the garden. It was an inspired choice. Mrs Farrand, surely one of the most brilliant garden designers of all time, not only knew all about plants and planting but also had a profound mastery of garden architecture and an unerring eye for form and detail. From the beginning she and Mildred Bliss worked closely together, Mrs Bliss bringing a wide knowledge of art and architecture, a flair for garden planning and a strong personal vision. It was an ideal partnership, which produced what I regard as one of the most hauntingly beautiful gardens in the world.

You enter the garden from R Street through a set of imposing wrought-iron gates featuring a wheatsheaf and the Bliss family motto 'Quod Severis Metes' (as you sow, so shall you reap). As soon as you enter the garden something elusive whispers to you and beckons, and you follow, but it remains only half there – hidden in the shadows or camouflaged in the sunlight shimmering through the leaves. Following a path to the east you come to a little Pan figure sitting nonchalantly cross-legged on a pillar, holding a pipe in his left hand and pointing

south with his right. Half-human, half-goat, he is one of those boundary figures that we have encountered in other gardens. He welcomes us into an Arcadia where human artifice mingles with nature in a near perfect balance.

In the direction he is pointing the path leads downhill into a little amphitheatre with brick tiers overlooking a pool flanked by classical columns. The symbolic significance of this spot, and of the Pan figure, become clear from a passage in the *Plant Book* that Beatrix Farrand wrote for the garden and its future owners. 'The seats of the amphitheatre', she writes, 'have been adapted from the well-known open-air theatre on the slope of the Janiculum Hill at the Accademia dell' Arcadio Bosco Parrasio.'[15] The academy she refers to, known more briefly as 'the Arcadians', was founded in Rome in the eighteenth century and named after Sannazaro's poem *Arcadia*. Their meeting place on the Janiculum, the Bosco Parrasio, where they read their compositions, was built in 1725. As Linda Lott, Librarian of the Garden Library, further explains in her monograph on the ornamentation of the garden: 'The stated aim of the academy was to eliminate bad taste in literature and free Italian poetry from the "barbarism" of the seventeenth century, and return to the simplicity of nature. As symbols of classical purity all members took names [comprising] both a region of Arcadia and an Arcadian shepherd. They adopted the pipes of Pan along with a pine branch as their badge.'[16]

From the amphitheatre and the pool a walk called Mélissande's Allée leads between silver maples, and in spring past crocus, narcissus and lily-of-the-valley, down to the kitchen garden and the lower part of the grounds. Alternatively if, instead of following Pan's pointing figure, you go into the area closer to the house, you enter an enticing complex of terraces, arbours, gazebos, fountains, enclosed gardens, graceful stone retaining walls and flights of steps – everything looking so perfectly in place that one can easily forget the colossal work that went into building the garden. The richness of ornament and architectural detail is one of the striking features: wrought-iron gates, benches, finials, statues, balustrades and delicately scrolled stonework. Interestingly, many of these objects were tested out in advance in the form of mock-ups, made of clay if they were sculptures or thin wooden boards in the case of gates and other architectural features.

Another thing that strikes one is the abundant use of inscription. I have earlier described how Ian Hamilton Finlay rediscovered the classical tradition through struggling with the placing of inscriptions

in a landscape. Beatrix Farrand and the Blisses must also have struggled to find the right placings for their inscriptions – and with equally felicitous results. On one terrace, within a wooden arbour festooned with wisteria, is a stone plaque dedicated to the Blisses' friend, the Italian diplomat Gelasio Caetani, with a quotation from Dante's *Purgatorio*: 'QUELLI CH ANTICAMENTE POETARO LETA DELL ORO & SUA STATO FELICE FORSE IN PARNASO ESTO LUCO SOGNARO' (Those who in old time sang of the Golden Age and of its happy state, perchance, upon Parnassus, dreamed of this place). Another inscription in stone is found by the steps leading down from the swimming pool. The words are by the poet Joseph Auslander, another friend of the Blisses, and allude poignantly to the white azaleas that are one of the glories of Dumbarton Oaks:

> Like the flash of a wing
> I came upon
> The loveliest thing
> Since Avalon
> White blossoming
> Azaleas wan
> As a wounded king
> As a dying swan.

Here again we find that powerful resonance between a poetic inscription and its surroundings that we encountered at Finlay's Little Sparta.

The *Leitmotif* of the wheatsheaf and its accompanying motto reappear a number of times in the garden, for example exquisitely set in coloured pebbles glazed over by the water of a shallow pool which you can look down upon dramatically from an upper terrace. From here you can also survey the garden towards the south. Down the centre runs a path lined with box hedges and ending in an ellipse with an antique Provençal fountain in the centre. To the left are Crabapple Hill and Forsythia Hill. The planting of the grounds has been brilliantly orchestrated. The fine old oaks, maples and tulip trees, which were there originally, have been retained. Bold structure is provided by the extensive use of blocks of evergreen: yew, privet, holly and box. Colour is there in abundance: golden forsythia in the spring, white magnolia and azalea in the summer, massed chrysanthemums in the autumn – and much else.

An idea of the subtle care that Beatrix Farrand brought to her planting can be gained from this quotation from her *Plant Book*: 'Two or three skilfully wall-trained *Forsythia* may be used on the south front underplanted with ivy; the underplanting is needed in order to make a background for the yellow flowers which without the ivy foliage are unpleasant in colour immediately close to the brick wall.'[17]

One of my favourite spots at Dumbarton Oaks – and one of the most mysterious – is the Star Garden, a secluded little paved area next to the east wing of the house and surrounded by a hedge of white azalea, where the Bliss family used to dine outdoors. Here the theme is cosmological and astrological. Against the brick wall to the west is a little fountain with an Aquarius figure in lead relief pouring water from an urn into a stone basin. Most striking of all is the pattern set into the stone pavement: a sun within a ten-pointed star, within a circle, within a square. At the corners of the square are lead figures of four constellations: Capricorn, Aries, Pegasus and the Phoenix. And around the circle is a quotation from Chaucer's translation of Boethius' *Consolation of Philosophy*: 'O thou maker of the whele that bereth the sterres and tornest the hevene with a ravisshing sweigh.'[18] When I stand here it feels as though the whole spirit of Dumbarton Oaks is concentrated in this place. It has a Pythagorean quality that speaks of divine order reflected in microcosm. You almost feel that if you listened very carefully you could hear the distant music of the spheres.

When I enquired at the house about the meaning of the Star Garden I found that there was virtually no information about it available apart from two pages in Mrs Farrand's *Plant Book* with instructions about how the plants should be tended. Yet the images and the quotation are too carefully chosen to be merely decorative, and my feeling is that the Star Garden and the whole grounds are intended to inspire us with the vision of civilization, beauty and divine order that the Blisses and Beatrix Farrand cherished. 'Gardens have their place in the humanist order of life', wrote Mildred Bliss in the inscription above the entrance to the house – and I will leave her with the last word.

Feng shui in New England: Innisfree, New York State

Almost contemporary with Dumbarton Oaks is Innisfree, the remarkable garden created by Marion and Walter Beck for their home at Millbrook, New York, from 1930. After the demise of the Becks

the garden was further developed by the landscape architect Lester Collins, who died in 1993 and who has left behind a very loving and detailed description of the garden and its creation in his book *Innisfree: an American Garden*.[19] The property is now run by a trust for the study of garden design and is open to the public from spring to autumn. The name is taken from the poem by W.B. Yeats ('I will arise and go now, and go to Innisfree').

The house that the Becks built on the site was based on the head-quarters of Britain's Royal Horticultural Society at Wisley in Surrey – all half timber, generous overhanging roofs and soaring brick chimneys. Their original intention was to create a traditional English garden to go with the house, but the landscape around it called for something quite different, and finally the Becks decided to build a garden along traditional Chinese and Japanese lines, influenced particularly by the Chinese horticulturist, poet and statesman, Wang Wei (AD 699–759).

The Becks formed an ideal partnership – she with a detailed knowledge of plants, he an artist with a strong visual imagination and a profound interest in oriental gardening traditions. From Wang Wei they took the concept of a series of visual oases or focal points set within a landscape, some of them as small as a single, carefully placed rock. For these Walter Beck used the term 'cup gardens'. Another source of influence was the Japanese work *Sensai Hisho* (The Secret Garden Book), probably compiled in the eleventh or twelfth century and containing detailed advice on both the practical and the aesthetic level. Not surprisingly, the spiritual and symbolic dimension is strongly present at Innisfree – in the veneration for rocks, the balance of *Yin* and *Yang* and the use of appropriate visual images, such as the Dragon of the *Ch'i*. To give an impression, I quote from Collins' book:

> While the landscape architects and gardeners of the DuPonts, Wideners and Vanderbilts were following the estate rules established in Europe, Beck was in the field experimenting with Eastern design principles. Each day he worked with twenty or more men. On the terrace floor beside the house he personally incised the slate and cement inserts with Chinese symbols, including playful elephants and phoenixes. . . One of the first, and one of the most beautiful of Beck's cup gardens begins with a high stone wall. . . A row of cedars heightens the wall and connects it to the woodland beyond. Built into the wall is a five-

foot circular cave. With a *yang* and *yin* sense of humour, Beck filled the entrance to the grotto with two stones, definitely male and female, to guard the grotto.[20]

Another area, called the Point Cup Garden, features three carefully positioned rocks:

> The center rock, a rather homely boulder, became important when it was given stone feet. It became dynamic yet amusing, a friendly dragon guarding the south water entrance to the garden. The huge, flat, upright rock called the Owl Rock faces east, forming a foil to the trees behind. The pine tree, leaning into the space, binds together the Owl Rock and the Dragon Rock, leaving the Turtle Rock, the third rock, isolated, its influence bearing on the water. The three rocks and the pine lift this cup garden out and up from the Lake. Interchange the rocks and the picture is shattered. . . In the center of the dark water Beck planted a tuber of white lotus.[21]

Innisfree is an inspiring example of a garden in which oriental forms have, with enormous effort and skill, been successfully introduced into an American setting.

A garden of emblems in North Carolina

From New York State we move to the grounds of a college in North Carolina and to a garden of densely packed emblems that takes us back into the atmosphere of the Renaissance and of *Poliphilus*, with echoes of alchemy, sacred geometry and much else. This remarkable garden was created in the 1990s at the North Carolina Center for the Advancement of Teaching in Cullowhee by Neill Clark, who, in correspondence with the author, describes the genesis of the garden as follows:

> The idea came to me in a dream. I had retreated to the North Carolina mountains where I sat on my little porch gazing down the sloping lawn at the river where ancient Cherokees had built fish traps out of stones. Watching the river I fancied I was purifying my soul by purging the images of the city and replacing them with images from nature: the river, the farm field, the mountains,

the birds. That night I dreamed of mandalas, geometrical patterns inscribed within circles, vividly colored. All were constructed of flowers. I awoke with a compulsion to plant a garden. When I looked outside I was shocked to discover that my landlord had 'improved' the property by 'topping' the four old maples that marked a large rectangle between the house and the river. I was furious. I moved out and began to plan a garden.

The North Carolina Center for the Advancement of Teaching was conceived as a place for teacher renewal in the noblest sense. The teacher is offered a free week-long seminar in a topic of their choosing which they pursue in the resort setting adjacent to Western Carolina University in Cullowhee. To make a Renaissance garden on the Center grounds seemed to me an apt symbol for the personal renewal of those most directly responsible for maintaining and disseminating the best of that tradition: the teachers. So, for the next three years over 75 North Carolina public school teachers participated in building a garden in the Renaissance style which contained allusions to significant aspects of the tradition and which provided them with practical training in the rudiments and some of the fine points of gardening. Since Hermetic knowledge was a major content of the early Renaissance, it seemed appropriate to refer to these themes in the details of the garden. The motto of the garden was taken from the *Hypnerotomachia Poliphili*, which is a milestone in the history of printing, publishing and gardening. A gazebo is decorated with a wood sculpture derived from one of the woodcuts from this intriguing book. It depicts a serpent and a recumbent goddess flanking the motto *panton tokadi* ('to her who is the mother of all things'). That this book is a series of illustrations of dream gardens, which later inspired actual gardens and which was unknown to me when I had my own 'garden dream', seemed synchronistic and added a personal 'secret' to the garden. Other mottoes were chosen for their Renaissance connections: At the gate is the motto chosen by Lorenzo as his personal motto in the tourney he and his brother Giuliano presented in 1579: *Le Temps Revient* (time returns) beside a figure of eight signifying infinity. Indeed the Renaissance itself was a 'return', and for the teachers at the Center their personal renewal was a 'return' to the sources of learning for its own sake that had originally

inspired their choice of a career. Another homage to an early Renaissance prince came about by chance. Converting my napkin sketches to actualities the architect produced a pattern of the cross of Lorraine in the balustrade on the second story of the gazebo. This we ascribed to the spirit of René d'Anjou, who was a major transmitter of the Hermetic tradition in Italy and had the cross of Lorraine as his personal sigil. Near the center of the garden is the inscription *Et In Arcadia Ego* which is familiar to readers of *The Holy Blood and the Holy Grail*.[22] Arcadia is famous in English literary tradition through Spenser's work. A somewhat sad secret of our personal association is that it expressed the feelings of many of the staff that the Center might be moving away from the high-minded beliefs in personal renewal to the more organizational notions of 'professional development' in the direction of the Center; thus when death speaks that 'even in Arcadia, I am', he spoke for us as well.

The main part of the garden is a rectangle measuring about 80 by 60 feet with a hedge of arborvitae (*Thuja*) on three sides and an inner perimeter fence of wooden paling. In one section, paths of crazy paving form a circle within a square, with four paths joining the circle to the corners of the square. In the middle is a pool with a three-tiered fountain fed by spring water. Here, as Neill Clark indicates, is a small-scale paradise garden with its central fountain and four paths representing the four rivers. The circle in the square is intended as an alchemical reference, while the medicinal herbs planted in the spaces between and around the crazy paving are meant to evoke the medieval physick garden. Outside the arborvitae enclosure is a bed subdivided according to the golden section, a proportion in sacred geometry where a line is divided in such a way that the smaller section is in the same ratio to the larger one as the larger is to the whole. Rectangles and curves can be derived from the same proportion, and here two such curves are outlined in holly against bedding annuals. As Neill Clark explained in the same correspondence, 'the mathematical notion of a hidden force that runs through all things we expressed through the choice of dimensions from "fibonacci numbers", which are the arithmetical expression of the principles of the golden ratio. This underlies some of the deepest mysteries of the Renaissance and the transformation of culture brought about as contemporary science emerged from the shadows of occult philosophy.'

Neill Clark tells me that the garden is still open to visitors to the NCCAT, located directly across from the entrance to Western Carolina University in Cullowhee, which is just a few miles west of Sylva, North Carolina. He adds that 'over the years the arborvitae have grown to great height and completely enclose the garden on three sides so that only the peak of the gazebo is visible from outside and is like a watch tower commanding a view of the entire center from within, but protects the *hortus conclusus* inside'.

Gardening as a rite of passage: The Hide, Ohio

Another American garden that is rich in symbolic meaning – of a rather different kind – is The Hide, located in the country 15 miles from Cleveland, Ohio. At first glance The Hide appears to have little that is symbolic about it – a crisp, modern house made of wood shingle and built on a slope, with generous picture windows and terraces at different levels, set in three acres of woodland. To understand the symbolism of The Hide one has to talk to the man responsible for it, Jan Heynike, a South African architect who lived there with his wife Trilly and their family from 1997 to 2000 – a man with an eclectic religious background and a profound interest in mythology and the Jewish mystical tradition of the Kabbalah. At the time when they moved in, their son Charl was approaching his 13th birthday, the traditional age of passage when one begins to grapple with questions about values and moral issues. Heynike felt that creating a philosophical and mythical garden would be a good way for him and his son to explore together some of these questions in a symbolic yet concrete way. They used one acre of the land for the garden, which took ten months to plan and another ten to build.

They began by discussing primitive man and his basic needs. 'The first idea that came up', Heynike explained, 'was the theme of the mystical castle, standing on a rock of time, to express humankind's eternal need for shelter, comfort and sanctuary. The castle was the house itself. Then all the other bits dropped into place.' From this basis they set up a cosmology in which each element carried a message. 'The centre was a point in the house which we called the Source. It was a doorpost totem from a Dogon village in west Africa, depicting a Mother Earth figure with prominent breasts and vulva – a fertility symbol similar to the Mother Earth figures from Crete. The house also became the sun, the source of light, as well as the source of knowledge.'

Around the house they drew a circle approximately 100 feet in radius, with the totem at the centre, representing truth. Because truth is always shifted by human beings, they moved the centre of the circle slightly to one side to represent prejudice, and from this new centre they cast a wider circle to represent the cosmos itself. This outer circle then became a boundary between an inner and an outer realm, between dark and light, right and wrong, order and untamed nature. Everything beyond the outer circle was 'left to God and nature'. They also wanted to emphasize that the boundary between the inner and outer realms is movable and not always clear. The trees, predominantly oak, within the wider circle came to represent elements of darkness (shade) inside the realm of light.

Names were also given to other features in the garden. The 'Edge of Darkness' was a point where a wooden deck, projecting from the house, reached the outer circle. Around an electrical transformer in the grounds next to the outer circle they built a circular stockade made of logs and called the spot the 'Last Outpost'. The lawn became the 'Emerald Sea', and there was also a 'Witches' Cauldron' (a nest woven out of twigs from the wood), a 'River of Leaves' and a 'Crystal Eye' (the swimming pool).

As they worked, they learned much about the abundant and varied plant life – including day lilies, daffodils, ivy and 14 types of wood fern – and they enhanced the visual texture of the garden by laying paths, lawns, areas of pebble and wood mulch, using only what they could harvest from the wood itself. The result was a place of great beauty that astonished their friends in the neighbourhood. Perhaps more than any other garden described in this book, the message of The Hide lay as much in the process of creating it as in the end product.

Gardens in cyberspace

What place is there for gardens – and their gods – in the digital world of information and communication technology? Actually, a very important one. And vice versa – information technology has enormous and exciting implications for horticulture, which are only just beginning to be explored. In the space available here I can do no more than touch on this subject, but some interesting ways can be mentioned in which information technology is relevant to the theme of this book.

First, there are gardens that can be visited in varying degrees of virtual reality via the Internet, including many that have been described in this book. What follows is only a tiny sampling and obviously subject to change, as web sites come and go constantly. And of course any trawl of the Internet, using a good search machine such as Yahoo, Altavista or Lycos, will reveal a vast number of garden-related sites.

One useful starting point is the web site of the Museum of Garden History in London, the first museum of its kind in the world: http:www.cix.co.uk/~museumgh. Located on the south bank of the Thames in the converted church of St Mary-at-Lambeth, it contains exhibits illustrating the history of gardening, its changing styles and its famous exponents through the ages. The small churchyard is itself a charming garden, shaded by trees and containing a replica of a seventeenth-century knot garden. Buried in the churchyard are several famous people including Captain Bligh of the *Bounty*, Elias Ashmole, founder of the Ashmolean Museum at Oxford, and John Tradescant, the explorer and plant-hunter. Tradescant's tomb, which also commemorates two other generations of the Tradescant family, is carved with a remarkable and mysterious series of reliefs, which include a landscape of ruined pyramids and temples (reminiscent of the symbol-strewn landscapes of Freemasonry) and a seven-headed dragon (possibly an allusion to the dragon of the Hesperides). The home page of the museum contains a moving panorama of this delightful oasis, and there are also links to other gardens open to the public as well as to information about books, societies, courses and other garden-related matters.

Leaping to the Far East, one can find web sites for most of the gardens that I have mentioned. In Japan, for example, the Kyoto Prefecture has a site illustrating many of the city's great gardens, such as the Ryoanji (http:www.pref.kyoto.jp/intro/trad/isan/ryoan_e.html). Islamic gardens are also well represented. A good site for the Taj Mahal is http://rubens.anu.edu.au/student.projects/tajmahal/home.html, which has coloured plans and photographs and an interesting description of the complex irrigation devices. Moving to Renaissance Italy, it is not surprising to find that Bomarzo has several web sites. A good one for taking a virtual tour of the garden (although with text only in Italian) is wysiwyg://6/http://www.acpb.com/bomarzo/index_it.html). Bomarzo's modern descendant, the Tarot Garden of Niki de Saint Phalle, is also present on the Internet (e.g. at http://www.nikidesaintphalle.com).

Coming back to England, there is a very well-designed site for Stowe at http://www.nationaltrust.org.uk/places/stowgardens/approaches.html, enabling you to move easily around the garden and providing detailed information about its history, buildings and design. In addition to these web sites for famous gardens there are also many private garden owners who have set up home pages. Although most of these do not have any special symbolic dimension, they can be a good source of horticultural ideas.

The second important use of computer technology in relation to horticulture is in the designing of gardens. A glance at the web site of any on-line bookseller, such as Amazon, will reveal a large selection of garden design programs on compact disc. These give you the possibility to create your own garden on screen, starting from an empty site of any dimensions and adding plants, trees, paths, walls, changes in ground level and ornamental features to create a detailed image of the desired plan, which you can move around in and view from any angle. The visual quality and resolution of these programs is improving all the time, and the best ones allow you to see what the plants will look like at different stages of growth as well as at different times of day and year. Thus you can experiment with as many different designs and planting schemes as you wish before you go out and start building your real garden.

Taking this technology a step further, it would be possible to create virtual gardens that could be enjoyed for their own sake. Already there are computer games in which one can move around inside astonishingly realistic worlds, and these could include gardens. With the use of three-dimensional goggles and sensory-simulation devices it would be possible to give the user a convincing illusion of being in a real garden, complete with scents, breezes and bird songs. Although few people would ever consider such gardens as a substitute for the real thing, they would have certain advantages over reality. For one thing, apart from the investment in the necessary hardware and software, there would be relatively few limitations of expense. Using virtual reality technology that has become commonplace, one could create one's own version of the Taj Mahal and its paradise garden or build something even more extravagant in one's private domain. Nor would there be any restrictions of climate, geography, soil conditions or the other natural factors that the gardener must pay attention to. The garden could be filled with whatever plants or trees one fancied, however exotic. These could be replaced at a moment's notice or made

to grow instantly to any size. Indeed, it would be possible to invent amazing new types and species and to populate the garden with mythical creatures – living gryphons, sphinxes and satyrs instead of stone ones. But here we are approaching the hubris of attempting to vie with the gods themselves. Moreover, in a garden where anything could be created at the touch of an electronic control we would lose that fertile tension between art, with its urge to stretch boundaries, and nature, with its laws and limitations. And, as we have seen, it is at the intersection of art and nature that the magic of gardens happens.

11

CONNECTING WITH NATURE

A garden, as we have seen, is an interface between art and nature. So far in this book the emphasis has been on art, that is to say, on gardens that have been designed, shaped and ornamented to create meaning. Now it is time to look at the other half of the equation, namely nature itself – both as a kind of text full of divine meaning if we know how to read it and interpret its manifold layers, and as a realm full of conscious entities and living energies that can work in partnership with us if we are sufficiently sensitive to them.

There is one obvious difficulty that can arise here. In trying to balance art and nature we may find situations where one conflicts with the other. Restorers of public parks and gardens are familiar with this problem. Just when they are about to start work restoring a formal parterre to its original splendour the local nature conservation lobby steps in and says on no account can they remove the clump of alder trees that have colonized the spot and provide essential habitat for numerous forms of wildlife. Or take the controversy that arose recently over a fountain to Hercules in the grounds of a castle in Schleswig-Holstein. One faction wanted to restore the statue and clear the basin, which was clogged up with two centuries' growth of vegetation. The other faction saw it as unique biotope, which had to be preserved at all costs. In the end the restorers prevailed, but who is to say which side was right? The same kind of dilemma can face the private gardener. Do I clear that patch of nettles, cow parsley and other wild plants to make way for a labyrinth, or do I follow the advice of my biodynamic gardener friends and leave

it as it is? Do I dig up the weeds, kill them off with herbicides or live with them as part of the diversity of nature? These are not easy questions. And after all, most of the gardens that have been described earlier in this book involved much clearing, re-shaping and constraining of the natural environment.

Anyone trying to combine art and nature in a garden will to some extent face this conflict of interest, although it might help to see it as a creative tension rather than a conflict. A garden that was pure art would be sterile and a garden that was pure nature would not be a garden. Each gardener must find his or her balance between the two.

This chapter will first describe the subtle alchemy of plants and how it is influenced by the moon's phases and other cycles. Next we shall consider the subject of companion plants, then look at the intelligences at work within the plant world and how we can work in harmony with them. Finally we shall investigate the patterns of energy within the earth itself and explore ways of detecting and using them positively. Each of these subjects is of course a vast area requiring a lifetime of study, and this chapter can do little more than scratch a tiny part of the surface. One should also bear in mind that this terrain should be approached with an attitude of humility, reverence and patience and without expecting any quick or easy recipes.

Understanding the alchemy of plants

Plants are continually performing a process of alchemy that is in its way as miraculous as the transformation of lead into gold. This process, known as photosynthesis, is familiar to every student of elementary botany, but it might be helpful to look again at how it works before considering its deeper significance.

The green parts of plants contain a pigment known as chlorophyll, which is energized by absorbing light quanta from the sun. The resulting energy then enables the plant to split water molecules and produce oxygen, which it transforms into nutritious phosphates. Plants also perform a vital role by emitting oxygen into the atmosphere. In a separate process the plant uses the acquired energy to absorb carbon dioxide from the atmosphere and process it into sugar and starch. Most of the body of the plant consists of substances that it has taken from water and air, while a smaller proportion is drawn from material in the earth. Here we have a perfect example of the four alchemical elements – Earth, Water, Fire and Air – working together.

In India there is a traditional belief that plants are in fact in a process of continual deep meditation in which they listen to the primal mantra, *Om*, emitted by the sun, and transmit it to the earth. This might be one reason why plants often react sensitively to sound. As the German ethnobotanist Wolf-Dieter Storl writes:

> The primal mantra, embodied in light, is transmitted to us by plants in a life-giving process. Only plants are able to connect in this way the celestial and mundane realms. In the sacred language of the Vedas plants are designated by the word *osadhi*. The word is made up of *osa* (burning transformation) and *dhi* (vessel). In this sense plants can be regarded as vessels for the metamorphosis of the cosmic fire.[1]

The alchemical analogy can be taken further by seeing the four elements reflected in the structure of the plant, as Rudolf Steiner, the founder of the Anthroposophical movement, believed. He set out the correspondences as follows:

> Roots = Earth
> Leaves = Water
> Blossom = Air
> Seed (and the oil derived from it) = Fire

According to Steiner's view, one way in which a plant communicates its essential nature to us is according to whether its energy is focused downwards towards the roots (i.e. towards the physical realm) or upwards towards the outer leaves and blossoms (i.e. towards other-worldliness and spirituality). For example, plants that produce a lot of etheric oil (the spiritual pole) tend to be short on production of vitamins (the physical pole), and vice versa.

However, the energy of a plant is not static, but changes in a daily, monthly and yearly rhythm. Obviously the solar year is the basic cycle for all gardeners and farmers, but there is also an ancient tradition of planting and harvesting according to the cycles of the moon. The ancient Greek author Hesiod compiled a lunar agricultural calendar in the eighth century BC, which became the model for subsequent calendars. With the advent of modern, mass-production agriculture the practice went out of favour, but it was revived by Steiner as part of the biodynamic agricultural system that he developed in the 1920s.

In the 1950s the method was taken up enthusiastically by the German Anthroposophist Maria Thun who, at the time of writing, is in her 80s and still active. Her books on moon-based gardening, some of which were written with her son Mathias, have influenced gardeners and farmers throughout the world. There is now an abundant literature on the subject of gardening by the moon, and annual lunar calendars have become indispensable for many gardeners. There is also, not surprisingly, a vast amount of information on the subject available on the Internet.[2]

How does the method work? Just as the moon controls the tides in the oceans, so it also causes the rise and fall of moisture and vital energies in the soil. The gravitational pull is strongest at the new moon and the full moon, when the sun and moon are approximately lined up with the earth, and weakest at the half moon. At the same time, the more moonlight there is, the more vital energy will be drawn upwards. The combination of gravitational pull and moonlight determine the best times for planting, depending on the crop. The first quarter, for example, when gravity is strong and moonlight beginning to increase, is good for balanced root and leaf growth and is the best time for planting above-ground crops that produce their seeds outside the edible parts – such as lettuce, spinach, broccoli and cauliflower. The third quarter, when moonlight is decreasing and the energy moving downwards, is best for planting root crops such as carrots, onions and potatoes.[3] The moon's phases are also used to determine the best times for harvesting. Among herbalists there is a tradition that herbs can best be gathered at the new moon, when the tide of life energy is rising up into the leaves.

For many 'lunar' gardeners another important consideration is the zodiacal sign in which the moon is placed. The moon moves into a new sign approximately every two days, and each sign is believed to have its own properties that will favour certain plants or indicate a suitable time for planting or harvesting. Astrologers divide the signs into four groups of three, each group corresponding to one of the four elements. Aries, for example, is a fire sign and is considered barren and dry. The period when the moon is in Aries is good for harvesting root and fruit crops and for weeding and getting rid of pests. Taurus, on the other hand, is an earth sign, productive and moist and good for planting both root crops and leafy vegetables. Cancer is a water sign, very fruitful and moist and the best sign of all for planting and transplanting.

Apart from the yearly and monthly cycles, the daily cycle can also be important. It is widely believed among herbalists that the best time for picking is the early morning before sunrise. But if the herb is intended to cure a particular ailment and if the herbalist is also an astrologer then he or she may pick the plant at the hour corresponding to the planet which governs the affected organ.

From a different perspective, it is the transitional, 'threshold' times that are often favoured in traditional cultures, especially if the plant is being gathered for magical purposes. Wolf-Dieter Storl writes as follows about the times favoured by the Celts for gathering plants:

> The short span of time when the sun appears over the horizon or crosses its zenith, the moment when the cock crows or the morning star fades, the twilight hour when the swallows return to their nests and the bats to their holes, the seasons when certain stars such as Sirius rise or fall, the times of the solstices and the equinoxes – such transitional moments were regarded by the Celts as laden with magic.[4]

Here are some suggestions for ways to heighten your awareness of these temporal rhythms. Go out into the garden at night during the changing phases of the moon. Sense how different energies are emanated at the new moon, the full moon, the half moon and the degrees in between. Try to develop an empathy with the plants and feel how they are experiencing the moon's influence. Smell the flowers and try to detect whether their scent changes over the cycle. Pick the leaves of a herb such as mint or chives at intervals during the lunar month and observe any differences in taste. Do the same with some root vegetables if you have any. You could also try a similar exercise at different times of day. As you attune yourself to these subtle patterns of ebb and flow, so you will deepen your rapport with the plants in your garden.

Companion plants

Another exciting and very practical dimension opens up when we consider that there are certain pairs or groups of plants that exist in friendly cooperation. For instance, wherever there is a patch of nettles there are usually dock plants growing as well, and most people who

have ever been stung by a nettle know that an immediate remedy is to rub a dock leaf on the sting. Nettles, in turn, can be beneficial to other plants. In the proximity of scent-yielding herbs they can increase the amount of aromatic oil by up to 80 per cent; and, like foxgloves and lily-of-valley, they enhance the keeping quality of neighbouring plants, especially tomato.[5] There are countless other examples of how plants can work together – protecting, nourishing or in some way complementing each other. This complementarity works in various ways. The chemicals exuded by a plant can often protect its neighbours from pests. Mint, for example, in a cabbage patch or rose bed, will repel a whole variety of pests including ants, aphids and black flies. At the same time its scent will attract bees and therefore assist neighbouring plants in pollination. Another type of complementarity is between plants that fix nitrogen into the soil and those that draw heavily on nitrogen.

Just as there are complementarities so there are also antagonisms in the plant world. Basil and rue, for example, do not get on with each other, and certain trees, such as the maple and the sycamore, inhibit plants growing beneath them.[6]

If you are uncertain whether two plants are friendly or hostile to each other, and you are unable to find a book or a gardener to tell you, one way to find out would be to use a dowser's pendulum. One of these can easily be made using, say, a pebble with a metal eye attached to it, such as would be used for a pendant. Hang the pebble from a piece of string or picture cord and adjust the length until it feels right. Then establish a yes–no code by asking a question to which you already know the answer like 'Is my name. . .?' The pendulum will swing clockwise for yes and anti-clockwise for no, or vice versa. Then you can hold it over one of the plants and ask 'Does this plant go well with. . .?'

Be aware that if you decide to pursue companion planting seriously it will have profound implications for the kind of garden you will create. It will no longer be possible simply to pick the plants you like from a catalogue or garden centre and insert them where you think they will look good. Some plants will have to be excluded and others may have to be re-located. As you become familiar with the plant complementarities you will become more inclined to favour plants that are native or well established in your region and will not upset the ecological balance. And, as you work with and contemplate the subtle web of interactions between the plants and their environment,

you will find the concept of sacred gardening taking on a whole new meaning.

Working with nature's intelligences

All cultures of the world, except for the modern Western one, have believed that nature is animated by conscious beings. Anthropologists dismiss this belief as 'animism' and relegate it to an earlier and more childish phase of human history along with its attendant practices such as fertility rites. Yet there is a growing number of people – environmentalists, gardeners, biodynamic farmers – who accept the 'animistic' view of nature or something very like it. Even among hard scientists there are those who acknowledge that plants are in some sense conscious.

In their book *The Secret Life of Plants* Peter Tompkins and Christopher Bird describe some of the remarkable discoveries in this field.[7] They relate how in 1966 an American lie detection expert named Backster linked the electrodes of his galvanometer to a dracaena plant in his laboratory. After testing its reactions to various stimuli he decided to see what would happen if he burned the leaf to which the electrodes were attached. To his amazement the plant reacted sharply as soon as the idea came into his mind and before he could even reach for a match. This was the beginning of a long series of experiments carried out by Backster and others, indicating that plants possess extra-sensory perception to a high degree. They show distress when in the presence of destructive intention or of people who are habitually harmful to plants. On the other hand they react positively when plant-friendly people are near. They can pick up signals from each other and can form ESP bonds with their keepers even over long distances. They are also extremely sensitive to sound. They thrive when classical music is played at them, while hard rock makes them wilt.

From the findings described by Tompkins and Bird it is not such a big leap to the work of Peter and Eileen Caddy, who in 1962 founded the now famous Findhorn community on the east coast of Scotland together with their friend Dorothy Maclean. The Caddys had worked successfully for several years running a hotel, when their employment was abruptly terminated. Following guidance received in meditation, they moved with their three young sons and Dorothy to the nearby village of Findhorn, where they settled in a caravan on a particularly

bleak and windy piece of coastland. Here in the caravan park they began to create a garden, guided by messages they received from the devas (intelligences of the plant world) through the mediumship of Dorothy. After a period of hard struggle and many setbacks they began to achieve astonishing results. They planted vegetables in sandy soil that was, according to the books, completely unsuitable. Yet, instead of withering, the vegetables not only grew but reached a size that astonished the gardening experts who saw them. Soon they were harvesting cabbages ten times the normal weight and broccoli that was so heavy it could hardly be lifted from the ground.

As news of the project spread, other people were drawn to Findhorn and began to take up residence in the neighbouring caravans. Soon the caravans were not enough and a series of wooden bungalows was built. By the early 1970s there was a community of more than 300 people living, working and studying at Findhorn, and in 1972 the project was registered as a foundation with charity status. Today the Findhorn Foundation, as its web site explains, 'is the central educational and organisational heart of a widely diversified community of several hundred people, spanning dozens of holistic businesses and initiatives, all linked by a shared positive vision for humanity and the earth'.[8] At the time of writing Eileen Caddy still lives at Findhorn. Dorothy Maclean has moved to the USA, and Peter Caddy died in 1994.

What are we dealing with here? Are there really nature spirits? The term might suggest gnomes or semi-diaphanous figures with gossamer wings, but these are surely only ways of visualizing entities or forces that are really too subtle for us to perceive them directly. We therefore clothe them in the form that corresponds to our visual conventions. The Scottish esotericist R. Ogilvie Crombie (Roc, as he was known to his friends), who collaborated in the Findhorn project and whom I met once in the early 1970s, recounted to me the now famous story of how he encountered a Pan-like creature one day in the Edinburgh Botanical Gardens. Having a Western classical education, he naturally saw a goat-legged figure with a Pan-pipe, who might have come from one of Claude Lorrain's paintings of Arcadia. In similar circumstances the American Indian and the African bushman would have seen a quite different form appropriate to their own traditions.

To our ancestors these entities were never far away. They appear in numerous folk tales and legends, and they were regularly honoured in seasonal festivals with dancing, song and carousing. The Mayday

and harvest festivals of today are but pale remnants of those great pagan celebrations. In the modern world the nature spirits are for most people no longer an integral part of life, but they live on in country places, among the volcanic hills of Iceland and in suburbia in the form of garden gnomes. These cheeky figures, with their big heads and pointed hats, might seem kitschy, but we should not forget what lies behind them. Wolf-Dieter Storl has the following interesting observations to make on this topic:

> The red-capped dwarfs, scorned by intellectuals as the epitome of petit-bourgeois bad taste, are in fact visual representations of the etheric forces in a garden. These and other terracotta figures – statues of Bambi, Snow White, Saint Francis and the Virgin Mary – support, even if perhaps unconsciously, the gardener's imagination. . . helping to create the etheric space in which the invisible helpers can 'incarnate' and operate. These helpers really do find in such figures a sort of shelter, in which they can feel secure and to which they can retreat. The little statues then become literally animated. . . One does not need to be particularly clairvoyant to recognise that something lives in them and that, out of those glazed ceramic eyes, something returns one's gaze.[9]

In the light of the exciting recent discoveries about plants, many traditional practices that sceptics would dismiss as superstition take on a new light. Carrying out fertility rites, blessing the crops, encouraging them through dance, chanting and music and other such activities seem not so far fetched after all. On the contrary, they make just as much sense today as they have for thousands of years. Connecting with nature through ritual is something that anyone can do, however modest a garden they have – even if it's just a balcony or a few pot plants. A ritual need not be complicated. It could be something as simple as going out into the garden at a particular time (such as one of the threshold times described above), sitting in a favourite place and meditating on a particular plant or group of plants, trying to put oneself into rapport with them. More elaborate rituals could involve friends or family members and might include seasonal celebrations – say processing barefoot into the garden at dawn on the spring equinox, feeling the fresh dew under one's feet, facing east and welcoming in the spring, dancing in a circle and singing something joyful

and vernal. Whatever the form of your ritual, if it is carried out with feeling the plants will respond and the atmosphere in the garden will be enhanced.

Resonating with the earth

In creating a sacred garden much depends on the energies present in the actual ground. Most of us know the experience of walking into a room and finding the atmosphere somehow positive and friendly. Other rooms, by contrast, immediately strike us as having an uninviting or even repellent feeling. The same is true of gardens. The positive or negative vibrations that we feel upon entering are partly due to the way in which the space has been arranged, but in some cases we sense that these vibrations are coming from the earth itself. The lines of energy in the earth are often compared to the acupuncture meridians in the human body. It is no coincidence that acupuncture was invented by the Chinese, who also developed to a high degree the art of geomancy or *feng shui*. Just as the acupuncturist works with the life forces flowing through these meridians, so the geomancer works with the forces flowing through the earth. *Feng shui*, which has already been described in Chapter 2, is today enjoying great popularity in both East and West. However, it is a highly complex system which would require at least a whole volume to itself to explain properly. In the next chapter I provide a case study using a very simple and intuitive form of *feng shui*, but if the reader wishes to pursue it more deeply, they can refer to any of the many books on the subject currently available.

In the West there has developed a rather different way of perceiving the energy lines in the earth, or 'ley lines' as they are widely called. These lines are also believed by many to have their negative counterparts, known to dowsers as 'black streams', the presence of which are thought to have a draining and depressing effect on human, animal and plant life.

Both ley lines and black streams can have practical implications for the horticulturalist. If there are ley lines in a garden one would want to make the best use of them in laying out paths, flower beds and other features. The energy would be particularly strong at the nodal points where the lines intersect, and at one of these points one might wish to place an important feature such as a special tree, a sundial, a fountain or a seat for meditation. On the other hand, if black streams are

present it is possible to counteract them through 'earth acupuncture'. The British dowser Tom Graves writes as follows on this theme:

> The harmful effect of the stream can be reduced, or even neutralized, either by spraying some surface above the stream with blue paint, or in some cases by 'staking' it by hammering nails or rods into the ground above or to one side of it. Use a pendulum [see above under 'Companion plants'] to check in each case the most suitable 'cure', and to find the right colour paint or the right material for the nails or rods. You can then find the best place or places to apply the cure. . . I've no idea why these unlikely-sounding stratagems should work – I only know that they do and have been so used by the farmers and farriers for centuries.[10]

Graves describes visiting a small religious community in a Cotswold valley. When the community first moved there the valley was bare of wildlife and marked by a heavy, oppressive feeling. Newcomers were afflicted by a mysterious stomach complaint within a few hours of arriving. 'One of the community's members was, among other things, a dowser, and. . . he came to the conclusion that some outside disturbance was affecting the overall "balance" of the valley. So he went out with a bundle of small wooden stakes, each with a twist of copper wire at the top, and hammered one into the ground at each of the twenty places in the valley that his rod had indicated.' The result was that the oppressive feeling and the sickness vanished within a few days and the wildlife returned.[11]

Similarly remarkable results have been achieved by the Slovenian artist Marko Pogačnik, now living in Germany, who has developed a form of earth acupuncture that he calls 'lithopuncture'. This involves, among other things, placing stone pillars at critical nodal points in the ground. Each pillar is given its own signature in the form of a pattern carved into the stone and in some way reflecting the quality of the energy at that particular spot. In his book *Die Erde Heilen* (Healing the Earth) he describes carrying out a lithopuncture operation in the grounds of Türnich Castle, a moated stately home in the Rhineland.[12] The owner Count Hoensbroech was concerned about the run-down state of the property when he inherited it from his father. Over the years neglect, groundwater extraction and vandalism had taken their toll. Many of the trees were dying, the wildlife was

greatly reduced and generally the estate was looking much the worse for wear. Pogačnik carried out a lithopuncture exercise involving a revitalization of the energy lines in the park, and the effect was dramatic. Within a year or so the trees had begun to recover, the diversity of plants had increased, birds and other wildlife were again present in large numbers and – perhaps most remarkable of all – the vandalism had decreased markedly.

Any gardener who wants to work with earth energies would find it very helpful to acquire some basic skills in dowsing. Most people in fact possess to some degree the ability to dowse and can develop and refine it through practice. The equipment that one needs is very simple. I have described above the use of the pendulum. Another tool commonly used by dowsers is the traditional Y-shaped twig. Held in both hands at the forked end and pointed horizontally away from the body, the twig will react to what it is you are looking for by pointing up or down. Alternatively many dowsers today use two L-shaped metal rods, which can easily be made from a pair of wire coat hangers. Grasped lightly in the hands and pointed horizontally forwards, they will react by moving together or apart. When searching a piece of land for, say, a ley line or a buried water pipe, the technique is to work your way across the area, going back and forth as though you were mowing a lawn. Every time your instrument reacts you mark the spot with a peg, so that when you have finished you have a line of pegs marking the course of the pipe or ley line. If you wish to explore this fascinating subject, there are many practical manuals available, and there are also dowsing societies, courses and innumerable web sites on the Internet.[13]

Having looked at the two sides of the gardening equation – art and nature – we are now in a position to put the two together in planning and creating an actual garden. This process we will explore in the next chapter.

12

CREATING A GARDEN OF MEANING

The aim of this chapter is to give you some ideas on how to build your own garden of meaning. The intention is not to provide hard and fast recipes but rather to describe some possible approaches that may stimulate your own creativity and inventiveness. You may also wish to turn back for ideas and themes to the various gardening traditions described in earlier chapters.

Readers will approach the task of building their garden from many different possible starting points, depending on their individual tastes, interests and requirements. Some will have in their minds a particular gardening style or overall symbolic theme; others will know the kind of feeling they want to create but be undecided about what form to give it; others again will want to build the garden around some special feature or around particular plants that they are fond of. To take account of these different possible forms of approach, this chapter presents a series of steps involving different groups of options, rather like menus on a computer. I have organized these into a sequence that I think is easy to follow, but you are free to use any sequence that makes sense to you. After these steps have been outlined I then present a series of case studies, describing some specific ideas for creating a garden of meaning in different types of space.

A good general tip is to start with a clear and simple plan and a few carefully chosen features. Later you can allow the garden to develop greater complexity if that is appropriate. Bear in mind also that the symbolic message of a garden need not be immediately obvious or totally transparent. Nor does every plant and feature need to be part

of the symbolic scheme. My own preference is for gardens which have subtle layers of meaning, and which, like the greatest works of art, leave room for the observer's own personal interpretations.

Tuning in to the space

Each site has its own potentialities, limitations, energies and character. Before beginning to work on the space, therefore, it makes sense to put yourself intuitively in touch with it. First of all, simply go out into your garden, patio or yard and stand or sit quietly in it, feeling its energies. Pay attention to any images that come to your mind. Listen to the 'voice' of the space and what it may tell you about the best way to use it, what kind of mood or style would lend itself to this particular spot and what features would go there. Clearly common sense as well as intuition is involved here. It would not make sense to attempt to plant a sacred grove in a tiny square patio in London, nor to build a sensual Islamic paradise garden on a windswept Scottish hillside. The site itself will therefore open up certain choices and exclude others.

Try to sense also the lines and points of energy in the space. At an early stage locate the focal point, which is unlikely to be at the very centre unless the garden is totally symmetrical. At the most basic level this exercise is rather like walking into a party or a restaurant and intuitively finding the spot or the table where you feel comfortable and relaxed. Mark the focal point with a stick or some other object. There may also be other points that have a significant feel about them, and you may sense energy in the garden flowing along certain lines. If you have some dowsing skills you can use a pendulum, a forked stick or divining rods to find these lines and points (see Chapter 11 for information on dowsing). Draw a map of the site and indicate the key points there as well as on the ground. This will come in useful later when you are planning the layout and deciding what to put where.

If you believe that there are conscious intelligences in the plant world, then ask for their guidance in planning the garden and deciding what to plant and where. The Findhorn garden in Scotland (described in the previous chapter) is a superb example of what can be achieved through cooperation between human beings, nature spirits and 'devas' (the word 'deva' meaning a spirit governing a particular type of plant). Peter Caddy, co-creator of the Findhorn garden, described this cooperation as follows: 'Man does not forego his own powers and

abilities, approaching the devas as helpless, expecting them to supply the answers. Not at all. Man contributes his part to the work as an equal, and the devas respond by contributing theirs.'[1]

Choosing the overall mood and style

To simplify matters I have identified below 13 different basic types of mood or atmosphere, all of which we have encountered in the gardens explored earlier in the book. Of course, there is an infinite number of possible moods as well as combinations and permutations of mood. Those listed here are merely suggested starting points, and you may wish to add more. Each mood is identified by some key words or phrases and followed in brackets by gardening styles or particular places that exemplify the mood:

1. Serene vibrations, spiritual harmony (Chinese and Japanese gardens)
2. Reflections of paradise, divine order (Islamic gardens)
3. Modest simplicity (the medieval monastic garden)
4. Lightness, joy, sensuality (Villa d'Este, Villa Garzoni)
5. Drama, grandeur, visual rhetoric (Versailles)
6. Philosophical, contemplative, emblematic (Little Sparta)
7. Lyrical, dreamy, poetic (Weimar, Stowe, Dumbarton Oaks)
8. Initiatic, esoteric, hermetic (Wörlitz, the Tarot Garden)
9. Haunting, mysterious, enigmatic (Bomarzo)
10. Fairy tale, fantasy, make-believe (Thieles Garden, The Hide)
11. Playfulness, wit, humour (Little Sparta)
12. Archaic, druidic, Celtic (Bossard Temple)
13. Arena for nature spirits and earth energies (Findhorn)

From the choice of mood and the nature of the site will emerge the appropriate style for the garden. Apart from the examples of style given above in brackets, you can turn to any other examples given here or in other books on garden history. You may of course want to combine a number of different styles, which is fine, although you should not overdo it. Some combinations mix well, others do not (e.g. don't try to mix Zen and Islamic), and in any case avoid too many styles in one space.

If you have one of the garden design computer programs on compact disc, described in Chapter 10, you can try out a Zen garden,

an Islamic paradise garden, a Renaissance garden and any other type before you commit yourself to one particular approach or to a mixture of approaches.

At this stage keep in mind the practical considerations. Most gardens today have to be more than just gardens. Often little remains of a garden once one has made room for the barbecue area, the swimming pool, the sandpit, the swing, the shed, the garage, the hard surface for the caravan, or any of the numerous other things that compete for space in the modern front or back yard. Even if you do without any of the above, there is one feature that you should try to allow room for if at all possible, namely the compost heap, an invaluable source of nutrients for your garden and an excellent way of recycling kitchen waste along with grass cuttings, weeds, fallen leaves and other organic matter. If you like, think of the compost heap as an alchemical furnace. In alchemy matter must 'decay' and pass through a 'black' phase before it can be raised to a higher state. And this is exactly what is taking place all the time in the compost heap. What emerges is a rich 'elixir' which you can dig into the soil to help keep the garden healthy and vigorous.

You also need to decide whether to include a vegetable patch. Vegetables are not only a marvellous way of being partially self-sufficient, they are also fully compatible with most of the sacred and symbolic approaches to gardening that have been described. Moreover they can be extremely decorative in a garden.

Another aspect that should not be forgotten is the spirit of play that I have touched on in earlier chapters. If you have children you can enlist their help here. One of the things we do as children is to re-name things so that they take on a make-believe quality, and a garden gives us a wonderful opportunity to do this afresh. A piece of shrubbery can turn into a jungle or an enchanted forest, an arch in a trellis can become a door into another dimension, a shady spot at the end of the garden can be the abode of elves. In Chapter 10 I described the garden at The Hide, Ohio, created by the architect Jan Heynike and his 13-year-old son Charl, where the *Leitmotif* is precisely this element of make-believe and creative fantasy.

Choosing themes and motifs

Once you have chosen the mood and the style of your garden, you can then begin to find visual motifs to place in it. As we have seen,

there are certain motifs that are perennial and universal, while others are specific to particular cultures. Look again at Chapter 1 for ideas on some basic motifs. A good place to begin is the focal point of the garden. As mentioned above, it is a good idea to find this at an early stage. When you place an object in this central position you are symbolically marking it as the centre of your mini-world and creating a reflection of the universal centre, the 'axis of the world' that occurs in so many traditions. The marker can take many forms. It can be a mound, a tree, a fountain, a pillar, a sundial, a standing stone or any number of other objects. The centre could also coincide with the middle point of a labyrinth – another universal motif.

Another important point to pay attention to is the entrance, which ideally should be emphasized in some way. This is where you pass from the ordinary, everyday world into the special world of your garden. We have seen how different traditions mark this threshold between mundane and sacred space: the Chinese moon gate, the Islamic *talar*, the sphinxes, centaurs and dual creatures that we encountered at the gateways to many gardens. Some gardens will have an obvious entrance, such as an alley between the side of the house and the neighbour's wall. In other cases the entrance will be less marked – it might, for example, be simply a kitchen door leading directly on to a back terrace. But usually there will be some way of creating the sense of a threshold – an opening in a trellis, a topiary arch, a pair of stone sphinxes, a path leading between two trees, or simply a pair of boulders or stone spheres placed on either side of the point where you enter the garden.

A threshold presupposes some kind of boundary enclosing the garden. You may be limited in the kind of boundary you can create – it is not always possible to build a wall or plant a high hedge, but usually one can find a way of creating some sense of enclosure, even if it is only in the form of a series of boundary stones set out at intervals. If your garden is small, you may want to give the illusion that it extends further than it does. This can be done, for example, with a *trompe l'oeil* arch of trellis work against a brick wall, or even with a mirror set into a niche.

When thinking about the boundary, think also about the compass directions. In many of the gardening styles that we have looked at, these play an important symbolic role. You can emphasize them by the layout (e.g. paths pointing north, south, east and west) or by appropriate objects placed at each compass point. As already mentioned, the cardinal points are associated with elements and with

seasons – east with air and spring, south with fire and summer, west with water and autumn, north with earth and winter. One can carry this symbolism further and link the four directions with the four suits of the Tarot cards: east with wands, south with swords, west with cups and north with discs or pentacles. In the tradition of Kabbalistic magic there are Hebrew divine names that go with each direction, and in many traditions the directions also have their appropriate colours. One arrangement could be silver or yellow for east, red or orange for south, blue for west and green or brown for north. For each cardinal direction, element, etc there are many symbols that you can use, from the simple to the elaborate. An obvious symbol for the west and water, for example, would be a fountain, but if that is not feasible, then a pattern of shells – or a single large one – set into a wall would serve the same purpose. For east/air one could install some wind chimes or perhaps the image of a bird. For south/fire a possible symbol would be an obelisk, which to the Romans represented a solidified ray of sunshine. And for north/earth one might opt for a grotto or miniature cave, built with rough, irregular pieces of stone. Another simple way of marking the elements is by using the alchemical symbols for them: an upward-pointing triangle for fire, a downward-pointing one for water, an upward-pointing one with a line through it for air, and a downward-pointing one with a line through it for earth. These could be built into trellis work, cast into concrete paving stones, outlined in pebbles set into cement or represented in many other ways.

Nowadays suppliers of garden decoration are offering an increasing range of well-made traditional features – sculptures, fountains, urns, columns, obelisks, etc. For example, if you are looking for an obelisk but do not want to buy a stone or terracotta one, an alternative would be a wooden frame in the shape of obelisk on which to grow climbing plants. When looking for objects to use as symbols it is best to be flexible and not have too rigid a conception of what you need. In that way, you can remain open to what coincidence or synchronicity may bring you. Furthermore, the symbols that are most meaningful to you may be of a highly personal nature and not necessarily have anything to do with any tradition.

Choosing the plants

The plants that you grow in the garden offer a whole other level of meaning. The cardinal points, seasons and elements can be marked

by flowers or foliage of appropriate colour and/or by plants that flower at the corresponding time of year. The herbs with their astrological correspondences offer another dimension. Indeed, as we have seen, in every gardening tradition there are plants with symbolic or mythological associations. Many of these have been mentioned in earlier chapters, and a selection of them is found in the appendix.

As with decorative features, the meanings attached to plants may be personal to the individual gardener. On the other hand the colours of plants constitute a language that is almost universal. It is possible to put the colours of the rainbow on a scale according to the energy they radiate and the kind of mood they generate. At one end of the spectrum are the warm colours: red, which is highly energetic, vigorous, active and stimulating; yellow, which is optimistic and expansive; and orange, which is youthful, playful and exuberant. At the other end are blue, indigo and violet, which go with a mood of withdrawal, dreamy quietude, inwardness, even melancholy ('the blues'). In the middle is green, which combines the warm and cool colours and therefore generates a mood of balance and harmony. The characteristics of these colours are often matched by the chemical properties of plants. For example alkaloids that have a quietening effect are found in many plants with blue flowers, such as skullcap, which yields a strong sedative.

The colours of plants therefore offer a wide range of possibilities for achieving the desired mood in your garden. You might, for example, wish to create a quiet, contemplative corner of the garden, dominated by flowers of blue-to-violet hue, such as campanula, buddleia, lilac and lavender. A good setting to go with these colours would be an enclosed or partially enclosed area, ideally with appropriately restful sounds such as flowing water or wind chimes. On the other hand, an open area where you sit with friends would be a suitable spot for red-to-orange flowers or shrubs, such as sunflowers, poppies, red roses, daffodils, forsythia or gorse.

The suggested planting schemes in the following case studies are based partly on colour and partly on other considerations such as shape and mythological association – always bearing in mind that there are also down-to-earth, practical reasons for putting a plant in a particular spot. For seeing how different planting schemes would look you can again use a garden design computer program.

Case studies

In this section I present three case studies involving different types of space and showing different approaches. Each is illustrated by a plan. Note that I have not shown many of the typical features of modern gardens – there are no sandpits, dog kennels, barbecue areas, swimming pools, compost heaps or vegetable patches. This is not to say these should be excluded (see above), but I will leave it to readers to find room for them as and where they think fit. Inevitably these suggested designs reflect my own personal tastes. Given the same space, the reader might want to do something different, but hopefully these examples will at least touch off some ideas.

Case study 1: Druidic mystery in a town garden

This case study is based on a garden I once owned in the London suburb of Crouch End. It lay behind a red-brick Edwardian terrace of the kind that you can see all over the suburbs of English cities. Such terraces are typically homely and quietly respectable on the side facing the street, but often the houses conceal behind them a cherished, private world, lush with greenery, floral colour, carefully tended grass, and perhaps a garden gnome or two. A very English world. Still, one can find similar spaces in cities elsewhere – in Bremen and Baltimore, Sydney and San Francisco. For the kind of garden we have in mind here, the main thing is that it should be quiet and fairly well enclosed – a little bit secret. I will describe the garden as I began to construct it and how it might be continued from the point where I left off.

The garden was just over 40 feet long and about 20 feet wide (approximately 12.5 by 6 metres), and ran slightly uphill to the south from the house. Entered from a side alley, it was surrounded partly by brick walls and partly by fences, mostly thickly covered by bushes. Next to the house was a narrow, paved terrace, separated from the lawn by a low retaining wall. At the back, next to a wooden shed, was a dark area overhung by tall bushes. The space was therefore pleasantly secluded, and I began to see the possibilities of creating here a small garden of the gods. In terms of the moods listed earlier, I was inclined to opt for a mixture of 1 (serene and harmonious), 8 (initiatic and esoteric), 9 (haunting and mysterious) and perhaps a dash of 12 (archaic, druidic, Celtic).

But first there were two main problems to cope with: the angle of the ground and the way the garden had been laid out previously. From the small terrace behind the house the ground rose in a straight ramp almost to the far wall, where it levelled out a little. Straight up the left-hand side ran a flower bed, and straight up the right ran a concrete path with another flower bed behind it. In between was a strip of lawn. From a *feng shui* point of view the design was hopeless. It was more like a bowling alley than a garden. The energy seemed to zoom away up the middle of the lawn, lose momentum somewhere near the top and then roll feebly back towards the house.

The first thing to do was to break up the monotony, both horizontally and vertically, to create what the Japanese call *suchigaete*, avoidance of symmetry. I spent several back-breaking days digging out part of the slope three quarters of the way up the lawn, and using the displaced earth to create a terrace in the shady area at the back. To support the terrace I made a retaining wall of old bricks running in an irregular double-S shape right across the garden, with a small flight of steps leading to the shed. Next I removed the concrete path to the right and gave the flower bed a more irregular shape, with part of the lawn running right up to the wall. I used my own kind of *feng shui* – intuitive rather than systematic.

Now the whole feel of the garden was dramatically improved. Instead of going in a straight line, the energy undulated and snaked around the space. And in the main bend of the wall, where the lawn had been levelled out, was a delightfully tranquil place to sit.

What I needed now was a presiding deity to express the spirit of the place (*fuzei* in the Japanese tradition). In a dealer's yard in Gloucestershire selling recycled architectural bits and pieces I found a carved stone head of a Green Man, with hair and beard made of leaves – an ancient motif representing the raw, generative force in nature. I placed it somewhat provisionally against the right-hand wall. Shortly after this, work on the garden stopped. The circumstances of my life took me elsewhere and I moved out, eventually selling the property and taking the Green Man with me.

For the purposes of this case study, let us take the garden at the point I left it. We have the basic shape, the terraces, the retaining wall, the shed, the flower beds, the lawn and the Green Man. As regards the plants, let us imagine that we have a free hand to take out and insert whatever we wish. How shall we proceed from here?

Looking at the accompanying plan (on page 157), what strikes the eye immediately is that the garden falls into three areas. This in itself

A small suburban garden

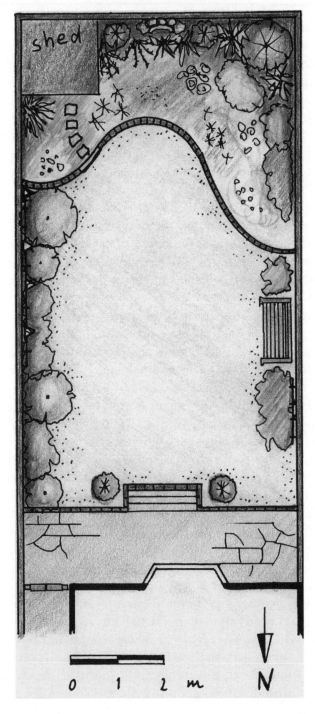

shed

0 1 2 m

N

can be treated symbolically. If we think of the garden as a kind of druidic temple to the Green Man, we have an entrance and anteroom (side alley and lower terrace), a main reception area (the lawn) and an inner sanctum (the upper terrace).

The entrance, down the shaded alley between the house and the neighbour's brick wall, is already a little mysterious. Where the alley emerges into the garden I would suggest placing an arch in wooden trellis work, surmounted by an appropriate image or symbol – say a pentagram, an ancient magical symbol often used to deter evil influences (in Goethe's *Faust* there is a pentagram on the threshold of Faust's study, and at Goethe's Garden House in Weimar there is one set into the paving by the gate). The illustration gives an impression of what the entrance would look like with ivy growing up it. Ivy is sacred to Dionysus, the god of intoxication but also of vegetation, blossoming and the return of spring. It would go well in this shady spot, and particularly suitable would be a five-pointed variety such as *Hedera helix pedata*, which has very long, pronounced leaf-lobes.

The visitor passes under the pentagram, but does not immediately enter the main area. Instead they cross the small sunken paved terrace by the house, which can serve as an anteroom. From here, let us create a second threshold in the form of a little flight of steps leading up from the lower terrace to the lawn. And for further emphasis, on either side of the steps let us place two small evergreen trees in pots. A good choice would a dwarf cypress such as *Chamaecyparis obtusa* 'Kosteri'.

From here the visitor looks straight towards the inner sanctum, the back terrace. This is the obvious spot to place the Green Man – or whatever motif is chosen to represent the *genius loci* – against the back wall, mounted on a rough stone pillar or pedestal and perhaps surrounded by an arch of similar stone. This spot should have the feel of a sanctuary about it – mysterious and a little bit inaccessible. Here are some plants that would help to achieve this atmosphere: flanking the shrine, a pair of Irish junipers (*Juniperus communis* 'Hibernica'), like two evergreen pillars giving a ceremonial quality to the spot; in the right-hand corner a yew (*Taxus baccata*), sacred to the Druids of ancient Britain as a symbol of everlasting life; ferns such as *Dryopteris filix-mas* and *Osmunda regalis* growing around and in front of the shrine; and, for its striking deep blue-green foliage, *Hosta tokudama*; then, for ground cover, the evergreen *Cotoneaster dammeri*, as well as some colourful low-growing flowers such as *Geranium*

macrophyllum, *Alchemilla mollis*, and some primulas (e.g. *Primula* 'Argus'). A cherry laurel (*Prunus laurocerasus*), another evergreen shrub, would go well against the right-hand wall, along with a patch of lavender, such as *Lavendula angustifolia* 'Munstead'. By the shed, to the right of the door, we suggest placing a yellow lily (*Lilium* 'Sun Ray' would be an appropriate choice for the south side of the garden) and, to the left of the door, a *Pieris japonica*, an evergreen shrub with clusters of little bell-like white flowers in late winter and spring. A compost heap is not shown on the plan, but an obvious place to put it would be in the back right-hand corner, where it would be partially concealed by bushes.

Down the left-hand (east) side of the garden we have placed various shrubs and trees. At the top, just below the retaining wall, is a Japanese quince (*Chaenomeles japonica*), with a mass of orange or red flowers in spring and a yellowish fruit which can be used to make jelly. Continuing down the same side, we have: *Daphne mezerum alba*, a deciduous shrub with creamy white flowers and yellow fruit, a bright yellow gorse (*Cytisus praecox*), a corkscrew hazel (*Corylus avellana* 'Contorta'), a spindle tree (Euonymus 'Emerald Gaiety') with bright green leaves, fringed with white and pink margins, and a common holly (*Ilex aquifolium*). Completing the east side is a wall climber, *Clematis tangutica*, with bell-shaped yellow flowers.

The right-hand (west side) of the garden below the retaining wall is taken up by a bench flanked on the south by a bush rose (*Rosa* 'Blue Autumn') with unusual blue flowers, and on the other side by a climbing wisteria (*Wisteria sinensis*) with blue flowers. This part of the garden is therefore predominantly blue, which accords with its western position (west corresponding to the water element in occidental magic).

Case study 2: As above, so below

For the second case study we take a larger garden – perhaps belonging to a house in the country or in the outer suburbs. It lies on level ground facing east from the house, measures 66 by 49 feet (about 20 by 15 metres), is surrounded by fences and at the outset contains little except grass.

As we have more space to play with here we can be more ambitious. As the overall motto of the garden, let's take the ancient hermetic saying 'as above, so below', meaning that what is in the heavens is

reflected in microcosm here on earth – e.g. every planet has its corresponding metal, herb and human characteristic. As regards mood, we will have an element of the initiatic and hermetic (mood 8), expressed through some striking images and carried out with a certain amount of visual rhetoric (mood 5). Here is our tentative design for the space.

In the centre of the garden is a circular paved area with a sundial in the middle representing the sun and also standing for the *axis mundi*, the symbolic centre of the world. It is surrounded by a circle of seven or 12 beds with herbs or other plants corresponding to the seven planets or the signs of the Zodiac (although the correspondences are primarily planetary, the herbals give some zodiacal correspondences, and one could also choose the plants by their time of flowering or by some other feature).

Between the circle of herb beds and the house is another circle the same size and laid with gravel, forming a kind of entrance to the garden. The two circles together form a figure of eight or, if looked at sideways, the symbol for infinity, emphasizing that the garden is intended to be a small window on to the infinite universe.

At the four quarters are features representing the four elements. In the east is a set of wind chimes (D), perhaps made of bamboo or some other wood rather than metal, if the latter is too loud for the neighbours. In the south is a sharply pointed pyramid in trellis work (E), representing the fire element. As a slight variation one could have an obelisk, a solar symbol that we have encountered before. The pyramid is planted with a yellow jasmine (*Jasminum humile*).

In the west, standing for water, is a bird bath (A) in the shape of a shell set into the wall of the house. As blue is the colour for this quarter, a blue wisteria (*Wisteria sinensis*) grows against the house wall.

In the north, corresponding to earth, is a cave or grotto made of rough stone (B), suggesting both the mineral kingdom and the womb of the Earth Mother. There is also a polarity between this female symbol and the phallic male symbol of the pyramid or obelisk. One can think of the Sun at midday shining into the cave and symbolically fertilizing it, as in the grotto at Castello.

As in the first case study, the plants have been chosen partly for their symbolic meaning and partly for purely aesthetic and horticultural reasons. Moving clockwise around the garden, following the numbered plan shown here, we come to a maple tree (*Acer*

A medium-sized suburban or country garden

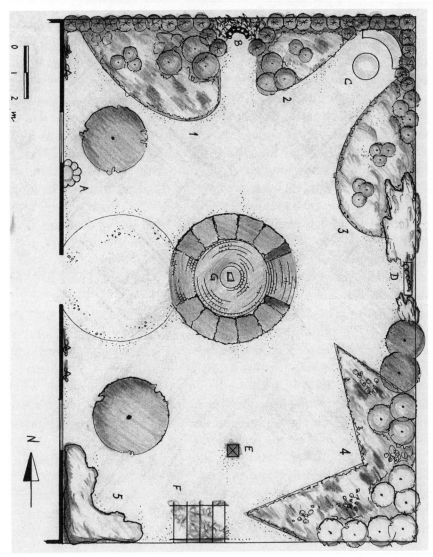

campestre), then to the north side of the garden (1 and 2), where massed evergreen trees (thuya, Lawson cypress, yew and holly) extend along the wall, partly hide the cave and act as a backdrop to a colourful variety of shrubs such as cornelian cherry (*Cornus mas*), spiraea (e.g. *S. arguta*), winged spindle (*Euonymus alatus*), viburnum (e.g. *V. rhytidophyllum*), and flowers such as verbascum (with tall, striking candles of blossoms), lilies, delphiniums, lupins, day lilies (*Hemerocallis*)

and alchemilla (e.g. *A. mollis*, with its masses of tiny, greenish-yellow flowers).

In the north-east corner, again backed by evergreens, is a curved bench of wood or stone with a round table in front of it. In bed 3 are some colourful shrubs such as mock orange blossom (*Philadelphus coronarius*), the red-leaved stag's horn sumach (*Rhus typhina*), the white astilbe hybrid (*A. arendsii*), and the vivid blue *Buddleia davidii*, which is very attractive to bees and butterflies (air element!). These shrubs are interspersed with clumps of saxifrage and sedum as well as foxgloves, lilies and the silvery-leaved *Senecio cineraria* 'Silver Dust'. White or silver for air can alternate with other colours.

Moving down the east side, we come to the wind chimes. Flanking these are patches of bamboo (*Semiarundinaria*), which will make a gentle rustling noise in the wind, harmonizing with the chimes and futher emphasizing the air element. Next come two delicate, red-leaved Japanese maples (*Acer palmatum*).

The solar motif is taken up by the sharply pointed flower beds in the south-east corner (in the Nordic *Edda* sunlight is called 'the sword of the Gods'). These contain some colourful shrubs and trees such as the yellow *Forsythia intermedia* and *Kerria japonica*, and *Cotinus coggygria*, with leaves that turn orange-red in the autumn and striking panicles of blossom, turning from green to fawn-grey. Flowers suggested for this spot include the coneflower (*Rudbeckia*), with daisy-like yellow blossoms, as well as begonia, busy lizzie (*Impatiens*) and the Indian shot plant (*Canna indica*), with its lance-shaped leaves and iris-like, orange or red flowers.

In the middle of the southern side is a pergola with roses or common honeysuckle (*Lonicera perclymenum*). Close by, to the north-west of the pergola, is a *Robinia pseudoacacia*, the acacia having mythological associations with the Sun (see appendix), and in the south-west corner is the yellow-flowered *Rhododendron luteum*.

Case study 3: A *feng shui* patio

Here our space is a small town patio, say 16 by 16 feet (about 5 by 5 metres), surrounded by brick walls and facing west from the back of the house. Let us assume that we are starting with a completely empty space and that our aim is to create a restful haven from the city outside. We have chosen mood 1, the oriental mood of restful harmony and serene vibrations, and we wish to work with some very

A town patio

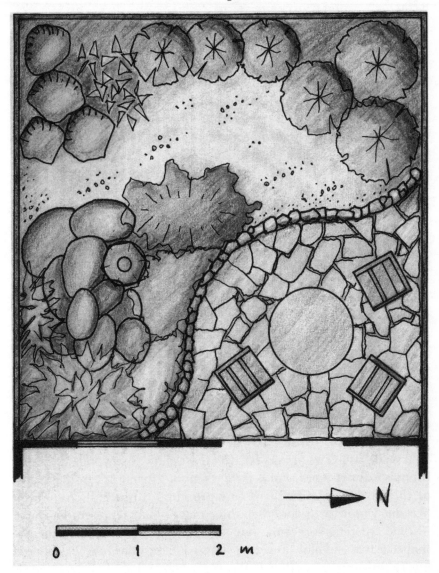

N

0 1 2 m

basic *feng shui* principles, without going into all the intricate correspondences that *feng shui* can involve.

The first thing to do, as in the case of the London garden, is to divide the space up to create a more interesting flow of energy, so once again we have suggested a retaining wall, about 1 foot (30cm) high, in a double-S shape, running across the garden from east to north,

dividing the space into two unequal sections and creating two different levels.

The smaller section, in the north-east corner, we have made into a sitting area with crazy paving and some garden furniture. The other section has an exposed area of gravel and some plants and other objects chosen and placed according to the *feng shui* principle of balance. As we have seen, one form of balance is between male and female. In the south-west corner are some tall, slightly pointed rocks corresponding to the male mode, and nearby to the east are some low, flattish, rounded stones for the female mode.

Another form of balance to be achieved is between the elements. In the Chinese and Japanese tradition there are five of these: fire, earth, water, wood and metal. Each of these has particular plant forms associated with it. 'Fire' plants are spiky or thorny and have bright red or pink flowers. 'Earth' plants grow close to the ground, expanding horizontally rather than vertically, and their appropriate colours are yellow, orange or brown. 'Metal' plants are roundish, and the predominant colours are white, silver and gold. 'Water' plants have wavy leaves and grow irregularly – colours that go with this element are black or dark blue. 'Wood' plants are those that expand unambiguously upwards: vigorous climbing plants or slim, column-like trees and shrubs – colours are green, blue or blue-violet. As the elements are not invariably associated with particular compass directions, we have placed the plants here according to where they 'feel' and look best. Along the back wall, from left to right, are some spiky yuccas (*Y. filamentosa*) for the fire element, followed by three columnar Irish yews (*Taxus baccata* 'Fastigiata') for wood, and some roundish dwarf pines (*Pinus mugo* 'Gnom') for metal. In the centre of the garden is a patch of low-growing juniper (*J. communis* 'Repanda') for earth, and then three more plants representing water – some creeping forget-me-not (*Omphaloides verna*), with heart-shaped leaves and blue flowers, a clump of Christmas rose (*Helleborus niger*) and, in the south-east corner, a maidenhair fern (*Adiantum aleuticum*). Finally, next to the 'female' rocks is placed a traditional Japanese lantern in stone or wood, again representing the fire element.

APPENDIX

SOME PLANTS AND THEIR ASSOCIATIONS

The following is nothing more than a small sampling of plants and some of their associations and symbolic meanings. Some were chosen because they are particularly well known. Others have been included because I found them to have specially interesting associations in lore and legend. Obviously, even to compile all the associations of one single plant would be impossible. Think, for example, of the rose and the innumerable meanings given to it by different cultures. Even within the same country the folklore surrounding a plant can vary markedly from one region to another. Then there are the difficulties of nomenclature: how do we know which plant is being referred to, when folk names do not respect neat Linnaean categories and ancient sources are often imprecise in their botanical descriptions? Nevertheless, I attempt here to give some idea of the immensely rich field of plant lore and symbolism by way of selective examples from the literature, folklore, mythology and religion of various cultures. Each entry in the main list describes an individual genus or species, identified by the most familiar English or Latin name with the botanical identification in brackets. An additional section at the end is included for herbs on account of their special magical and astrological associations.

Acacia (various species, family *Leguminoseae*)

The acacia tree, with its rows of delicate, oar-like leaves, has had a

special place in many different cultures. One of its associations is with the Sun. As Robert Graves writes: 'It was from its water-proof timber that the arks of the Sun-hero Osiris and his counterparts Noah and Armenian Xisuthros were built.'[1] Osiris, in Egyptian legend, was dismembered and later resurrected by his wife Isis. The acacia re-appears in connection with the theme of death and resurrection as a grave marker in the story of the architect Hiram Abiff, which plays an important role in masonic lore. As we saw in Chapter 9, J.E. Cirlot writes: 'In Hermetic doctrine, according to Gérard de Nerval in his *Voyage en Orient*, it symbolizes the testament of Hiram which teaches that "one must know how to die in order to live again in eternity". It occurs with this particular symbolic meaning (that is, the soul and immortality) in Christian art, especially the Romanesque.'[2]

In India, where it is known as *sami* in Sanskrit and Hindi, the acacia has another set of mythological associations. According to legend, the fire god Agni concealed himself in the tree, whose wood, being very inflammable, came to be used as the appropriate fuel for sacred fire. In the Hindu system of planetary correspondences, the acacia corresponds to the planet Saturn (Sani) and to Saturday.[3]

A different genus, but belonging to the same family, is the *Robinia pseudoacacia*, ubiquitous in suburban streets and gardens.

Acanthus (numerous species, family *Acanthaceae*)

There are nearly 2,000 different species of this hardy herbaceous perennial, which grows all over the Mediterranean region and was first introduced into northern Europe in the sixteenth century. The thorny variety (*Acanthus spinosus*) is one of the most familiar. Also known as 'bear's foot' because of the shape of its leaves, the plant has tall, upright candles of flowers. The Greeks in the fifth century BC incorporated its leaves into the design of the Corinthian column. Consequently, it has become a familiar visual motif wherever Greek architecture is imitated. In ancient Greece and Rome it was also used as a motif on gravestones and mausoleums, and appears to have sym-bolized immortality on account of its endurance and prolific growth. In early Christianity the thorns of the acanthus came to represent suffering, the fall of humankind and the pricks of conscience. At the same time, much early ecclesiastical architecture puts the association with immortality in a Christian context by linking the acanthus leaf with the cross. The plant has always been much valued for its

medicinal properties. The ancient Greek botanist Dioscorides, for example, prescribes it, *inter alia*, for burns, dislocations, spasms and dizziness.[4]

Alder (*Alnus*, some 35 species, family *Betulaceae*)

Probably because of its fondness for moors and other damp, secluded places, the alder has often been associated with the eerie and uncanny. The alder wood burns readily, and the ancient Germanic people used to make fire by rubbing a stick of ash wood in a socket made of alder. This was seen as being symbolic of sexual generation, and in Germanic mythology the primal man and woman, Ask and Embla, were made out of ash and alder respectively by the gods Odin, Lodur and Hönir.[5]

Anemone (about 120 species, family *Ranunculaceae*)

These plants, with their open, saucer-shaped flowers in a wide variety of colours, are found all over the temperate zones of the world. The name comes from the Greek *anemos*, meaning wind, as the delicate petals and seeds are easily carried on the breeze. The goddess Venus is said to have dyed the flower with the blood of her dead lover, Adonis. In Greece it is popularly known as Adonis' blood. In Christian tradition it is symbolic of the Passion of Christ and the blood of the saints. It stands for hope and expectation but also for disappointment and transience.[6]

Apple (genus *Malus*, many species, family *Rosaceae*)

Few fruits have more mythological associations than the apple. At the same time, it is difficult to be sure if the apples referred to in myth and legend always correspond to what we now call the apple. The Latin word *pomum*, from which the French *pomme* is derived, is cognate with the name of the Pomona, goddess of all fruit trees, and in Roman times the word covered a wide variety of fruits including apples, pears, quinces, pomegranates and figs. The specific word used by the Romans was *malum*, which also means 'evil' (the masculine form *Malus* is used as the generic name today), and this ambivalence has persistently dogged the apple over the centuries. In ancient Greece the apple was associated with sexuality, fertility and

youth. One of the labours of Hercules was to capture the Golden Apples of the Hesperides (which may in fact have been oranges), which grew on a tree guarded by a 100-headed dragon. In the Nordic tradition a similarly vigilant dragon guards an apple tree of immortality belonging to the goddess Idun. The apple was also associated with Apollo, who is often shown with one in his hand. In the story of the Judgement of Paris, however, the fruit becomes a symbol of discord and mischief when Paris is called upon to award an apple to one of the three contenders for the title of the most beautiful goddess on Olympus. In the Judaeo-Christian tradition the apple is, of course, pre-eminently associated with the story of the Garden of Eden and the Fall of Adam. One quality of the apple holds a special fascination for esotericists: when the fruit is cut in half horizontally, the core is in the shape of a pentagram, a time-honoured magical symbol.

Aquilegia (various species, family *Ranunculaceae*)

A genus of about 70 species, native to most of the northern hemisphere. The flowers, ranging from pure white through pink and yellow to deep purple, are long and have distinctive spurs projecting back from the base. In some species they resemble groups of doves clustered together – hence the English name columbine. This feature has caused the aquilegia to be associated with the Holy Spirit. It has also been linked with the Trinity, on account of its three-lobed leaves, and with the quality of humility. In German, the popular names for it include *Elfenhandschuh* (elves' glove) and *Frauenhandschuh* (Our Lady's glove). In pagan tradition it is linked with sexuality, with the goddess Venus and with Freya in her role as love goddess, and the blossoms have often been used as an aphrodisiac.[7]

Artemisia (genus of about 300 species, family *Asteraceae/Compositae*)

Also known as mugwort, sagebrush or wormwood, Artemisia is sacred to the goddess Artemis (or Diana), a moon goddess whose brother and counterpart is Apollo, the Sun god. The plant can be used to aid the digestion and help women in pregnancy or giving birth. It also yields a poison, as befits Artemis, who is sometimes cruel as well as benevolent.

Ash (*Fraxinus excelsior*, family *Oleaceae*)

In Nordic mythology the ash plays a special role as the Ygdrassil, the tree sacred to Odin, who hung on the tree for nine nights in order to obtain the secret of the runes. The tree encompasses the nine worlds of the Nordic cosmos. In Greece the ash was sacred to Poseidon, and is associated with the sea. Robert Graves writes that in ancient Wales and Ireland 'all oars and coracle-slats were made of ash'.[8] Culpeper says that the ash is sacred to the Sun and that its leaves can be taken as a protection against poisonous snakes.[9] It has its counterpart in the bodhi tree (*Ficus religiosa*), the world tree of Hindu tradition.

Bamboo (*Bambusa*, over 100 species, family *Gramineae/Poeceae*)

In east Asia the bamboo is, variously, a symbol of male virility, longevity and, in the Confucian tradition, righteousness – like the bamboo that bends in the wind but does not break, the Confucian scholar/official knows how to adapt to circumstances without compromising his principles.

Birch (about 60 species, family *Betulaceae*)

The many species of birch include the familiar silver birch (*Betula pendula*), common throughout Europe, Russia and Asia Minor, and the paper birch (*Betula papyrifera*), found in North America. It is a symbol of vitality, spring, light and female beauty and youthfulness. The deities to whom it is sacred are Thor, Frigg and Venus. By the people of eastern Europe it is held in special affection, as the linden tree is by the Germans. In Siberia it is the world tree of the shamans. Its sap yields a delicious drink with many medicinal uses including treatment for impotence. In certain parts of Europe its branches were used as a charm against witches. Bundles of birch rods are traditionally used as instruments of punishment. In the runic system, the Berkana (birch) rune is linked with mothers, children, gestation, birth and rites of passage.

Box (*Buxus*, about 70 species, family *Buxaceae*)

Those who know the neatly clipped box hedge as a familiar symbol of suburban respectability would perhaps be surprised to learn that

in the ancient world the box was one of the most revered of plants, belonging to those that signify both death and immortality. Its dark colour and the fact that animals avoid its leaves (because of their toxic alkaloids) are among the factors that account for its morbid associations and its dedication to Hades, god of the Underworld. It was also sacred to Cybele and Mercury, but was hated by Venus. At the same time its evergreen foliage and its vigorously growing twigs, which renew themselves rapidly after pruning, have made it a symbol of endurance and immortality and, in the Christian tradition, eternal life through Christ. For the same reasons it is a popular plant for topiary. Its exceptionally hard, fine-grained wood made it a favourite for flutes as well as for ornamental woodwork. Box was also the wood from which Cupid usually made his arrows.[10]

Cherry (*Prunus*, numerous species, family *Rosaceae*)

Brought to Europe from Asia Minor by the Romans, the cherry is associated, among other things, with spring, eroticism, female beauty, betrayal and lost virginity. In Asia, especially in Japan, it is a sacred tree, whose fragile beauty has been revered for centuries by emperors, poets and mystics. In the twelfth century the statesman and poet Fujiwara no Kitsune wrote the lines:

> As the spring wind
> takes the snowflakes of cherry blossom
> softly away
> and gives them back to the earth,
> so falls the Self and passes.[11]

Chrysanthemum (about 20 species, family *Compositae*)

In its homeland of China, the chrysanthemum is a symbol of autumn and of long life – which was thought to be promoted by eating its petals or contemplating a landscape in which it grew in abundance. Because it can bloom vividly late in the year when other plants are fading it is also seen by Chinese as a symbolizing the capacity to remain beautiful in the face of difficulties. In the fourth century it was imported into Japan, where the six-petalled chrysanthemum became the symbol of the realm and the Emperor, who forbade

ordinary people to grow it. In the mid-nineteenth century it was imported into Europe, where it became a symbol of oriental exoticism.[12]

Cypress (*Cupressaceae*, genus and family of about 24 species)

The cypress, if it is cut down to the trunk, never sprouts again. Because of this, and perhaps because of its dark foliage, it is associated with death. At the same time, because of its evergreen nature and upward-thrusting shape, it is symbolic of eternal life. Consequently it is a common graveyard tree in both Muslim countries and in the Christian countries bordering the Mediterranean. The classic cypress, shaped like a tapering candle, is the *Cupressus sempervirens*.

Elder, common (*Sambucus nigra*, family *Caprifoliaceae*)

Attitudes towards the elder in popular tradition vary from fear to reverence, depending on the region. In British lore and legend it is commonly portrayed as an unlucky tree, associated with death and witchcraft. In Germany it is one of the most revered of trees, partly because of the abundance of medicinal substances contained in the berries, the leaves and the bark. The German name for it is Holunder, derived from the fact that it is sacred to Holla, the Germanic goddess of winter but also of wild creatures, sexual love and the Underworld. In the Germanic countries there is a folk saying that, when it snows, 'Frau Holla is shaking her pillows'. Arguably the country of Holland is also named after her. It is also attributed to the Nordic goddess Freya.

Fern (numerous genera and species belonging to the *Polypodiaceae*, *Dryopteridaceae* and other families)

In Celtic and Germanic folklore, the spores of the fern can make one invisible. In Christian iconography the fern, because of its liking for shaded, half-hidden places, is a symbol of humility and the life of the hermit. For the same reason, in folk tradition it is among those plants associated with eeriness and magic. It is also a love charm – either for inflaming or for damping down the passions.

Fig (*Ficus*, various species, family *Urticaceae*)

The hardy form of this tree, *Ficus carica*, is familiar throughout the Mediterranean region and has been grown in northern and western Europe since the mid-sixteenth century. Among the ancient Greeks it was sacred to Dionysus. With its abundant fruit, soft flesh and countless seeds, it symbolized fertility and sexuality. The fruit was often seen as a symbol of the female sexual organs (but in Japan of the male organs). The fig was also sacred to the phallic god Priapus, whose images were carved out of its wood.

Fir and spruce (*Abies* and *Picea* – both genera of various species belonging to the *Pinaceae* family)

These two conifers are often symbolically lumped together, although they have certain obvious differences – e.g. the cones of the fir grow upright like candles, whereas those of the spruce droop downwards. In ancient Greece these trees were sacred to Dionysus. For the Germanic peoples their evergreen nature and ability to withstand intense winters made them a symbol of strength, hope and the Sun of the waxing year. Hence, in the north they are dedicated to Baldur, the Sun god. At the festival of the mid-winter solstice their branches were ceremonially carried, and a Yule log of fir or spruce was burned in the hearth as a token of the returning Sun and also as an offering to the protective spirits of the forest. It is probably this veneration of the fir at midwinter that led to its being adopted as the Christmas tree.[13]

Ginkgo (*Ginkgo biloba*, family *Ginkoaceae*)

Possibly the oldest type of tree in the world, the ginkgo is believed to have existed for over 300 million years. It was introduced into Europe from Japan in the early eighteenth century, and is now a popular tree for streets and gardens over much of the world. It is easily recognizable by its simple, fan-shaped leaves. A famous example in Hiroshima survived the atomic blast and began putting out shoots again the following spring. For this reason the ginkgo became for many a symbol of invincibility and hope. Traditionally in Asia it is also symbolic of fertility and long life.

Hazel (*Corylus*, various species, family *Corylaceae*)

The appearance of its male catkins in late January or early February

have made the hazel a symbol of rebirth and immortality. Its nourishing nuts make it also a symbol of fruitfulness. In the Nordic pantheon it is sacred to Thor in his capacity as god of marital fertility, and to Idun, goddess of health, vitality and germinating life. It also stands for beauty, wisdom, luck and the fulfilment of wishes. Altogether a tree with very fortunate associations.

Heather (*Calluna vulgaris*, genus of one species but many varieties, family *Ericaceae*)

Robert Graves writes that heather is 'sacred to the Roman and Sicilian love-goddess Venus Erycina; and in Egypt and Phoenicia to Isis' as well as to the Gallic heather goddess, Uroica, whose 'name is half-way between *Ura*, and the Greek word for heather, *ereice*'. He adds that it is associated with mountains and bees, and that 'the Goddess herself is a queen bee about whom male drones swarm in midsummer'.[14] Red heather stands for passion, while the rarer white heather is considered a protection against the dangers of passion. In certain parts of Europe, such as Scotland and Germany, heather has become a much-loved symbol of one's home and native region. As indicated by the name of the plant, cognate with the word 'heath', the heather is fond of wild, open and often remote places – hence it is also associated with love of solitude. In the era of Christianization such places were slow to convert, hence the word 'heathen' (literally a 'heath-dweller') came to mean a worshipper of pre-Christian gods.

Hyacinth (*Hyacinthus orientalis*, family *Liliaceae*)

Native to Asia Minor and the eastern Mediterranean, this bulbous perennial was introduced into western Europe in the sixteenth century. Although it comes in different colours, the best-known variety has brilliant blue flowers – a relatively unusual feature in the plant kingdom. In Greek mythology, Hyacinth was a handsome youth, accidentally killed by a discus thrown by his friend Apollo. Sacred to Apollo and to Adonis, the flower was in antiquity symbolic of transience and ephemeral beauty, perhaps because of the short-lived scent given off by the flowers. In Christianity, its heavenly blue colour has made it a symbol of Christ and the Virgin Mary.

Iris (many species, family *Iridaceae*)

The iris, as distinct from the lily with which it is often confused, has an iconographic history going back to ancient Egypt, where it figured as a symbol of regal dignity as well as of the god Horus and of resurrection. It is probably the iris, and not the lily, that appears on the coat of arms of the Kings of France – perpetuating the regal associations that it had for the Egyptians.

Ivy (*Hedera*, numerous species, family *Araliaceae*)

A plant with multiple associations including death, immortality, drunkenness and fidelity, the ivy has a mythological lineage dating back to ancient Egypt, where it was sacred to Osiris, whose death and resurrection formed a central theme in Egyptian religion. To the ancient Greeks it was, like the vine, sacred to Dionysus. Both are climbing plants, and the ivy, taken in small doses, can enlarge the veins and create a similar feeling of intoxication to that induced by wine. Dionysus was also the god of vegetation, of blossoming and the return of spring, as well as master of the arts of healing and prophecy. The healing properties of ivy as well as its evergreen nature have also contributed to its symbolic associations. The maenads, mythical followers of Dionysus, carried a rod known as the *thyrsos*, which ended in a bunch of ivy or vine leaves and symbolized rebirth and life after death as well as drunken ecstasy and wild abandon. Because of its orgiastic reputation, the stern goddess, Hera, protectress of marriage, allowed no ivy to be brought into her temples. It also came to be attributed to Thalia, the Greek muse of the theatre and of comedy. On account of its toughness and ability to cling firmly the ivy is also a symbol of faithfulness.[15]

Laurel (*Laurus nobilis*, family *Lauraceae*)

Also called bay, the laurel has dark, lance-shaped, aromatic leaves, from which the crowns of victors, heroes and poets are traditionally woven – they are also of course known to cooks throughout the world for their flavouring qualities. The tradition of the laurel crown or wreath comes from the tree's association with Apollo. The legend, as described in Ovid's *Metamorphoses*, relates how Apollo, pierced by Cupid's arrow, fell in love with Daphne, daughter of the river god

Peneus. She, however, had been pierced by Cupid's other arrow, which puts love to flight, and she fled from Apollo's advances. When he pursued her and drew close, she called out to her father to help her, and he did so by turning her into a laurel tree. Apollo, unable to make her his bride, declared instead that henceforth the laurel would be his tree.

Lily (*Lilium*, numerous species, family *Liliaceae* – see also 'Iris')

The lily, in various forms, appears in iconography and mythology from very early times, although it is not always clear whether it is the lily or the iris (belonging to a different family) or some other flower that is being referred to. In classical mythology and literature the lily is often linked with death. Persephone was picking lilies (or possibly narcissi) when she was snatched away by Hades, and in Virgil's *Aeneid*, when Aeneas descends into the Underworld he sees lilies growing on the banks of the river Lethe. But the lily has also been interpreted as symbolizing femininity, procreation and voluptuousness. In Christian tradition the lily has two meanings: on the one hand it is a symbol of Christ as Redeemer, on the other hand it is linked with Virgin Mary and the quality of purity.

Lime or linden (*Tilia*, many species, family Tiliaceae)

In the German-speaking lands the linden is a much-loved tree that goes with the idyll of peaceful village life and often forms part of the setting of romantic encounters in the works of poets and story-tellers. In the main square of many German villages is a linden tree, often beside a fountain, reproducing on a local scale the ancient idea of the tree as the axis of the world and the fountain as its centre. Culpeper attributes the tree to the planet Jupiter.[16]

Lotus or water lily (*Nymphaea*, 50 species, family *Nymphaeceae*)

The lotus has a special place in the religion and mythology of many countries including India, China, ancient Egypt and ancient Greece. In many ways it is paralleled in the West by the rose. Both are found as symbols of eternity, perfection and the unfolding of divine consciousness. In Hindu tradition, the god Brahma, creator of the material universe, was born out of a lotus in the following way. As

the god Vishnu lay on his couch in the celestial waters a lotus plant rose from his navel and gave birth to Brahma. This lotus represents Vishnu's wife, the goddess Padma, whose name means 'lotus'. Thus the manifest universe arose out of a male procreative force, Vishnu, interacting with the primal female energy, represented by water and the lotus. The lotus is frequently invoked in the sacred art and literature of both Hinduism and Buddhism. Often divine beings, Buddhas and bodhisattvas are shown seated on a lotus.

The ancient Egyptians, who identified the lotus with Osiris, had a similar account of the world's creation, in which a lotus appeared on the surface of the water and unfolded under the rays of the Sun. They used the lotus as an offering to the gods, as an adornment and as a motif in art and architecture. The seed and the root were also used as food. However, Barbara G. Walker, in *The Women's Encyclopedia of Myths and Secrets*,[17] has a different explanation for the term 'lotus eater'. The lotus, she says, represents the yoni or vulva, and in Egypt a form of ritual cunnilingus was practised by the Pharaohs to ensure their rebirth after death. This form of 'union with the lotus' was, she says, common in the Orient and is probably the true meaning of the 'Land of the Lotus Eaters' visited by Odysseus and his friends.

The ancient Greeks admired the flower as a symbol of beauty and eloquence. In their mythology, the nymph Lotus died of unrequited love for Hercules, but the goddess Hebe, taking pity on her, transformed her into a water lily.

Mandrake (*Mandragora*)

A plant that has had strong magical associations since biblical times, it has a parsnip-like root, spinach-like leaves and a yellow fruit. It is native to the Middle East and is difficult to grow in damp conditions. Its root was often thought to resemble a human body, and according to one superstition it would utter a piercing cry when uprooted, whereupon the person uprooting it would die. For this reason a dog was sometimes used to pull it out of the ground. It has been valued medicinally as an aphrodisiac, a fertility drug, an anaesthetic and a purgative, but it has also been frequently used as a talisman or magical charm.[18]

Mistletoe (*Viscum album*)

This evergreen, parasitic plant is charged with powerful mythological

associations. It grows in large, round bunches on deciduous trees such as apples, limes, poplars, maples and, occasionally, oaks. In December it produces white, sticky berries. Like many plants, such as the cypress and the yew, it is associated with both death and life. Probably it can be identified with the 'golden bough' which Aeneas, the legendary founder of Rome, used to compel the ferryman Charon to take him into the Underworld in order to speak to his father Anchises and learn about his future destiny. In the Nordic tradition it was an arrow of mistletoe wood which, through the malicious cunning of Loki, was used to kill the Sun god, Baldur, whose death symbolizes the temporary triumph of winter over summer. At the same time, the mistletoe heralds the return of spring. Hence the tradition in northern Europe of using it to decorate houses at midwinter. The mistletoe was especially revered by the Druids, who used to harvest it on the sixth day after the new moon with a golden sickle, after which two white bulls were sacrificed. In many folk traditions it was used as a charm against witches, and its leaves and berries yield a medicine which has been applied for a wide variety of illnesses from epilepsy to gout. According to Siegfried Seligman, the custom of 'kissing under the mistletoe' goes back to ancient Babylon where the plant was sacred to the goddess Mylitta. Female devotees of her cult had to offer themselves once in their lives to a stranger, which they did in the temple under a mistletoe bough.[19] After the coming of Christianity, the mistletoe was incorporated into Christian symbolism. Because the twigs have a habit of crossing over one another, the plant was given the name of *lignum sancti crucis* (wood of the Holy Cross), and wreaths made of mistletoe, known as pater nosters, were used as charms against evil.

Myrtle (*Myrtus*, two species, family *Myrtaceae*)

An evergreen shrub, producing fragrant white flowers in May–July, common in southern Europe and the Middle East, and grown in northern Europe from about the end of the sixteenth century. This is another of those plants with a dual life-and-death meaning. Robert Graves writes:

> The myrtle was sacred to the Love-goddess Aphrodite all over the Mediterranean. . . nevertheless it was the tree of death. Myrto, or Myrtea, or Myrtoessa was a title of hers and the

pictures of her sitting with Adonis in the myrtle-shade were deliberately misunderstood by the Classical poets. She was not vulgarly courting him. . . but was promising him Life-in-Death; for myrtle was evergreen and was a token of the resurrection of the dead King of the Year.[20]

At the same time the myrtle was a symbol of fertility and the bringing of children. In biblical times 'the meaning of the myrtle was. . . changed from the shadow of death to the pleasant shade of summer, on the authority of Isaiah who had praised the tree'.[21] This association appears to have passed into Muslim tradition, for myrtles are a common feature of Islamic gardens.

Oak (*Quercus*, over 400 species, family *Fagaceae*)

Honoured by many peoples as the king of the forest, the oak can live to a great age (in some species as much as 1,000 years) and often grow to over 100 feet. It stands for majesty, victory, glory, strength, pride, heroism, endurance, immortality and fruitfulness. In the ancient world it belonged to the highest of the Greek gods, Zeus, and to his Roman equivalent, Jupiter, and held a similarly lofty position among the Celts, the Slavs and the Germanic peoples. In the Germanic religion it is sacred to Thor, the god of thunder and lightning. Because its roots go very deep into the earth it attracts lightning more readily than shallower-rooted trees, but it also often withstands the lightning bolt. In the Teutonic realm there were many sacred oaks, the most famous of which was the oak of Geismar in Hessen, felled in 724 by the Christian missionary Saint Boniface in a terrible act of sacrilege. After the Christian conversion of Europe the oak was widely thought of as a haunt of the Devil and of malevolent spirits. Fortunately it has outlived this reputation and stands today as one of the most revered and loved of trees.[22]

Pear (*Pyrus communis*, family *Rosaceae*)

In the religion of the Germanic peoples the pear has a deep significance. It stands for protection, well being and affection but is also associated with witchcraft. In pear trees 'people saw gods or mysterious dragons. The Wenden [a Slavic people of eastern central Europe] used the same word for pear tree and dragon.'[23] Like the oak, the pear

was often felled by Christian missionaries, but it also found its way into monastery gardens.

Peony (*Paeonia*, about 30 species, family *Paeonaceae*)

In ancient Greece the peony was held in great reverence. There are various myths associated with it, but one of the most popular identified it with Aesculapius (or Asklepios in Greek), the son of Apollo, who became so skilled in the art of healing that he came to be known as *Pæon* (the helper) of the gods. When Aesculapius was killed on the instigation of Pluto, Apollo was so grieved by the death of his son that Jupiter took pity on him and, instead of giving the body into the keeping of Pluto, transformed it into a peony. Another story has it that it was Pluto himself who was cured of a wound by Aesculapius and in gratitude caused the flower to be named *paeonia* after him. The Greeks believed that the plant was an emanation from the Moon, and a small piece of the root, worn around the neck, was thought to protect the wearer against evil enchantments.[24] Culpeper, however, identifies it with the Sun and the sign of Leo.[25]

Periwinkle (*Vinca minor* and six other species, family *Apocynaceae*)

This evergreen ground-covering plant, with delicate blue, violet, purple or white flowers, is sacred to virgins and is symbolic of fidelity, constancy and eternal life. In the burial customs of many cultures wreaths of periwinkle were placed in the coffin along with the body. In some cultures it connotes death, and in the Middle Ages criminals sometimes wore a garland of periwinkles on their way to execution. It has a number of therapeutic uses, and the leaves have been used as an aphrodisiac.

Pine (*Pinus*, various species, family *Pinaceae*)

One of the symbols of longevity in east Asia, the pine also symbolizes tenacity because of the way it often grows on rocky cliffs with little soil and under harsh weather conditions. In the West it symbolizes steadfastness, loyalty, adaptability, courage, friendship, and happiness in marriage. It is sacred to Neptune, Sylvanus, Dionysus, Diana, Cybele and Aesculapius. In Christian tradition it represents the Church and the Virgin Mary and has the qualities of purity, virginity and heavenly wisdom.

Poppy (*Papaver*, 70 species, family *Papaveraceae*)

A symbol of fruitfulness and riches on account of its abundant seeds. In Greek mythology, the poppy was said to have been created by the goddess Flora as a narcotic to assuage the grief of Ceres, the goddess of crops and vegetation, after her daughter Proserpine (Persephone) had been abducted by Hades, god of the Underworld. Hence poppies were planted with corn and wheat to propitiate Ceres.

Rose (*Rosa*, innumerable species and varieties, family *Rosaceae*)

For centuries, and in many cultures, the rose has been considered queen of the flowers, and a considerable mystique has grown up around it. In many respects it can be seen as the Western counterpart to the lotus (see above) as a symbol of perfection, heavenly beauty and the mystic centre. To the Greeks, it was sacred to Aphrodite and to Dionysus and is the subject of many beautiful stories and poems. Perhaps because of the association with Dionysus, roses were hung over the doors of Roman taverns, and what was spoken there under the influence of wine was said to be 'sub rosa', that is secret or confidential. In Apuleius' story *The Golden Ass*, the narrator, having been turned into a donkey, is finally restored to human form when he eats some roses during a festival to Isis. Christianity added further dimensions to the mystique of the rose. The white rose became symbolic of the Virgin Mary and the red rose of the Passion of Christ. At the end of the *Paradiso* Dante, seeing an infinite multitude of angels circling around the divine light, describes how 'In fashion then of a snow-white rose / Displayed itself to me the saintly host'.[26] When the rose is round and many-petalled it is reminiscent of the mandalas of Hindu and Buddhist tradition. Coupled with the cross it becomes the symbol of the Rosicrucians.

Tamarisk (*Tamarix*, 54 species, family *Tamaricaceae*)

A hardy, evergreen shrub with feathery foliage, which in ancient Egypt was sacred to Osiris. In Egyptian art a tamarisk tree is often depicted growing beside the tomb of Osiris whose soul, in the form of a bird, rests in its branches.

Vine (*Vitis*, numerous species, family *Vitaceae*)

The grape vine (*Vitis vinifera*) is one of the oldest cultivated plants,

prized from ancient times not only for the wine made from its fruit but also for its many medicinal uses. In ancient Egypt it was sacred to Osiris, the slain and resurrected god, and it took on similarly sacred associations for many peoples of the Middle East, including the Jews, as indicated by the number of references to wine and vineyards in the Bible. For the ancient Greeks it was, like the ivy, sacred to Dionysus or Bacchus, the god of intoxication and revelry but also of vegetation. Along with the hedonistic aspect of the Dionysus cult, there was also a serious, initiatic side, celebrating nature's annual cycle of death and growth. The vine is therefore one of those multivalent symbols, standing alternately for the mystery of death, for resurrection, for initiation and for divine enlightenment. In Christianity it has taken on a supremely important significance in the Eucharist, and the vine often appears in iconography as a symbol of Christ himself, of his Church or of resurrection and eternal life.

Violet (*Viola*, 500 species, family *Violaceae*)

In ancient Greece the violet was dedicated to Orpheus and was under his protection. 'When the god of music, with his lyre, charmed all the birds and beasts, and even the rocks and the trees were moved by the strains, the flowers also came and danced around him. As exhausted, he sank upon a green bank to rest, his lyre dropped from his hand. On the spot where it fell sprang up the beautiful purple violet.'[27] Astrologically, according to Culpeper, it is attributed to Venus.[28]

Yew (*Taxus baccata*, family *Taxaceae*)

In most European countries, the yew, with its highly poisonous leaves and berries, has understandably come to be associated with death. This would fit its association with the gloomy planet Saturn according to Culpeper's *Herbal*.[29] In Greece and Italy, according to Graves, it was sacred to Hecate, goddess of witchcraft. However, many plants have two opposite meanings, and the yew is also associated with eternal life. Vaughan Cornish, in a work on churchyard yews, writes:

> The Druids, the priestly caste of the British Isles and Gaul in the days before Christianity, preached the doctrine of immortality, as Caesar recorded. . . The conclusion that the adoption of the

evergreen Yew as the symbol of everlasting life was of Druidical origin has been generally accepted. Whereas, however, we have an account by Pliny of the Druids' veneration for the Oak, there is no evidence that the Yew was held sacred in Gaul, as it undoubtedly was in Britain. I draw the conclusion that the Yew was sacred in Britain before Druidical times, and was adopted there by the Druids.[30]

The ubiquitous presence of the yew in churchyards can be explained by both of its associations – with death and with immortality.

Herbs: their lore and attributions

Because of their aroma, their culinary value and their medicinal properties, herbs have often been given a specially honoured place in gardens, and a distinct tradition has built up around them. From ancient sources, such as the Greek botanist Dioscorides, the Western body of herbal knowledge has passed down via the writings of medieval scholars and has mingled with a vast array of occult lore and folk traditions as well as with Christian symbolism. Sources on the esoteric dimensions to herbalism include the great sixteenth-century alchemist and physician Paracelsus and the seventeenth-century English herbalist, Nicholas Culpeper, whose *Complete Herbal* is still read today.

There are basically two symbolic or esoteric 'languages' of herbalism, namely the doctrine of signatures and the system of astrological attributions. The doctrine of signatures says that you can tell the medicinal properties of a plant by some particularly telling outward characteristic or sign. Threefold plants such as the clover were thought to be good for disorders of the male genitals; those with spotted leaves were prescribed for acne; and the wild pansy, on account of its heart-shaped leaves, was believed to be a good cardiac tonic. Many cures based on these signatures later passed into orthodox medicine – for example, a substance obtained from the wild pansy is indeed used in curing valvular heart disorders – but modern science has conveniently forgotten the origin of these treatments.[31]

Astrologically, each of the well-known medicinal herbs is governed by a planet and, in some cases, is linked with the zodiacal sign governed by that planet. These attributions differ somewhat from one

source to another, but here are some for the seven traditional planets, taken from Culpeper's *Complete Herbal*.

Sun: bay, St John's wort, lovage, rosemary, rue.

Moon: moonwort, cerastium, poppy, purslane, saxifrage.

Mercury: mandrake, caraway, dill, fenugreek, lavender, marjoram, parsley.

Venus: origanum, feverfew, cotyledon, mint, thyme.

Mars: basil, chives, garlic, madder.

Jupiter: melissa, betony, potentilla, houseleek, hyssop, sage.

Saturn: wild campion, comfrey, fumitory, equisetum.

NOTES

Chapter 1: The symbolic language of gardens

1 Simon Schama, *Landscape and Memory* (London, HarperCollins, 1995), p 300.
2 René Guénon, *The Lord of the World* (Moorcote, England, Coombe Springs Press, 1983). Originally published in French as *Le Roi du Monde*, 1927.
3 Quoted in May Woods, *Visions of Arcadia: European Gardens from Renaissance to Rococo* (London, Aurum Press, 1996), p 76.
4 See John Prest, *The Garden of Eden: The Botanic Garden and the Re-creation of Paradise* (New Haven and London, Yale University Press, 1981), p 54.
5 J.E. Cirlot, *A Dictionary of Symbols*, tr. Jack Sage (New York, Philosophical Library, 1962), p 323.
6 W.B. Crow, *The Occult Properties of Herbs and Plants* (Wellingborough, England, Aquarian Press, 1980), p 77.
7 Paola Maresca, *Bosci sacri e giardini incantati* (Florence, Angelo Pontecorboli, 1997), p 9.
8 Quoted in Naomi Miller, *Heavenly Caves: Reflections on the Garden Grotto* (London, George Allen & Unwin, 1982), p 13.
9 *Ibid.*, p 15.
10 Janet Bord, *Mazes and Labyrinths of the World* (London, Latimer New Dimensions, 1976), p 140.
11 *Ibid.*, p 141.

Chapter 2: Balancing the forces of nature

1 Maggie Keswick, *The Chinese Garden* (London, Academy Editions, 1978), p 36.
2 *Ibid.*, p 40.
3 Pierre and Susanne Rambach, *Gardens of Longevity in China and Japan*

(original French edition, Geneva, Editions Skira, 1987; English edition, New York, Rizzoli, 1987), p 22.

4 For a general popular account, see Man-Ho Kwok and Joanne O'Brien, *The Elements of Feng Shui* (Shaftesbury, England, Element Books, 1991).

5 Keswick, p 53.

6 Charles Jencks, 'Meanings of the Chinese Garden', concluding chapter to Maggie Keswick, *The Chinese Garden*, p 196.

7 *Ibid.*, p 198.

8 Raymond Lo, 'Hong Kong, the Nine Dragon Town', *Feng Shui for Modern Living* 1/3 (June 1998), pp 74–6.

9 Keswick, pp 161–2.

10 Christopher Thacker, *The History of Gardens* (paperback reprint, London, Croom Helm, 1985), p 47.

11 For a selection of these associations, see Thacker, pp 55–8.

12 Lafcadio Hearn, *Glimpses of Unfamiliar Japan, Second Series* (London, Jonathan Cape, 1927), pp 14–15.

13 Thacker, p 63.

14 Hearn, pp 12–14.

15 Quoted in Rambach, p 14.

16 Thacker, p 68.

17 *Ibid.*, p 67.

18 Günter Nitschke, *Der japanische Garten* (Cologne, Benedikt Taschen Verlag, 1991), p 68.

19 Thacker, p 68.

20 Marie Luise Gothein, *Geschichte der Gartenkunst* (Jena, Eugen Diederichs, 1926), Vol II, pp 353–4.

Chapter 3: A foretaste of paradise

1 John Brookes, *Gardens of Paradise: The History and Design of the Great Islamic Gardens* (New York, New Amsterdam Books, 1987), pp 17–18.

2 *Ibid.*, p 21.

3 *Ibid.*, p 23.

4 Elizabeth Moynihan, *Paradise as a Garden* (New York, Braziller, 1980), pp 71–2.

5 *Ibid.*, pp 23–4.

6 Brookes, p 143.

7 Moynihan, p 100.

8 James Dickie (Yaqub Zaki), 'The Mughal Garden: Gateway to Paradise', in *Muqarnas*, annual on Islamic art and architecture, Vol 3 (Leiden, Brill, 1985), pp 131–2.

9 James Ferguson, *History of Oriental Architecture*, Vol 2 (London, 1910), pp 289–90, quoted by James Dickie in 'The Mughal Garden'.

[10] Wayne E. Begley, 'The Garden of the Taj Mahal', in James L. Westcoat Jr and Joachim Wolschke-Buhlmann (eds), *Mughal Gardens: Sources, Places, Representations and Prospects* (Washington DC, Dumbarton Oaks Research Library and Collection, 1996).

[11] Quoted by Wayne E. Begley, p 221.

[12] Begley, p 225.

[13] *Ibid.*, p 228.

[14] *Ibid.*, p 230.

[15] *Ibid.*, p 231.

[16] Moynihan, pp 89–90.

[17] Dickie, p 133.

[18] Brookes, p 199.

[19] *Ibid.*, p 190.

[20] Quoted by James Dickie (Yakub Zaki), 'The Hispano-Arabic Garden', in *The Legacy of Muslim Spain*, ed. Salma Khadra Jayyusi, Vol II (Leiden, E.J. Brill, 1994), pp 1016–1035, p 1026.

Chapter 4: Gardens of gods and gardens of saints

[1] Christopher Thacker, *The History of Gardens* (paperback reprint, London, Croom Helm, 1985), p 81.

[2] John Prest, *The Garden of Eden: The Botanic Garden and the Re-creation of Paradise* (New Haven and London, Yale University Press, 1981), p 21.

[3] Thacker, p 83.

[4] Prest, pp 23–4.

[5] Ronald King, *The Quest for Paradise: A History of the World's Gardens* (New York, Mayflower Books, 1979) pp 83–4.

[6] Claudia Lazzaro, *The Italian Renaissance Garden* (New Haven and London, Yale University Press, 1990), p 47.

[7] *Ibid.*

[8] *Ibid.*

[9] Joscelyn Godwin, *The Pagan Dream of the Renaissance* (London, Thames & Hudson, 2002), p 2.

[10] Lazzaro, p 137.

[11] Emanuela Kretzulesco-Quaranta, *Les Jardins du Songe: "Poliphile" et la Mystique de la Renaissance*, 2nd edition, revised (Paris, Editions Les Belles Lettres, 1986).

[12] For a discussion of the *Hypnerotomachia* in this context, see Ioan P. Couliano, *Eros and Magic in the Renaissance*, tr. Margaret Cook (Chicago, University of Chicago Press, 1987).

[13] Frances Yates, *The Art of Memory* (ARK paperback edition, London, Routledge & Kegan Paul, 1984), pp 123–4.

Chapter 5: Ancient mysteries revived

[1] Joscelyn Godwin, *The Pagan Dream of the Renaissance* (London, Thames & Hudson, 2002), p 153.

[2] Emanuela Kretzulesco-Quaranta, *Les Jardins du Songe: "Poliphile" et la Mystique de la Renaissance*, 2nd edition, revised (Paris, Editions Les Belles Lettres, 1986), p 306.

[3] Ovid, *Metamorphoses*, tr. Mary M. Innes (Harmondsworth, England, Penguin Books, 1982), p 40.

[4] Claudia Lazzaro, *The Italian Renaissance Garden* (New Haven and London, Yale University Press, 1990), p 176.

[5] *Ibid.*, p 174.

[6] *Ibid.*, p 177.

[7] *Ibid.*, p 198.

[8] Hansmartin Decker-Hauff, *Gärten und Schicksale* (Munich, Deutscher Taschenbuch Verlag, 1994), pp 217–18.

[9] *Ibid.*, p 219.

[10] *Ibid.*, pp 145–63.

[11] Kretzulesco, p 286.

[12] Horst Bredekamp, *Vicino Orsini und der heilige Wald von Bomarzo* (Worms, Wernersche Verlagsgesellschaft, 1985).

[13] Manuel Mujica Lainez, *Bomarzo* (Buenos Aires, Editorial Sudamericana, 1981).

[14] Lainez, p 574.

[15] Bredekamp, p 51.

Chapter 6: Rosicrucian marvels and recreations of Eden

[1] John Prest, *The Garden of Eden: The Botanic Garden and the Re-creation of Paradise* (New Haven and London, Yale University Press, 1981).

[2] *Ibid.*, p 31.

[3] *Ibid.*, p 47.

[4] *Ibid.*, p 54.

[5] Facsimile edition, *Le Jardin Palatin*, with afterword by Michel Conan (Paris, Editions du Moniteur, 1981).

[6] For a searching analysis of the garden's symbolism, see Richard Patterson, 'The "Hortus Palatinus" at Heidelberg and the Reformation of the World', a two-part article in the *Journal of Garden History*, I/1, pp 67–104, and I/2, pp 179–202 (1981).

[7] See Frances Yates, *The Rosicrucian Enlightenment* (London, Routledge & Kegan Paul, 1972).

[8] Patterson, Part I, p 76.

[9] Patterson, Part I, p 75.

[10] Patterson, Part I, p 78.

[11] Adam McLean, 'A Rosicrucian Alchemical Mystery Centre in Scotland', *The Hermetic Journal* 4 (Summer 1979), pp 10–13.

Chapter 7: Theatres of transformation

[1] Stéphane Pincas, *Versailles: The History of the Gardens and their Sculpture* (London, Thames and Hudson, 1996). Translated from the French: *Versailles: un jardin à la française* (Paris, Editions de la Martinière, 1995).

[2] *Ibid.*, p 35.

[3] *Ibid.*, p 59.

[4] *Ibid.*, p 35.

[5] Ovid, *Metamorphoses*, Book II, tr. Mary M. Innes (Harmondsworth, England, Penguin Books, 1982), p 50.

[6] Hoog, Simone (ed.), *Louis XIV. Manière de montrer les Jardins de Versailles* (Paris, Editions de la Réunion des Musées Nationaux, 1982).

[7] Pincas, p 102.

[8] Emanuela Kretzulesco-Quaranta, *Les Jardins du Songe: "Poliphile" et la Mystique de la Renaissance*, 2nd edition, revised (Paris, Editions Les Belles Lettres, 1986), p 331.

[9] *Ibid.*, p 345.

[10] Marie Luise Gothein, *Geschichte der Gartenkunst*, Vol II (Jena, Eugen Diederichs, 1926), p 102.

[11] *Ibid.*, Vol II, p 103.

[12] J.E. Cirlot, *A Dictionary of Symbols*, tr. Jack Sage (New York, Philosophical Library, 1962), p 44.

[13] Jean Chevalier and Alain Gheerbrant, *The Penguin Dictionary of Symbols* (Harmondsworth, England, Penguin Books, 1996), p 189.

[14] Christopher Thacker, *The History of Gardens* (paperback reprint, London, Croom Helm, 1985), pp 171–2.

[15] *Ibid.*, p 173.

Chapter 8: Visions of a new Elysium

[1] Roy Strong, *The Renaissance Garden in England* (London, Thames & Hudson, 1979).

[2] Quoted in Ronald King, *The Quest for Paradise: A History of the World's Gardens* (New York, Mayflower Books, 1979), p 182.

[3] National Trust, *Stowe Landscape Gardens* (London, National Trust, 1997), p 67.

[4] *Ibid.*, p 5.

[5] *Ibid.*, p 17.
[6] *Ibid.*, p 63.
[7] Kenneth Woodbridge, *The Stourhead Landscape* (London, National Trust, 1986), p 19.

Chapter 9: The symbol-strewn landscape

[1] London, Batsford, 1991.
[2] This view is taken by Jay Macpherson in a paper to the British masonic research lodge Quatuor Coronati, entitled 'Masonic Landscape Design: or Down the Garden Path', published in *Ars Quatuor Coronatorum*, Vol 110, 1997 (London, Quatuor Coronati Lodge, 1998).
[3] Paperback edition, Rochester, Vermont, Inner Traditions International, 1992.
[4] Jacques Chailley, *The Magic Flute Unveiled* (Rochester, Vermont, Inner Traditions International, 1992), illustration 8.
[5] William Howard Adams, *The French Garden, 1500–1800* (London, Scolar Press, 1979), pp 118–20.
[6] *Ibid.*, p 120.
[7] Paola Maresca, *Boschi sacri e giardini incantati* (Florence, Angelo Pontecorboli, 1997), pp 53–5.
[8] *Ibid.*, p 58.
[9] August von Rode, *Beschreibung des Fürstlichen Anhalt-Dessauischen Landhauses und Englischen Gartens zu Wörlitz*, facsimile of 1814 Dessau edition, with afterword by Thomas Weiss (Wörlitz, Kettmann-Verlag, 1996).
[10] J.E. Cirlot, *A Dictionary of Symbols*, tr. Jack Sage (New York, Philosophical Library, 1962), p 3.
[11] Rode, p 104.
[12] *Ibid.*, p 106.
[13] To quote the words used by Paola Maresca in her *Boschi sacri e giardina incantati* (Florence, Angelo Pontecorboli, 1997) in describing the contrast between the desert and the forest.
[14] Rode, pp 126–30.
[15] *Ibid.*, p 131.
[16] Anon., *Der Königliche neue Garten an der heiligen See und die Pfauen-Insel bey Potsdam* (Potsdam, Carl Christian Horvath, 1802), p 8.
[17] Maggie Keswick, *The Chinese Garden* (London, Academy Editions, 1978), p 36.
[18] Adams, p 127.
[19] James Stevens Curl, *The Art and Architecture of Freemasonry* (London, Batsford, 1991), p 186.
[20] *Ibid.*, pp 183–6.

[21] *Ibid.*, p 197.

[22] *Veileder til Vigelandsparken* (Guide to the Vigeland Park) (Oslo, Vigeland Museum, 1990), p 37.

[23] Ulrike Breudel, *Thieles Garten: eine ideengeschichtliche Betrachtung* (unpublished diploma thesis for the Faculty of Landscape Development at the Technical University of Berlin, 1993), a fascinating account of the Thieles and their garden.

Chapter 10: The present age

[1] Katherine Kurs, *Ground of Meaning: Sacred and Rhetorical Dimensions in Ian Hamilton Finlay's Garden Landscape, Stonypath-Little Sparta*, unpublished PhD thesis (London, Royal College of Art, 1989).

[2] *Ibid.*, pp 29–30.

[3] *Ibid.*, p 31.

[4] *Ibid.*, pp 146–7.

[5] Niki de Saint Phalle, *The Tarot Garden* (Lausanne, Editions Acatos, 1999), pp 1–4.

[6] *Ibid.*, p 70.

[7] *Ibid.*, p 9.

[8] *Ibid.*, p 50.

[9] *Ibid.*, pp 22–6.

[10] Quoted from Fiona Dunlop, 'Niki in Wonderland', *Sunday Times Magazine*, London, 28 May 1989.

[11] Saint Phalle, p 22.

[12] *Ibid.*, p 49.

[13] London, Aurum Press, 1999.

[14] Inge Westbroek, 'Ein Schottischer Garten – nach der Chaostheorie', *Blätterrauschen*, journal of the Gesellschaft zur Förderung der Gartenkulture (Spring 1998), pp 3–4.

[15] Beatrix Farrand, *Plant Book for Dumbarton Oaks* (Washington DC, Dumbarton Oaks/Trustees for Harvard University, 1980), p 107.

[16] Linda Lott, *Garden Ornament in the Dumbarton Oaks Garden: An Overview*, Studies in Landscape Architecture, Dumbarton Oaks Informal Papers (Washington DC, Dumbarton Oaks, 1996), p 13.

[17] Farrand, p 3.

[18] Lott, p 34.

[19] Lester Collins, *Innisfree: An American Garden* (New York, Sagapress / Harry N. Abrams, 1994).

[20] *Ibid.*, pp 25–6.

[21] *Ibid.*, p 27.

[22] Michael Baigent, Richard Leigh and Henry Lincoln, *The Holy Blood and the Holy Grail* (London, Jonathan Cape, 1981).

Chapter 11: Connecting with nature

1 Wolf-Dieter Storl, *Pflanzendevas*, 2nd edition (Aarau, Switzerland, AT Verlag, 2001), p 18.
2 See, for example, www.gardeningbythemoon.com.
3 www.gardeningbythemoon.com.
4 Storl, p 178.
5 Prof. Stuart B. Hill, *Companion Plants* (article posted on Internet site www.eap.mcgill.ca/Publications/EAP55htm).
6 Peg Streep, *Spiritual Gardening* (Alexandria, Virginia, Time-Life Books, 1999), p 64.
7 Peter Tompkins and Christopher Bird, *The Secret Life of Plants* (New York, HarperCollins, 1973).
8 www.findhorn.org.
9 Storl, pp 134–5.
10 Tom Graves, *Dowsing: Techniques and Applications* (London, Turnstone Books, 1976), p 133.
11 Graves, p 133.
12 Marko Pogačnik, *Die Erde Heilen* (Munich, Eugen Diederichs Verlag, 1989).
13 Currently available books include: Hamish Miller, *The Definitive Wee Book on Dowsing* (Penwith, Cornwall, Penwith Press, 2002); Naomi Ozaniec, *A Beginner's Guide to Dowsing* (London, Hodder and Stoughton, 1994); and Richard Webster, *Dowsing for Beginners* (Saint Paul, Minnesota, Llewellyn, 1996). A wide range of information on dowsing can be obtained from the British Society of Dowsers, Sycamore Barn, Tamley Lane, Hastingleigh, Ashford, Kent TN25 5HW (www.britishdowsers.org) and from the American Society of Dowsers, P.O. Box 24, Danville, Vermont 05828 (www.dowsers.org). Counterparts also exist in many other countries.

Chapter 12: Creating a garden of meaning

1 Peter Caddy, 'Man Creates the Garden', in William Irwin Thompson (ed.), *The Findhorn Garden* (New York, Harper and Row, 1975), p 8.

Appendix: Some plants and their associations

1 Robert Graves, *The White Goddess* (London, Faber, 1959), p 262.
2 J.E. Cirlot, *A Dictionary of Symbols*, tr. Jack Sage (New York, Philosophical Library, 1962), p 3.
3 Shakti M. Gupta, *Plant Myths and Traditions in India* (Leiden, E.J. Brill, 1971), pp 18–20.

4 Ana María Quiñones, *Pflanzensymbole in der Bildhauerkunst des Mittelalters* (Würzburg, Echter Velag, 1998), pp 33–40.

5 Marianne Beuchert, *Symbolik der Pflanzen* (Frankfurt am Main and Leipzig, Insel Verlag, 1995), p 83, and R.L.M. Derolez, *Götter und Mythen der Germanen* (Wiesbaden, VMA Verlag, 1959), p 284.

6 Beuchert, p 19.

7 *Ibid.*, pp 15–17.

8 Graves, pp 168–9.

9 Nicholas Culpeper, *Culpeper's Complete Herbal* (facsimile edition, London, Foulsham, no date, c. 1970s), p 34.

10 Beuchert, pp 47, 359.

11 *Ibid.*, p 161.

12 *Ibid.*, pp 49–50.

13 Beuchert, pp 101–2, and Wilfried Weustenfeld, *Heilkraft, Kult und Mythos von Bäumen und Sträuchen* (Munich, Peter Erd, 1996), pp 113–17.

14 Graves, p 191.

15 Quiñones, p 78, and Beuchert, pp 63–5.

16 Culpeper, p 216.

17 German edition, *Das Geheime Wissen der Frauen* (Munich, DTV, 1995), p 625.

18 Joyce Froome, 'Mandrakes at the Museum', *Pagan Dawn* 139 (Summer 2001), pp 19–21.

19 Siegfried Seligman, *Die magischen Heil- und Schutzmittel aus der belebten Natur: Das Pflanzenreich* (Berlin, Dietrich Riemer Verlag 1996), pp 216–17.

20 Graves, p 260.

21 *Ibid.*

22 Beuchert, pp 69–70, and Weustenfeld, pp 55–60.

23 Beuchert, p 41.

24 Katharine M. Beals, *Flower Lore and Legend* (New York, Henry Holt, 1917), pp 89–90.

25 Culpeper, p 267.

26 Dante, *Paradiso*, XXXI, 1, 2.

27 Beals, p 46.

28 Culpeper, p 380.

29 *Ibid.*, p 398.

30 Vaughan Cornish, *The Churchyard Yew and Immortality* (London, Frederick Muller, 1946), pp 17–19.

31 David Conway, *The Magic of Herbs* (St Albans, England, Mayflower, 1977), pp 27–31.

GENERAL BIBLIOGRAPHY

Abrioux, Yves, *Ian Hamilton Finlay: A Visual Primer* (Cambridge, Mass., MIT Press, 1992)

Adams, William Howard, *The French Garden, 1500–1800* (London, Scolar Press, 1979)

Bord, Janet, *Mazes and Labyrinths of the World* (London, Latimer New Dimensions, 1976)

Bredekamp, Horst, *Vicino Orsini und der heilige Wald von Bomarzo* (Worms, Wernersche Verlagsgesellschaft, 1985)

Brookes, John, *Gardens of Paradise: The History and Design of the Great Islamic Gardens* (New York, New Amsterdam Books, 1987)

Caus, Salomon de, *Le Jardin Palatin*, with afterword by Michel Conan (Paris, Editions du Moniteur, 1981)

Chevalier, Jean, and Alain Gheerbrant, *The Penguin Dictionary of Symbols* (Harmondsworth, England, Penguin Books, 1996)

Cirlot, J.E., *A Dictionary of Symbols*, tr. Jack Sage (New York, Philosophical Library, 1962)

Collins, Lester, *Innisfree: An American Garden* (New York, Sagapress / Harry N. Abrams, 1994)

Curl, James Stevens, *The Art and Architecture of Freemasonry* (London, Batsford, 1991)

Decker-Hauff, Hansmartin, *Gärten und Schicksale* (Munich, Deutscher Taschenbuch Verlag, 1994)

Godwin, Joscelyn (trans.), *The Dream of Poliphilus* (London and New York, Thames & Hudson, 1999)

——, *The Pagan Dream of the Renaissance* (London, Thames & Hudson, 2002)

Gothein, Marie Luise, *Geschichte der Gartenkunst* (2 volumes, Jena, Eugen Diederichs, 1926)

Hearn, Lafcadio, *Glimpses of Unfamiliar Japan, Second Series* (London, Jonathan Cape, 1927)

Hoog, Simone (ed.), *Louis XIV. Manière de montrer les Jardins de Versailles* (Paris, Editions de la Réunion des Musées Nationaux, 1982)

Jay, Roni, *Gardens of the Spirit* (paperback edition, New York, Sterling Publishing Company, 1999)

Keswick, Maggie, *The Chinese Garden* (London, Academy Editions, 1978)

King, Ronald, *The Quest for Paradise: A History of the World's Gardens* (New York, Mayflower Books, 1979)

Kretzulesco-Quaranta, Emanuela, *Les Jardins du Songe: "Poliphile" et la Mystique de la Renaissance*, revised edition (Paris, Editions Les Belles Lettres, 1986)

Kwok, Man-Ho, and Joanne O'Brien, *The Elements of Feng Shui* (Shaftesbury, England, Element Books, 1991)

Lainez, Manuel Mujica, *Bomarzo* (Buenos Aires, Editorial Sudamericana, 1981)

Lazzaro, Claudia, *The Italian Renaissance Garden* (New Haven and London, Yale University Press, 1990)

Maresca, Paola, *Boschi sacri e giardini incantati* (Florence, Angelo Pontecorboli, 1997)

Miller, Naomi, *Heavenly Caves: Reflections on the Garden Grotto* (London, George Allen & Unwin, 1982)

Moynihan, Elizabeth, *Paradise as a Garden* (New York, Braziller, 1980)

Murray, Elizabeth, *Cultivating Sacred Space* (San Francisco, Pomegranate, 1997)

Nitschke, Günter, *Der japanische Garten* (Cologne, Benedikt Taschen Verlag, 1991)

Ovid, *Metamorphoses*, tr. Mary M. Innes (Harmondsworth, England, Penguin Books, 1982)

Palmer, Martin, and David Manning, *Sacred Gardens* (London, Piatkus, 2000)

Pereire, Anita, *Gardens for the 21st Century* (London, Aurum Press, 1999)

Pincas, Stéphane, *Versailles: The History of the Gardens and their Sculpture* (London, Thames and Hudson, 1996). Translated from the French: *Versailles: un jardin à la française* (Paris, Editions de la Martinière, 1995)

Prest, John, *The Garden of Eden: The Botanic Garden and the Re-creation of Paradise* (New Haven and London, Yale University Press, 1981)

Rambach, Pierre, and Susanne, *Gardens of Longevity in China and Japan* (original French edition, Geneva, Editions Skira, 1987; English edition, New York, Rizzoli, 1987)

Rode, August von, *Beschreibung des Fürstlichen Anhalt-Dessauischen Landhauses und Englischen Gartens zu Wörlitz*, facsimile of 1814 Dessau edition, with afterword by Thomas Weiss (Wörlitz, Kettmann-Verlag, 1996)

Saint Phalle, Niki de, *The Tarot Garden* (Lausanne, Editions Acatos, 1999)

Schama, Simon, *Landscape and Memory* (London, HarperCollins, 1995)

Streep, Peg, *Spiritual Gardening* (Alexandria, Virginia, Time-Life Books, 1999)

Thacker, Christopher, *The History of Gardens* (London, Croom Helm, 1979, reprinted 1985)

Woods, May, *Visions of Arcadia: European Gardens from Renaissance to Rococo* (London, Aurum Press, 1996)

Yates, Frances, *The Art of Memory* (ARK paperback edition, London, Routledge & Kegan Paul, 1984)

——, *The Rosicrucian Enlightenment* (London, Routledge & Kegan Paul, 1972)

Zuylen, Gabrielle van, *The Garden: Visions of Paradise* (London, Thames and Hudson, 1995)

INDEX